cottage and cabin

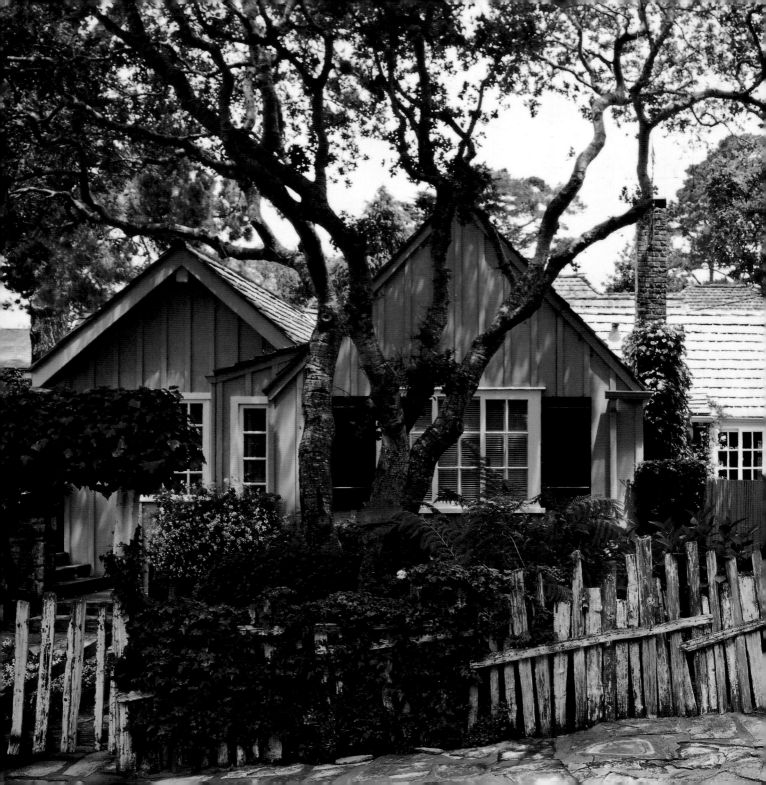

cottage and cabin

LINDA LEIGH PAUL UNIVERSE

First published in the United States of America in 2010
by UNIVERSE PUBLISHING
A Division of Rizzoli International Publications, Inc.
300 Park Avenue South
New York, NY 10010

2010 2011 2012 2013 / 10 9 8 7 6 5 4 3 2 1

Printed in China

ISBN-13: 978-0-7893-2014-8

Library of Congress Catalog Control Number:
2009943199

ACKNOWLEDGMENTS

THIS IS A BOOK ABOUT closing the door at the end of a week, month, or year and heading toward, by contrast, the foretold favors of a special location where choices are expressions of free will, and pleasure is proffered without constraints.

There are many things that bring a book together. The driving forces behind this one were Charles Miers, the publisher of Rizzoli, and James O. Muschett, associate publisher of Universe. Their concept for this collection was clear and thoughtful: the selection of 40 transcendent instances of "fair harbor" architecture that greets every configuration of a retreat, whether it is at the water's edge or on a mountainside. I am grateful to them for their vision.

The chance to work with James and his staff was also an honor. Each detail of the project was managed with masterful consideration and expeditious communication. The incandescent editor, Melissa Veronesi, inhaled the voluminous material and in her collaborative and enthu-siastic fervor, created this splendid package. I am very grateful to Melissa for her patience, her suggestions, and her stories! I wish also to thank the many photographers who gave us permission to publish their works here. Thank you all! I would also like to express my appreciation to Lori Malkin, our book designer.

As always, I give thanks to the architects who have created these wonderful places, or rescued and preserved these unique vernacular buildings. My eternal thank you is also extended to each and every homeowner who welcomed us into their homes.

It was a wonderful experience to work with those who enjoyed their work as much as I did on this project. Their unabashed willingness to create was an inspiration to me every day.

For Robert: Thank you for being my pure joy.

CONTENTS

PREFACE

WITH THIS NEW BOOK, I had a surprising chance to return to a pursuit of pure pleasure. Although I am often drawn to books for ideas and to reiterate personal truths, this time was slightly different. The journey through the 180 cottages and cabins featured in my earlier books became the wellspring for vacation architecture featured in this collection, *Cottage and Cabin*, our new publication. The selection of 40 of our favorite getaways involved a far richer democratic manner than anyone of us might have imagined. Decision-making was based upon the availability of images, which is why we have so many wonderful photographers to thank; owner approval, came into play, and for that, there are some very special homeowners to thank; and most importantly, it was thought that each refuge selected is, and must be, a place created from pure joy. It should be allowed to speak for itself and to make its special qualities known to all.

The subject is, of course, the nature of architecture. This book focuses on the ways in which architecture is dependent on its landscape for the definition of the design process. The design process questions the issues that surround an idea, thoroughly investigating them in a constructive and creative way, taking every imaginable constraint into consideration without preconceptions of what the result *should* be. Finally and ideally, the results are everything one would hope for, often many times better, and always creative.

Each of the five books from which these selections were taken has a theme of architecture and adventure. The exquisite Birding House, for example, appears to float soundlessly above the edge of a flat meadow, while in reality it is tucked into the surrounding cover of a tree line. The views to the West are unrestrained and broad enough to capture birding activity in the meadow and view the air

routes of the North American migratory flocks as they move over Puget Sound. The cabin's architectural complexity and simplicity disappear into the windless marshy flatlands; its beauty is exceeded only by the strong, stable form of a Red-billed Tropicbird, which—on a rare visit to the Pacific Northwest—is immeasurably beautiful in flight and shows her fine long feathery tail. On the ground, her very short legs allow her to remain obscured by the meadow grasses. The Birding House and the Red-billed Tropicbird are each created from the pure joy of their adventure and necessity.

Another example, Fair Harbor, in Carmel, California, illustrates the same idea. The adventure of Carmel-By-the-Sea is entwined in its early discovery as an almost mythical place, created by artists and intellectuals seeking time near the dazzling ocean. Carmel provided freedom for the creation art and literature. Carmel adventurer and world-traveled poet George Sterling wrote, "Carmel was the only place fit to live—it was the chosen land." Early cabins there had distinctive characteristics: temple-flared roof tops, a house made only of doors, a two-story tree house, houses of local stone, and two that were built to house a collection of boy dolls and girl dolls. The small cottage of Fair Harbor was built in the late 1920s. Havened by old oaks on a shady corner and unabashedly modest in style, the corner landscape was trimmed by a cobblestone sidewalk and a patchwork grape-stake fence that held back ferns and roses. Today misty moss and ivy textures of the old days bask in the morning fog. The afternoon sun floods the cottage with an *amber jeune* glow. Fair Harbor stands as the golden *essentia* of Carmel, the pure joy of its being and abiding.

I hope you find the magic of each of these special places. For everyone involved, here is *Cottage and Cabin*. Thank you.

—LINDA LEIGH PAUL

WOODLAND
RETREATS

INTRODUCTION

"…we enjoyed many an adventure hunting ducks from an air boat in the Glades; diving the reefs off Lauderdale to stock the fish tank for flying to Bimini and a wild weekend snorkeling for lobster. The gang had three boats and three aircraft. My friend had acreage in the Carolinas, too. He and I would fly up on weekends and work on his old cabin…" —LETTER FROM MY FATHER, 1999

ORIGINALLY A CABIN MEANT a new beginning. Now it is a literal last resort. We dream of an idyllic spot on earth where a warm, cozy cabin awaits—where, perhaps, an elk herd might wander past, or falling snow will build heavy, biomorphic sculptures outside the window, and luminous streamers of the aurora borealis will hold us spellbound in the night. The attractions of "going to the cabin" are found in its surroundings: inspiration and imagination are ignited by mountains, flatlands, meadows, valleys, high deserts, rivers, lakes, and of course, the ever-changing sky.

All of us who love cabins owe an allegiance to the early American cabins and the idealistic images that accompany them: Abraham Lincoln reading next to a candle, Emerson's eloquent essay "Self-Reliance," Thoreau learning to live "deliberately" at Walden Pond. The purpose of architecture, though, is to incorporate the function and location of a building into the design. A cabin is never solely about the architecture; it is always about where the architecture is placed and how well the cabin reflects that placement.

When American visionary architect Frank Lloyd Wright explored the possibilities of cabin design, it was 1923 and his palette was a pristine Lake Tahoe. The setting included Emerald Bay, forested slopes, an island in the lake, meadows—every imaginable cabin setting. His aim was to "bring the lake more fully within the scheme" of the design. His plan was a site that featured different types of cabins, including the floating cabin, which, true to its name, floated on the lake. He also planned the first hexagonal cabin, with a steeply pitched roof and a compact but dynamic variation of lodge architecture for a flat site. Sadly, the project never went beyond a few drawings of cabins that he named: the "Barge for Two," "Fallen Leaf," and the powerful "Shore Cabin." Five years later, Wright was working out some wonderful angularities for cabins in the Arizona desert. He was taken by the desert landscape and wrote to his son, John, "There could be nothing more inspiring on earth than that spot in the pure desert of Arizona"[1]; he did create a few cabins for his assistants at Ocatilla, their first camp in Arizona.

Wright believed in and sought meaning from design's adherence to place—so much so that he distinguished "his geometries not only to achieve an individual bond with each specific location … but to complete that location's underlying structure, so that each place [became] more fully revealed as an indivisible part of the ordered cosmos."[2] Wright's 1920s work with cabins marked a subtle change in his design theory. The modernist world became present, along with its newly available materials and the ease of movement into and throughout the landscape.

CABIN DESIGN SHOULD FREE US. Whether the setting is harsh or a perfect paradise, freedom from our usual obligations changes the way we think and feel. When, in 1913, the Vienna-born philosopher Ludwig Wittgenstein

was exhausted by work and distracted by life at Cambridge, he found solitude in a rustic cabin in Skoldjen, a small village in Norway, "where he could be himself without the strain of upsetting or offending people. He could devote himself entirely to himself—or rather, to what he felt to be practically the same thing, to his logic . . . the beauty of the countryside . . . long solitary walks, relaxation, and meditation which produced in him a kind of euphoria. Together they created the perfect conditions in which to think. Looking back years later he would say, '*Then* my mind was on fire!'"[3]

Every place, every setting, has its own particular genius, something about it that allows people to make it their own, something that allows people to learn to be happy there. This is the main ingredient in the recipe of the design process. The spirit of the site must rise through the foundations of the design, through the earth, and spread into the air. A cabin should say privacy, or solitude, or excitement. It must be a response to the nature that embraces it and in turn embrace those who will inhabit it.

American poet and essayist Gary Snyder lives in the forests of the Sierra Nevada. He has lived with his family amid the moods and cycles of weather, in harmony with the animals and birds, for more than 30 years. Snyder is a steward of the environment, living so deep within unspoiled nature that he has come to know how it can help one find the "wild mind," which he considers the heart of self-reliance. It has been challenging: "We figured that simplicity would of itself be beautiful, and we had our own extravagant notions of ecological morality. But necessity was the teacher that finally showed us how to live as part of the natural community. . . . We may not transform reality, but we may transform ourselves. And if we transform ourselves, we might just change the world a bit."[4]

THE CABINS PRESENTED IN THIS BOOK represent their owners' willingness to explore and celebrate the verities of landscape, the "wild mind," recreation, and architecture, and the ways in which these speak to one another. Old log cabins have been cared for and have grown small but respectful additions. New log and other vernacular cabins have been designed to recall a particular era or style. One lovely retreat was designed and built in honor of an old barn, for an owner who cherished childhood memories. Even some of the most innovative and imposing architecture still allows the landscape to take center stage. Other sanctuaries have elaborately finished interiors, but regardless of their luxury, they too respect their sites. Some are dynamic displays of engineering and boldly reflect the need to withstand the surrounding terrain or local climate. There are cabins outfitted with all the comforts of home, yet their owners look forward to leaving home to be in them.

It is from the cabin, whatever its design or furnishings, that the voices and shapes of nature are known. Each cabin speaks of a personal style: rugged, gentle, creative, refined, intellectual, athletic. So splash your toes in the lake; put on your skis; catch that salmon; play your flute on the porch; or simply listen to the birds for hours. The cabin is the past, present, and future.

ENDNOTES
1. *Frank Lloyd Wright Quarterly*, Volume 7, Number 3, Summer 1996 (The Frank Lloyd Wright Foundation: Scottsdale), p. 15.
2. Ray Monk and Ludwig Wittgenstein, *The Duty of Genius* (The Free Press: New York, 1990), p.94.
3. Ibid.
4. John Miller and Aaron Kenedi, *Where Inspiration Lives: Writers, Artists, and Their Creative Places* (New World Library: Novato, 2003), p. 54.

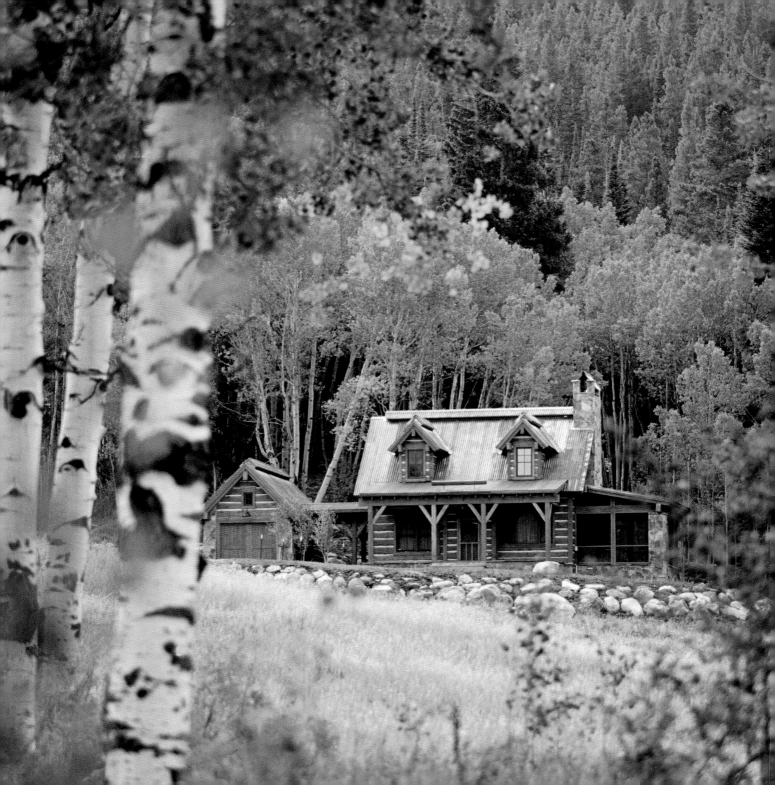

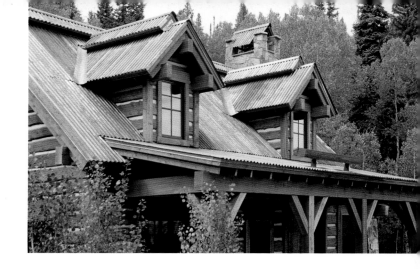

COLORADO LOG CABIN

THIS QUINTESSENTIAL OLD-STYLE MOUNTAIN CABIN WAS
DESIGNED AND USED AS ROBERT AND BEVERLY TRUSHEIT'S
COZY HOME WHILE THEIR MOUNTAIN RANCH WAS TAKING
SHAPE. DESIGNED BY CHARLES CUNNIFFE ARCHITECTS.
PHOTOGRAPHS BY TIM MURPHY.

THIS PROTOTYPICAL COLORADO CABIN is tucked into
the tree line near Steamboat Springs. Overlooking the
open meadows of wildflowers and hilly distances, the
views take in the blue and changing surface of the large
and cold mountain lake—Lake Catamount. Designed
and sited to appear as the original log homestead, the
architect detailed large-timber framing, exposed rafters,
and log slab siding with chinking visible inside and out.
Also essential were the stone base and the rusted-metal
roofing material. The owners live comfortably in their

The cabin and screened porch are nestled in the greenery of the
mountain and meadow (OPPOSITE); rusted metal on the steeply
sloping roof and porch, on the dormers, and above the chimney
enhances the peacefulness of the cabin and the site (ABOVE).

cozy home, while their plans for a mountain ranch, includ-
ing a barn, take shape.

The cabin interior is warm and offers an intimate
greeting in the open living space. The room is focused
around the prominent stone floor-to-ceiling fireplace. The
elevation of the great-room ceilings confers a generous
spaciousness to the modest floor plan. Thoughtful place-
ment of windows allows natural light and "snow shine" to
fill the room from every direction. The play of light alters
the interior experiences and sensations throughout the
day and the changing seasons in the high mountains. Well-
appointed fabrics, rugs, and finish trim harken back to a
western past, while maintaining the warmth of a family home.

The cabin also features several spaces for the enjoy-
ment of the outdoors. The front porch is a good place to
relax and take in the morning and evening light. A lovely
screened porch of timbers and stone is an extension of
the great room. From this outdoor room the views and
fragrances of the meadow, lake, and forest are within reach.
A patio at the back of the cabin runs adjacent to the breeze-
way that connects the cabin to the garage. It is enclosed with
a natural boulder wall and trees, and invites the entire inte-
rior living space of the cabin to enjoy an outdoor experience.

Views from the smooth stone cabin porch, over the meadow and hills, show Lake Catamount in the distance (**LEFT**); the large, open kitchen and bar is counterpoint to the smaller, more intimate dining area, which features bay window seating (**BOTTOM LEFT**); the area on the stair landing is used for a game of chess or checkers or as a private place to read (**BOTTOM RIGHT**); living spaces are defined by height, light, and perspective. Select amenities make a cozy room feel spacious (**OPPOSITE**).

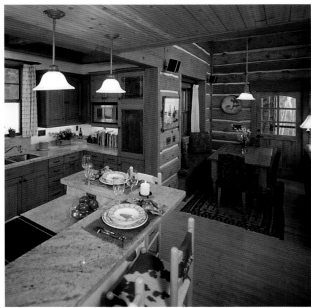

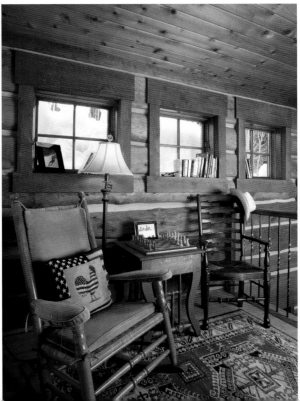

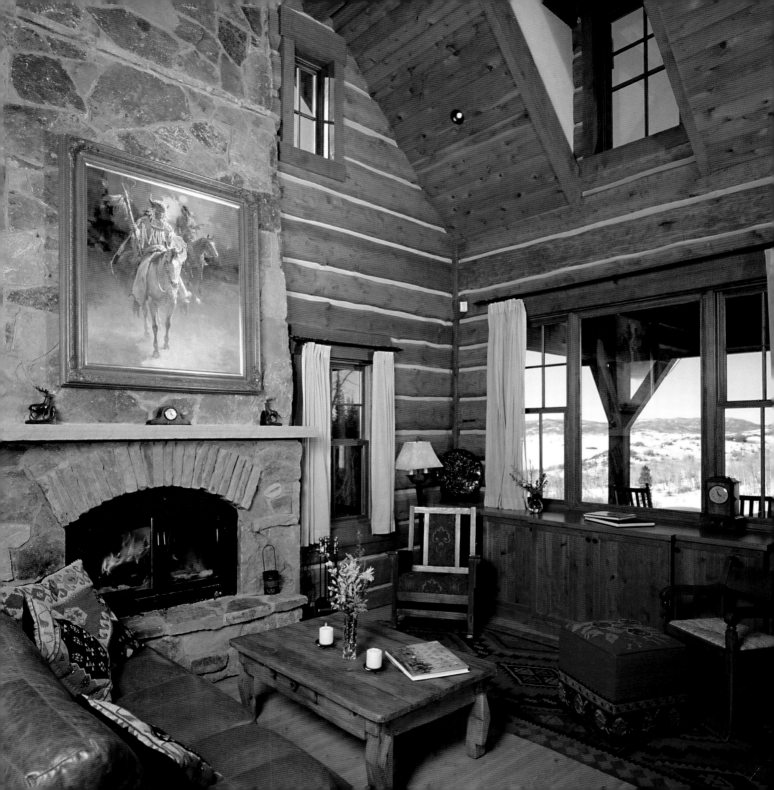

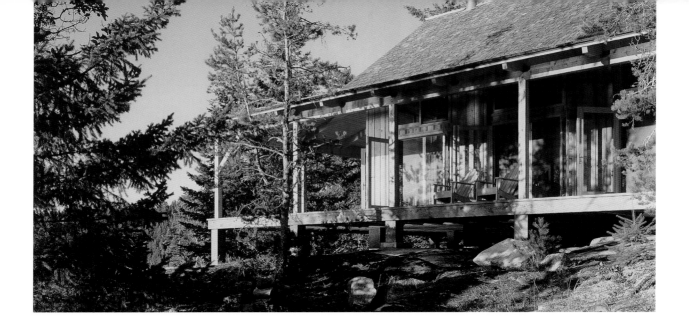

CORTES ISLAND CABIN

A CUSTOM TIMBER-FRAMED CABIN SITED ATOP A ROCK HOUSES THE IMPULSES OF MUSIC AND PAINTING. DESIGNED BY GREG ROBINSON, AIA, OF THE CASCADE JOINERY. PHOTOGRAPHS BY J. K. LAWRENCE.

CORTES ISLAND IS ONE of the many islands located between the mainland of British Columbia and Vancouver Island. The only way to reach it is by ferry or private boat from the Campbell River. No commercial center exists there, and there are very few roads. On a rocky point facing southwest, protruding into the aquamarine waters of

Built on the stony outcropping of glacial rock, the cabin faces the waters of the Strait of Georgia (OPPOSITE); the cabin "floats" on piers above the rock, where evergreens sprout around the wraparound porch (ABOVE).

the Strait of Georgia, is a getaway cabin inserted into the landscape.

For years the owners have spent their summers here in a cramped rustic cabin built in the early 1970s by a previous owner. As the new owners' family grew, and more guests arrived, they desired a smaller cabin where they could get away to relax from all the activities and pursue their individual interests in music and painting. The solution is the lovely 660-square-foot building on top of the rocky point. Built for summer use only, the generous use of French doors, which open onto a 10-foot-wide wraparound porch, extends the usable space to the outdoors and adds functional spaciousness it otherwise would not have. The French doors, large transoms, and gable-end windows fill the interior with natural light while the wraparound porch eliminates a glare that is quite disruptive to painting.

The location of the cabin had, of course, a significant influence upon the design. The rocky knoll and the absence of vehicle access made excavation impractical. The solution

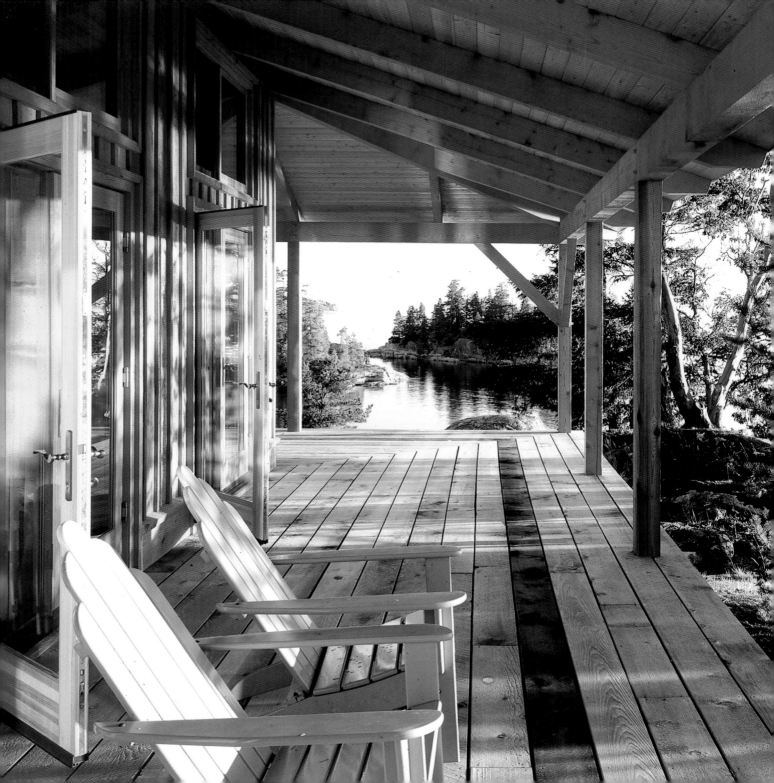

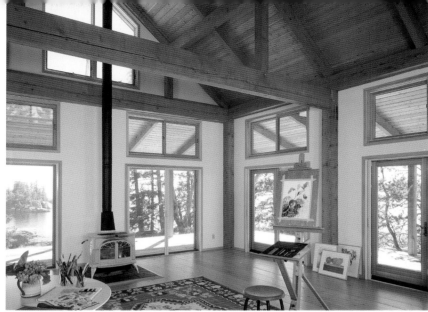

was to support the entire structure on concrete piers that were anchored to the rock. The overall effect is one of the cabin floating above the glacial rock and velvet moss below. All timbers were fabricated off site and delivered by helicopter from Campbell River. The entire frame was completely erected within four days. As a result, the site showed no evidence of disturbance. The simple and beautiful cabin lives in this remote and spectacular natural setting with no alteration to the natural landscape.

*French doors open to the 10-foot-wide porch where the cabin reaches into the landscape (**LEFT**); the large, light, and airy living room is encompassed in vignettes of island life in the Northwest (**TOP RIGHT**); simplify and the universe will grant time to think (**RIGHT**).*

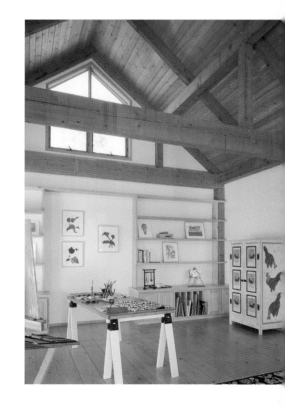

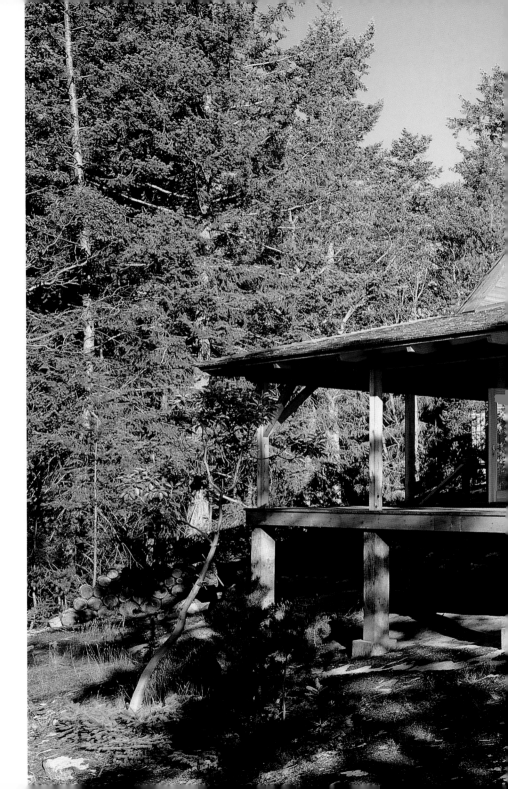

Strong, simple, and deliberate, the timber-frame cabin is a summer refuge.

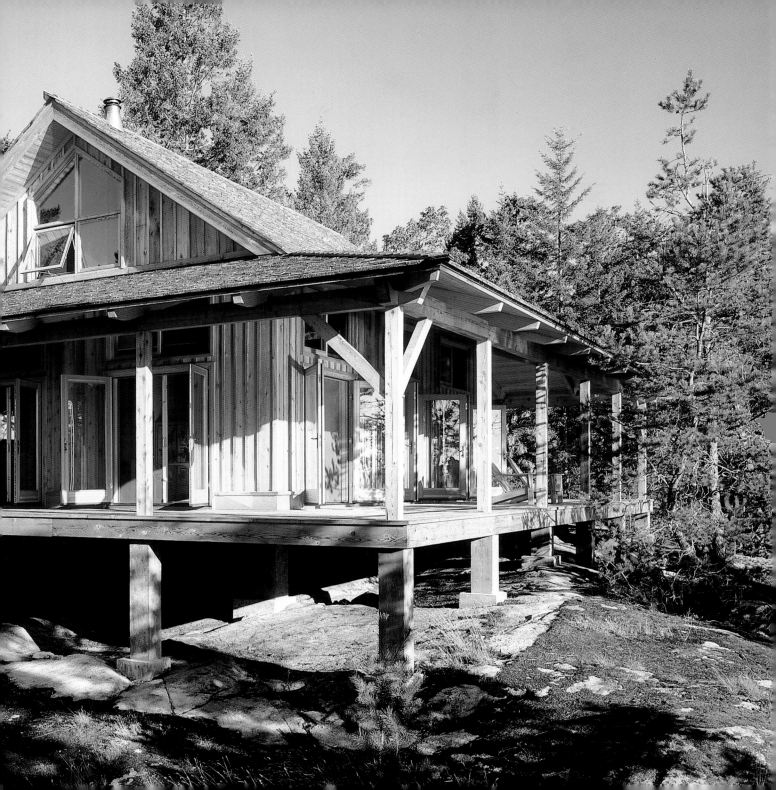

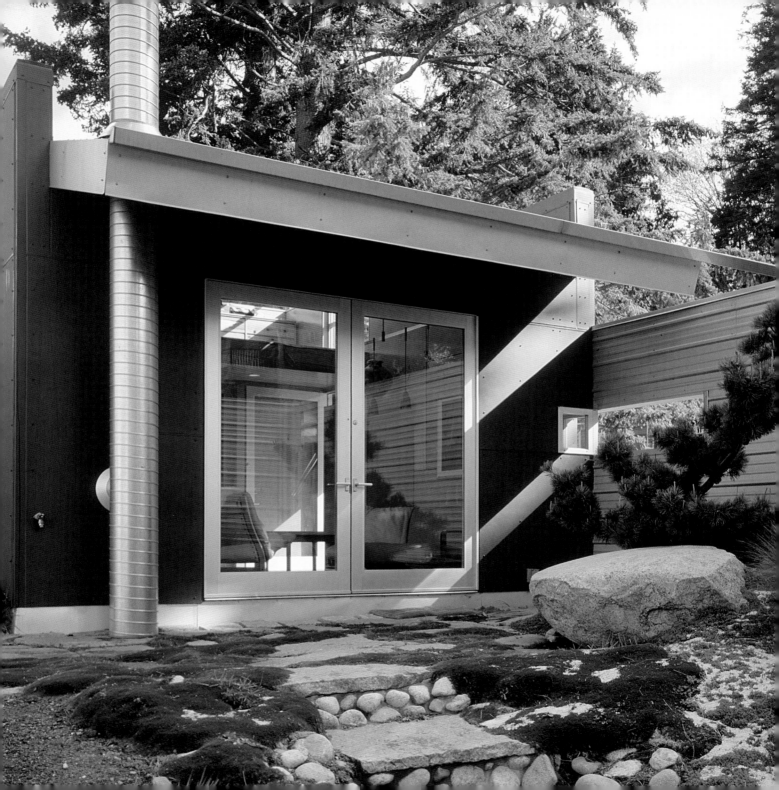

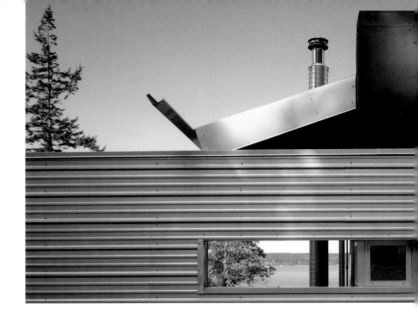

The moss and rock garden is an extension of the serenity of the cabin. The exterior is dark gray cement board. An L-shaped wall of galvanized steel encloses the cabin and the garden (OPPOSITE AND RIGHT).

CAMANO ISLAND CABIN

FOR A SAILOR WHO SPENDS MOST OF HER TIME ON THE WATER, THIS SHIP-SHAPE DWELLING OFFERS EVERYTHING THE SEA CANNOT. DESIGNED BY TIM CARLANDER OF VANDEVENTER & CARLANDER ARCHITECTS; OWNED BY KARIN VENATOR. PHOTOGRAPHS BY STEVE KEATING PHOTOGRAPHY.

ISLAND LIFE IS SPECTACULAR in many ways, not the least of which is the forever changing seascape. This cabin is on a high bluff of island waterfront with southwestern views across Saratoga Passage and the Olympic Mountain Range in Washington. Long and narrow, the site is accessible from the county road at the crest of the property. A drive winds down through a dense thicket of evergreens, opening at the cabin and revealing the glory of Puget Sound. A final hairpin turn brings the drive to

the cabin and garden, located on a low-sloped bench of land roughly one hundred yards from the bluff.

The owners split their time between the cabin and their 48-foot sailboat, *Ahti* (the Finnish god of the sea), which is moored in Semiahmoo, Washington. When they are not sailing in the Straits of San Juan de Fuca and Georgia, and around the Gulf Islands, they are happy to be at the cabin tending a precious garden. The design goals of the cabin were privacy, natural light, and an openness between indoors and outdoors, all packaged within an easily constructed building. The solution was a simple wood-frame box, topped with a sloped shed roof that accommodates a sleeping loft. An exterior landscape wall was built of galvanized steel to wrap around the diminutive moss and rock garden.

The cabin is an open volume: under the loft is a small kitchen. The main living area has two large sets of glazed doors that open south to the enclosed garden and west to the Sound. The owners became their own general contractors

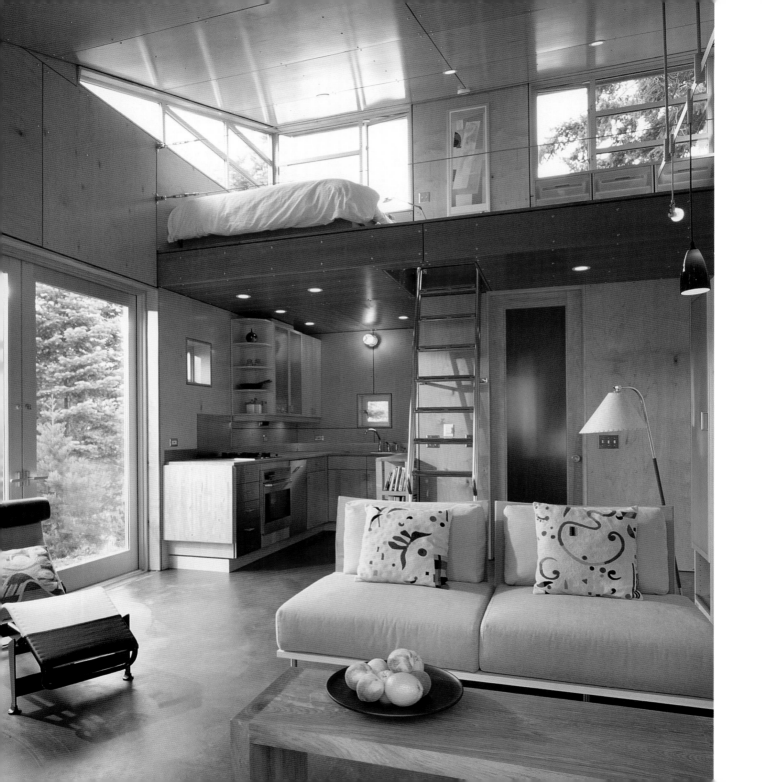

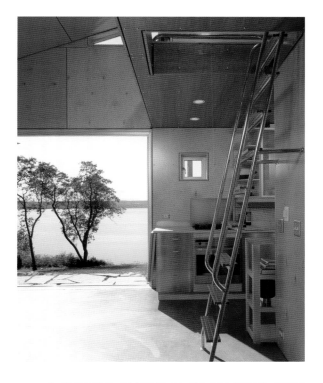

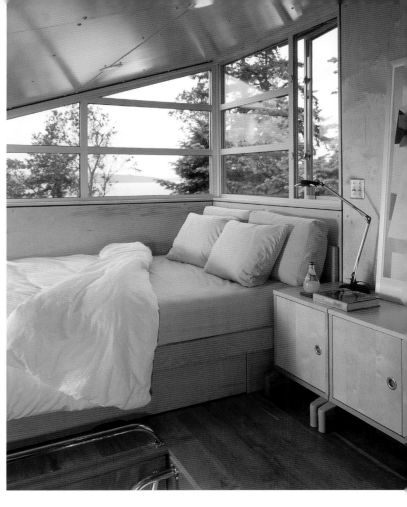

The interior is compact and efficient. A sleeping loft with a clerestory sits above the kitchen and bath areas, adding natural light to the living room (**OPPOSITE**); a ship's ladder leads to the sleeping loft. The doors open a large section of the wall to extraordinary views (**TOP LEFT**); the sleeping loft is exquisite in finish and detail (**ABOVE**); the living room ends with a wood stove and opens to the enclosed evergreen, stone, and moss garden (**LEFT**).

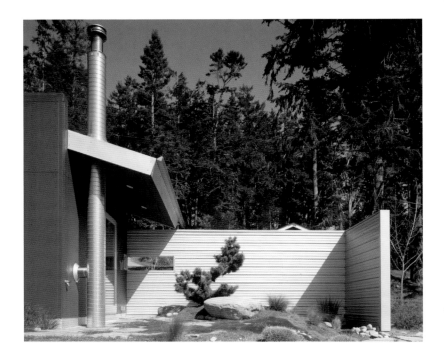

and finish carpenters. The exterior is finished with fiber-cement panels. A metal-clad wall creates a backdrop.

The interior is finished with a stained concrete slab floor on the main level and cherry-strip flooring in the loft. Walls and ceilings are finished in maple and cherry plywoods. The cabin is 352 square feet of elegance and flair, a perfect expression of understanding one's land-based needs and desires.

The use of steel and cement board materials is a counterpoint to the setting, as well as a way of emphasizing the natural surroundings (ABOVE); the cabin, garden, and site (RIGHT).

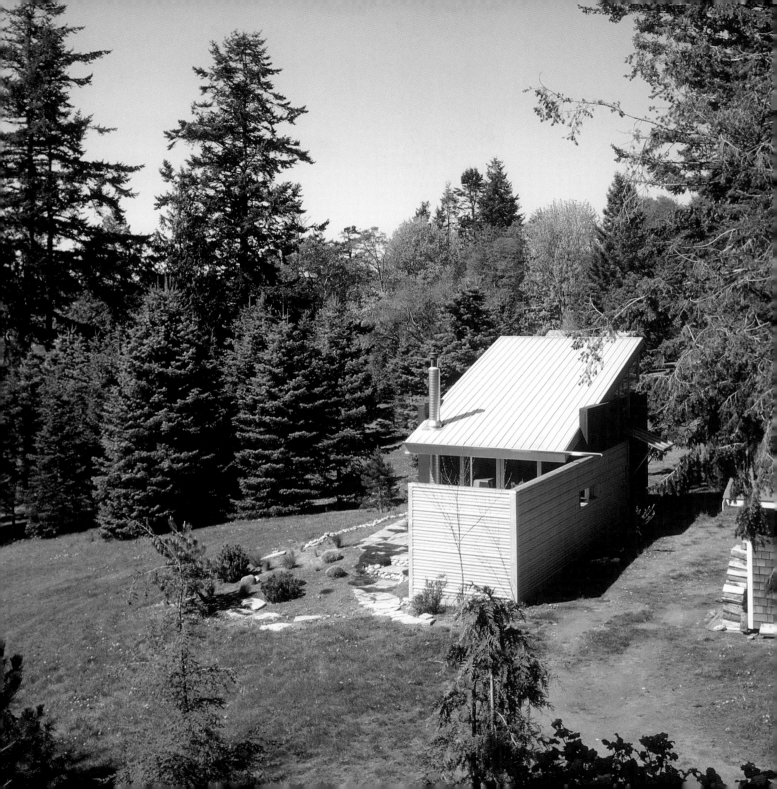

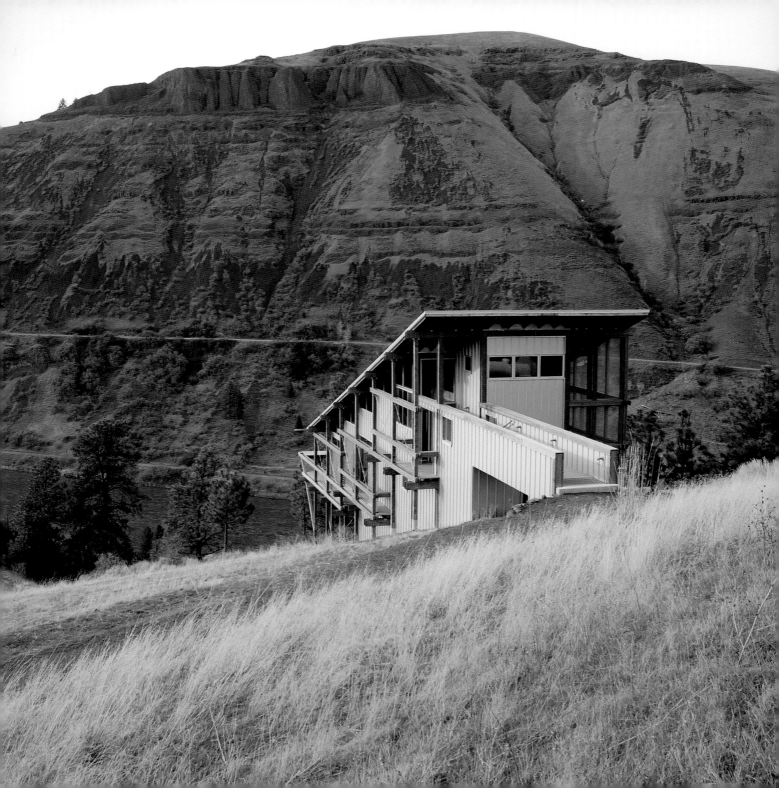

CANYON CABIN

MAGNIFICENTLY ISOLATED, A STUDIO AND CABIN COMMAND THE WILDERNESS OF THE CLEARWATER RIVER IN IDAHO. DESIGNED BY ARCHITECT PAUL F. HIRZEL, AND OWNED BY KENNETH AND JEAN CAMPBELL. PHOTOGRAPHS BY ART GRICE.

The bridge to the cabin, which overlooks the Clearwater River in Idaho (OPPOSITE); the studio path goes up-slope to the canyon house (ABOVE).

TEN MILES UPSTREAM from Lewiston, Idaho, is a wilderness retreat unlike any other. On 40 acres of southern canyon-side land overlooking the Clearwater River is a two-building getaway where life is vivid and thoughts of university teaching and the law office fade quickly. The Campbells asked their architect for a design that would help them "cultivate the spiritual aspects in the trinity of human, fish, and river."

The "cabin" is actually two cabins: "the bunkhouse" is settled into a ravine along a seasonal stream; the "studio house" is perched on a finger ridge where a slope of bunch grass and Idaho fescue meet a ponderosa pine forest about 300 feet above the Clearwater River. A third destination is a perfectly shaped basalt knoll with a commanding observation point overlooking the canyon, which was preserved as an "outside place." The location of the studio house was determined by the location of the best fish sightings. In Ken Campbell's words, it was sited "to mark the holding spot of steelhead for 200 yards in the fishy-looking run along the river's south bank."

The studio is a rectangular form anchored onto the hillside. A bridge extension provides access to a path that goes to the bunkhouse. The west side of the cabin is a *brise-soleil* that allows for easy window washing and is a support for removal of perforated sliding panels—for shading and wind protection. On the east side, the frame supports decks and a screened porch with an outdoor shower. Operable windows on all four sides of the cabin allow natural updraft ventilation as summer temperatures in the canyon often exceed 100 degrees Fahrenheit. Windstorms often blast through the canyon, gusting at 70 miles per hour.

The bunkhouse is a place of refuge. Tucked into the folds of a ravine about 300 yards from the studio, its east

and west façades are punctuated with windows that offer views of different micro-environments. A rock fall, a hawthorne thicket, vivid bird life, and the river below all occupy each frame. This is a perfect place to write, sleep, talk, eat, read, fish, cleanse, garden, and wander.

*This year-round retreat was created with utilitarian materials: the interior floors are galvanized steel diamond plate and oriented strand board. Douglas fir was used for framing, and Idaho white pine for walls and cabinetry (**RIGHT**); the stair descends from the upper-level loft to the dining level, and down to the living room level. Materials were chosen to provide hardiness to meet the challenges of the severe climate (**BOTTOM LEFT**); the lower living area offers a wood stove and built-in wood niches (**OPPOSITE**).*

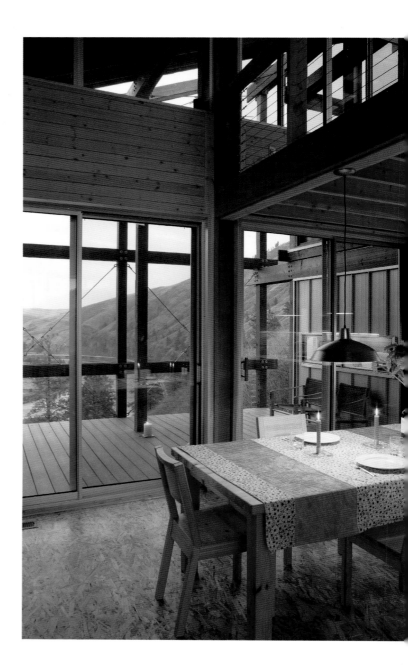

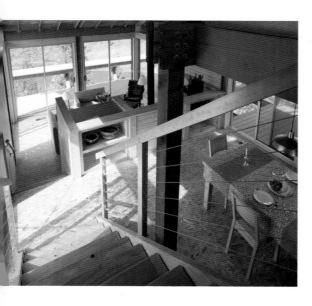

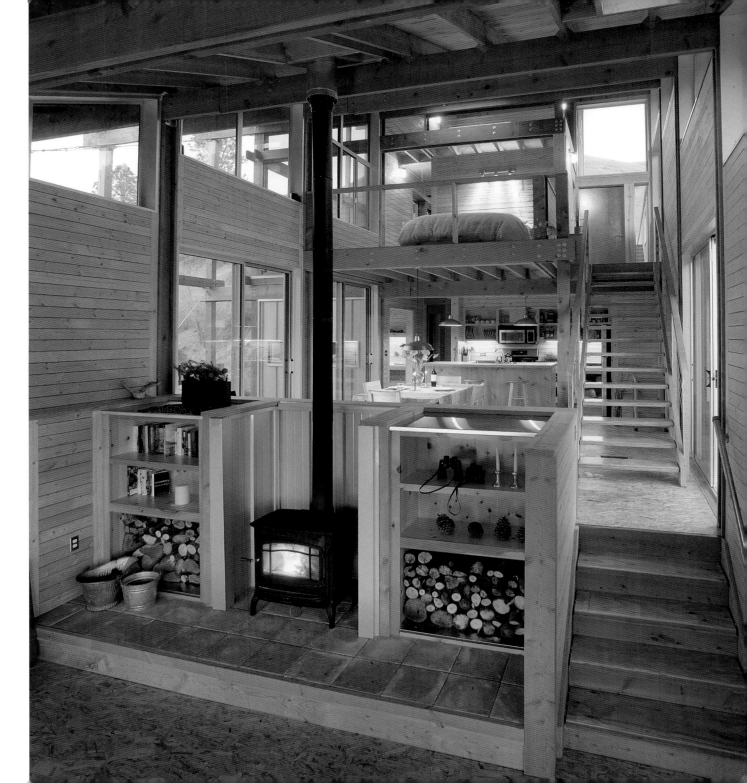

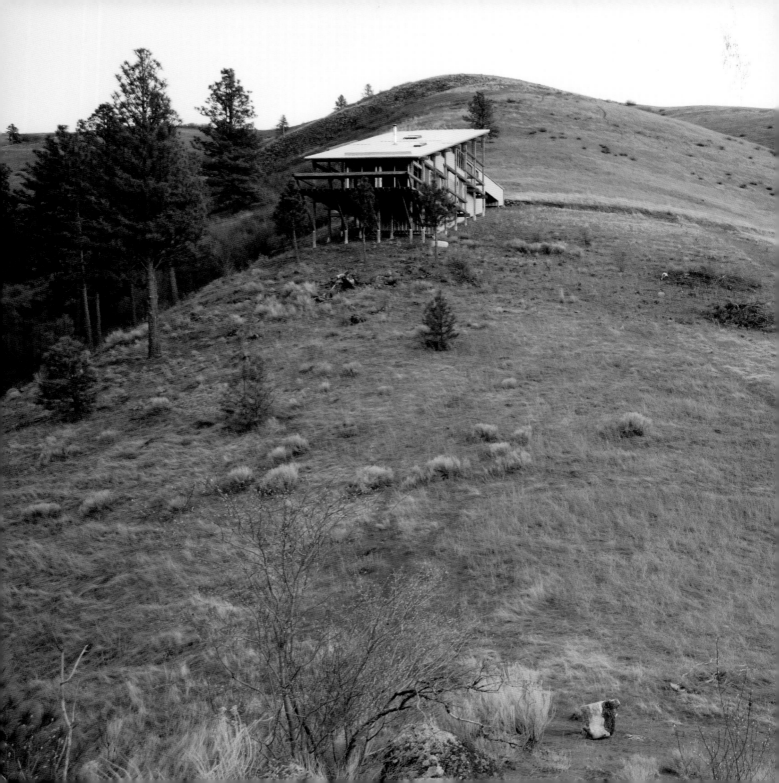

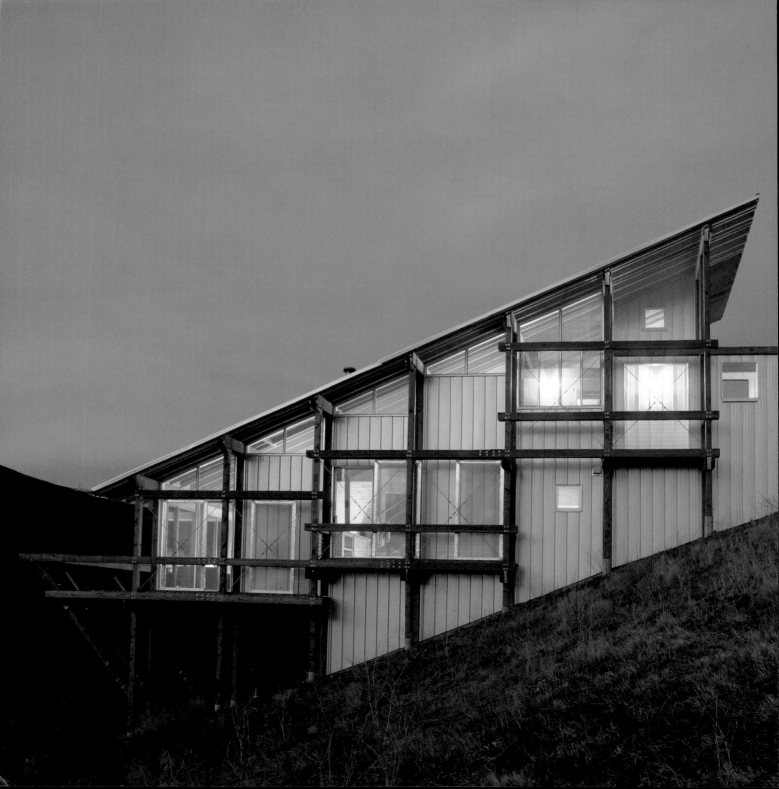

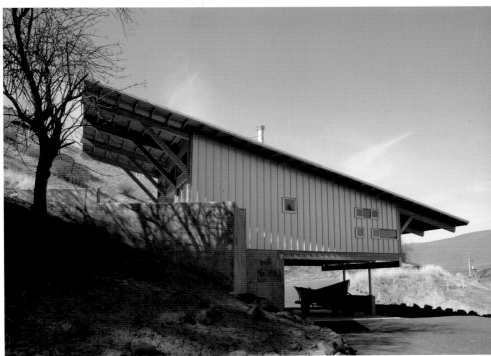

Perched on a finger ridge, the studio house is about 300 feet above the Clearwater River. The studio house is subject to extreme exposure, which called for a brise-soleil to accommodate removable, perforated sliding panels and to protect the house from high gusting winds and 100-degree temperatures (**LEFT**); the bunkhouse is tucked into the folds of a ravine, about 300 yards from the studio house (**ABOVE**).

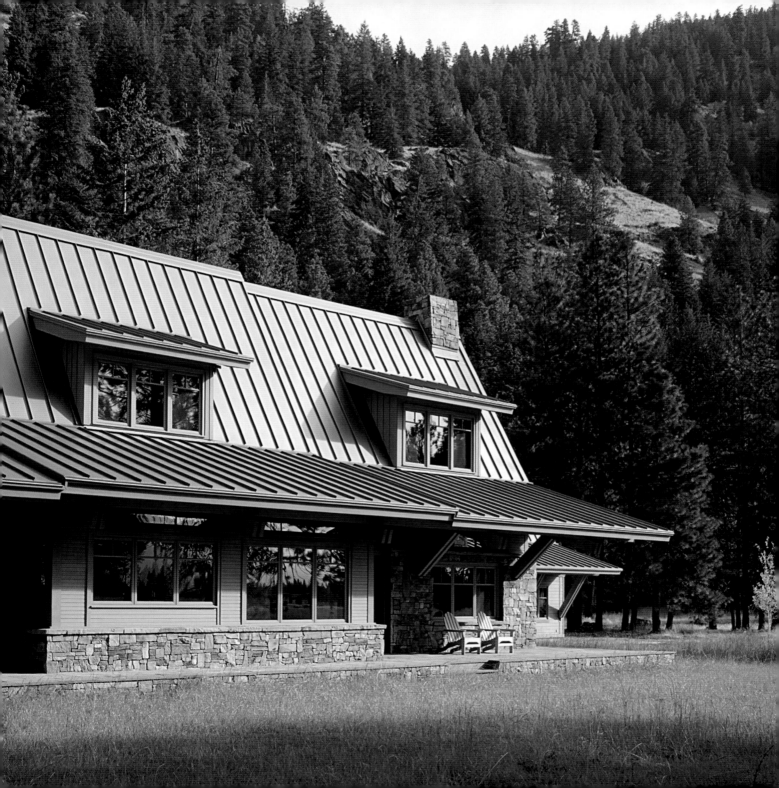

NORTH CASCADES CABIN

THE FINELY CRAFTED WOODWORK AND THE PERSONAL DESIGNS OF FURNISHINGS AND LIGHTS BY THE ARCHITECT NILS FINNE CREATE THE TIMELESS QUALITY OF LIFE IN THE MOUNTAINS. DESIGN BY FINNE ARCHITECTS. PHOTOGRAPHS BY ART GRICE.

The strength and power of the cabin design is a match for the extreme climate of the North Cascade Mountains (OPPOSITE AND ABOVE).

THIS CABIN IN WASHINGTON STATE's North Cascades is part of a continuing investigation into the lyrical qualities of wood and stone for architect Nils Finne. The site is located at the north end of a beautiful, pristine valley between a large open meadow and a dramatic mountain ridge. The meadow has a cross-country ski trail that is groomed during the winter, with links to other trails; when the cabin door is opened one is on the ski trail.

A series of complex wood trusses provides the major ordering element of the design. The trusses are supported by stone walls of split-face Montana ledge stone. The roof line begins very steeply at the peak, then breaks into a gentle slope over the nine-foot-deep stone porch, which is continuous on both sides of the cabin. The deep roof overhangs express a strong sense of shelter and also of welcome.

High clerestory windows allow the interior to enjoy generous amounts of natural light. Additional high windows placed within dormers also allow natural ventilation during the summer. The cabin is designed for both the cold, snow-laden winters, as well as for the hot, dry months. The broad porches provide protection from the heavy winter snows and are a wonderful, cool, shady place to sit during the summer.

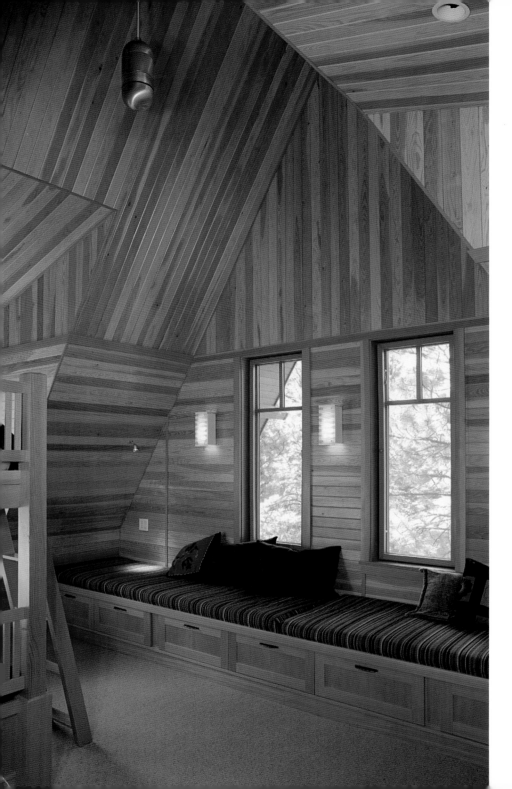

The interior is a straightforward plan, with an open space containing areas for living and dining; cooking takes place at the east end of the cabin. The bedrooms and a loft are at the west end. The long face of the cabin is to the south. A dramatic steel-and-wood bridge to the children's loft passes over the kitchen and ends at a stair, close to the front door, allowing movement to and from the loft—mostly by the children.

The major building materials are gorgeous Montana ledge stone for the exterior walls, and Douglas fir trusses, purlins, and interior wood panels. The exterior porches are stone; the interior floor is cast concrete with a custom veneer finish and features inlaid strips of stone mosaic. This Northern Cascades cabin will be in this family for many generations to come.

*Bunks and built-ins make good use of available space in beautiful wood interiors (**OPPOSITE**); sliding doors with frosted glass panes close easily and divide the bunk room from other areas (**RIGHT**); attention to detail is a Finne Architects trademark. Stair design is by Nils Finne (**BOTTOM**).*

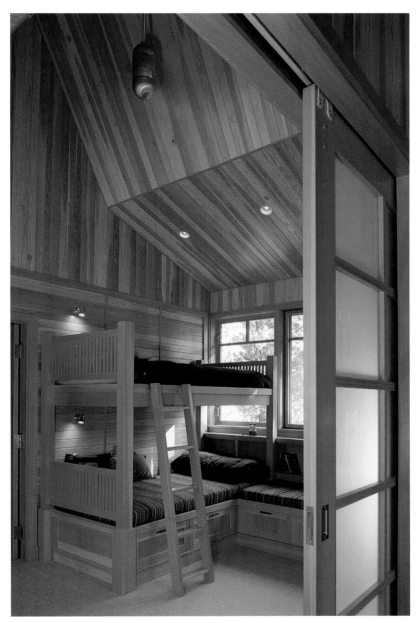

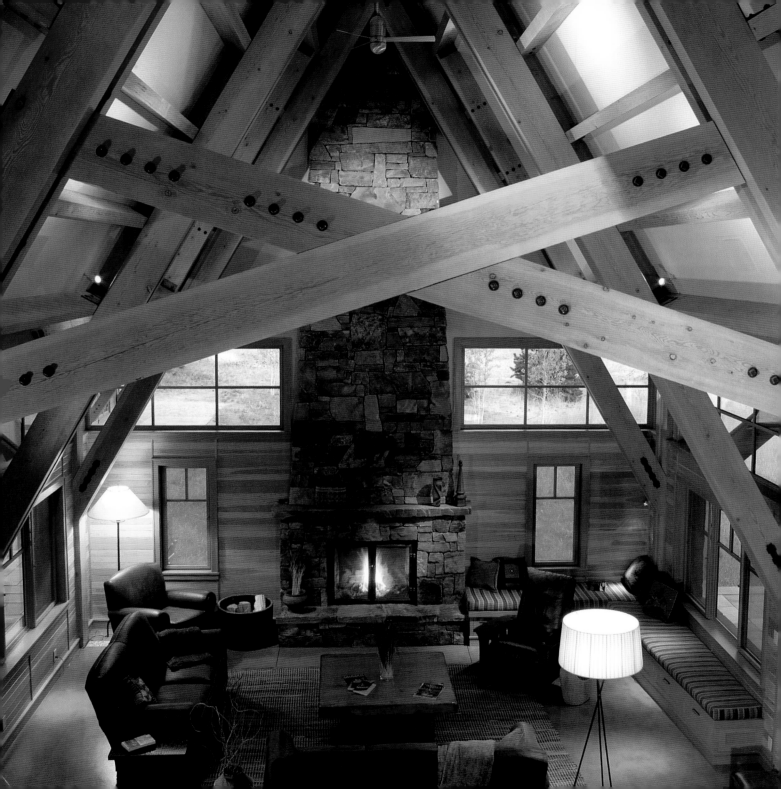

Complex Douglas fir trusses are the major ordering element in the design (**OPPOSITE AND RIGHT**).

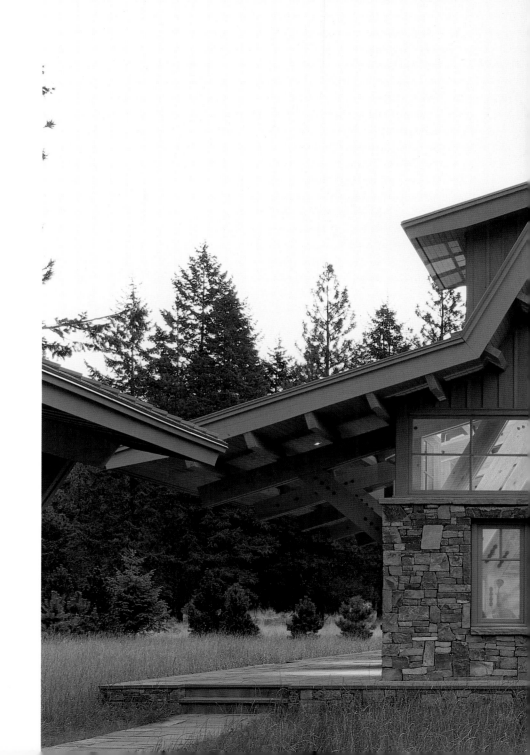

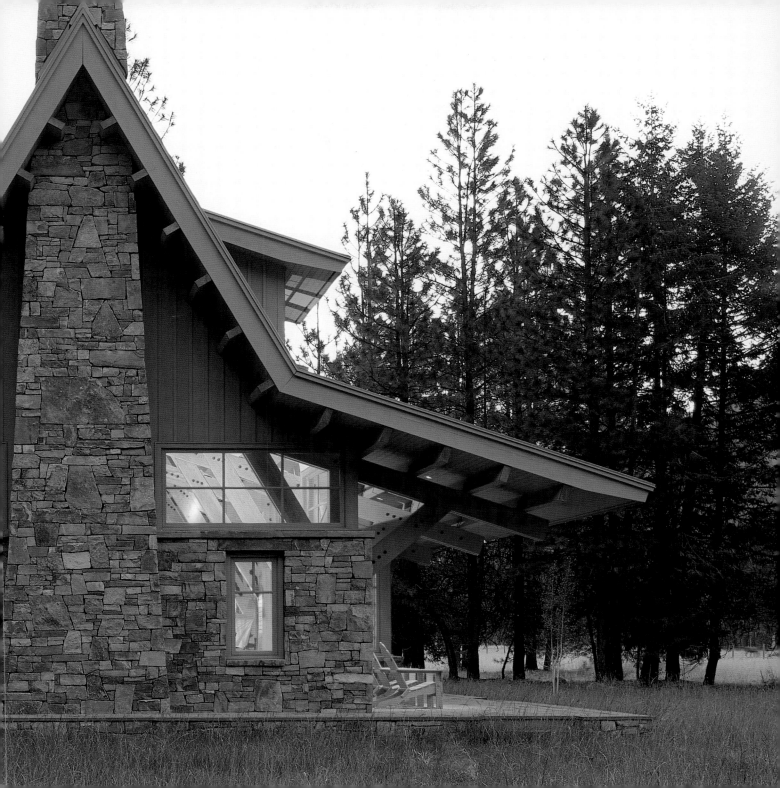

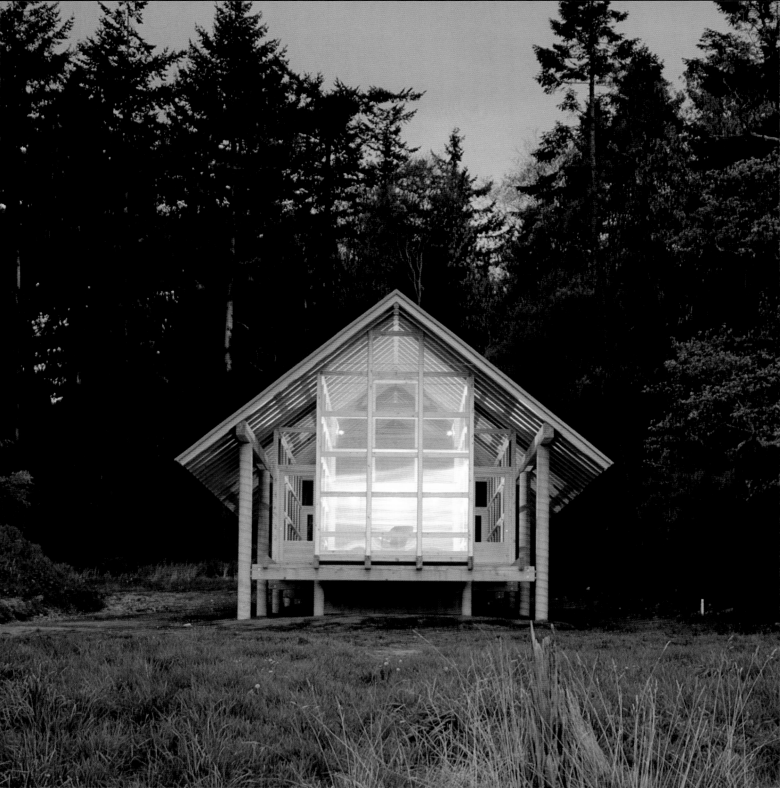

BIRDING CABIN

A DELICATELY SITED AND IMPECCABLY DESIGNED CABIN
ALLOWS AN EASE OF OBSERVATION OF THE MIGRATIONS OF
FLOCKS AND INDIVIDUAL BIRDS. DESIGNED BY ARCHITECT
SUYAMA PETERSON DEGUCHI, AND OWNED BY KRAIG AND
KATHY KEMPER. PHOTOGRAPHS BY DAVID STORY.

*The wood-framed rectangle of windows encloses the interior space
under a simple roof and affords views in all directions* (OPPOSITE
AND ABOVE).

IN THE SPIRIT OF A TENT, this wooden platform is protected by a simple gable roof that serves as inspiration for the owners, who are avid bird watchers. The cabin inhabits the edge of a meadow between woods and Puget Sound. The open gabled end of the cabin faces south toward the migratory routes of hundreds of species of birdlife. The plan of this refuge calls for a pool to be created with an end view of the structure. The pool will be an attraction for the birds and will cause the platform to appear as if it is cantilevered out over the water. This will bring observation closer and multiply the pleasures of watching the returning flocks year after year.

Large blocks of polished concrete form steps leading into the cabin and distinguish the movement from the natural to the man-made. Poured concrete columns hold the wood platform in place, off the ground, and continue upward to support the metal-clad roof. A wood grid defines the cabin's enclosure and is filled with materials of varying degrees of transparency: insect screening, glass, or tongue-and-groove cedar planks. Two screened porches flank the main living space and run the length of the cabin, much like the *engawa* found in Japanese residential architecture. An inner perimeter of glass and sliding wood panels (which are similar to shoji screens) partition the main living area from the sleeping areas. Obsessive, Japanese, blind mortise-and-tenon joinery proliferates throughout the cabin. Intended only for fair-weather use, the cabin is uninsulated, revealing even more of the meticulous construction. Natural finishes on the hand-planed, salvaged cedar planks preserve the beauty of the wood and warm up this simple, but never austere structure.

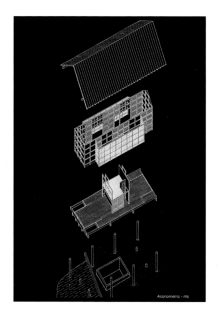

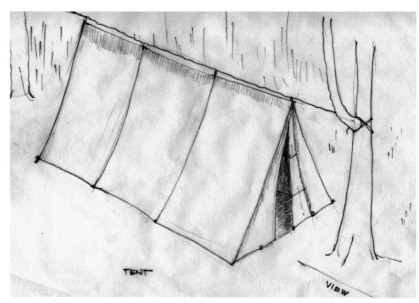

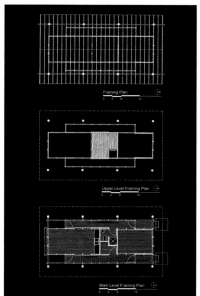

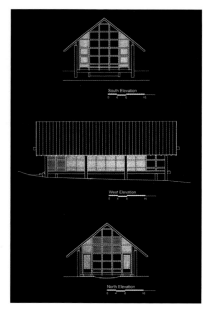

*An exploded model of structure (**TOP LEFT**); sketch of a simple tent (**TOP RIGHT**); plans of each level (**BOTTOM LEFT**); south, west and north elevations (**BOTTOM RIGHT**); the birding perch sits back against the trees with a full view of the migratory meadow and Puget Sound (**OPPOSITE**).*

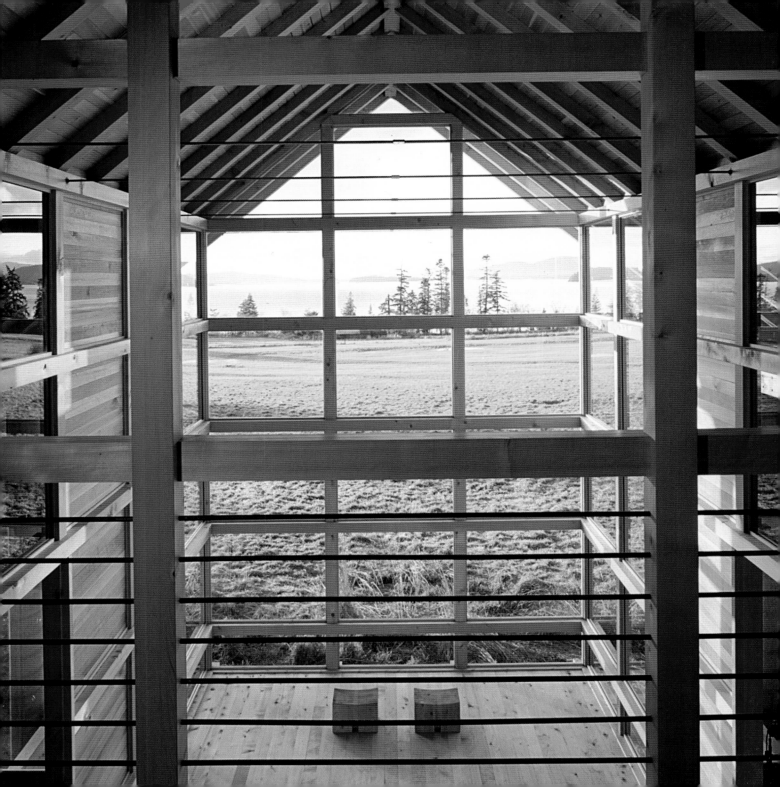

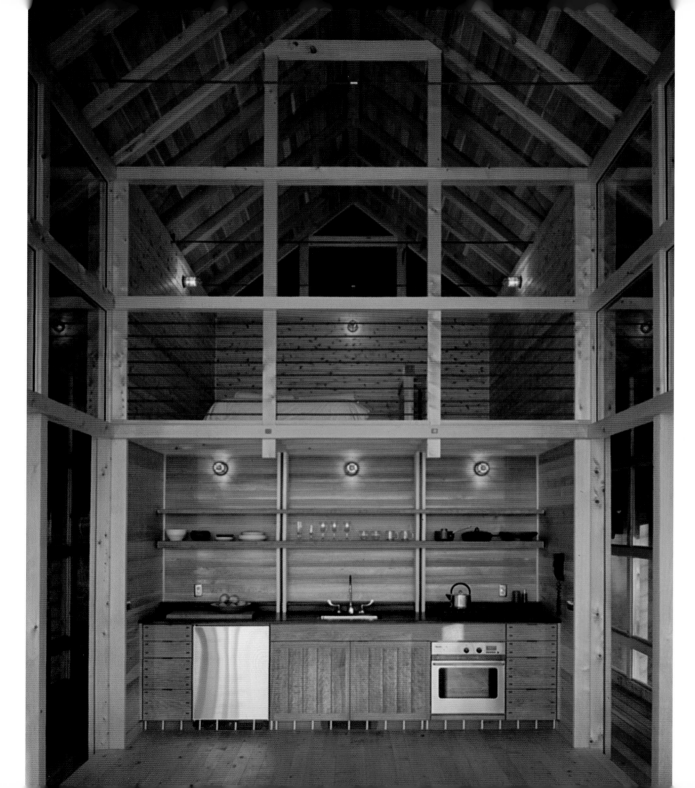

The center of the cabin is a small kitchen tucked under a sleeping loft. Fine joinery and exquisite simplicity define the interiors (**OPPOSITE**); a viewing room tucked into the other side of the two-level kitchen and loft looks back into the tree line (**LEFT**); in fair weather the secluded room opens to face the tree-protected north side by means of a movable wall (**ABOVE**).

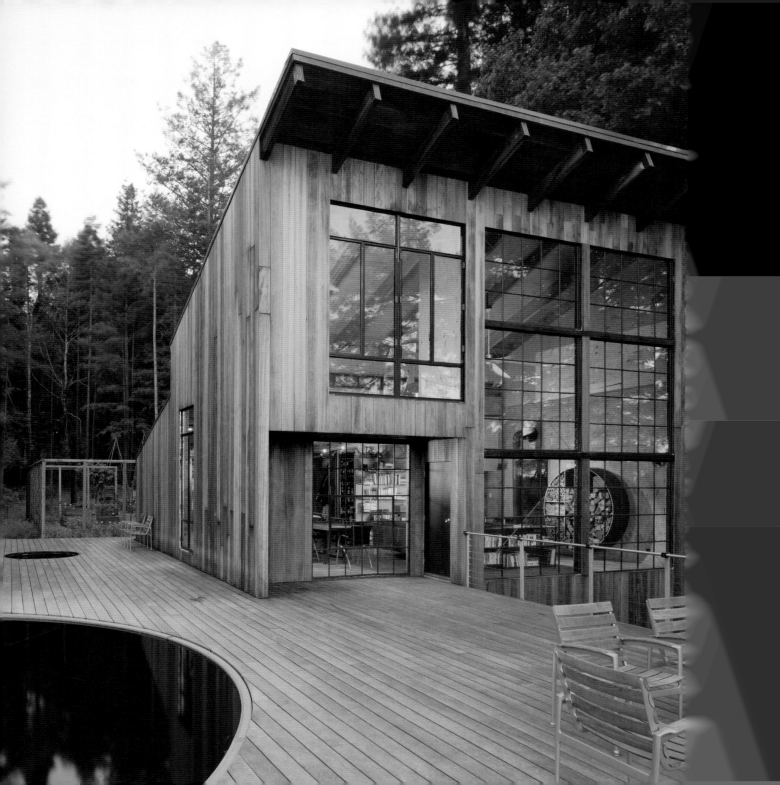

*Emphatic geometry, hidden calculus, and plenty of open space are trademarks of Olle Lundberg design (**OPPOSITE**); a protective enclosure ensures that Mary Breuer's garden is heavy with tomatoes, salad greens, vegetables, and flowers (**RIGHT**).*

SONOMA COUNTRY CABIN

EVERYTHING ABOUT THIS CABIN SHOWS THAT THE OWNERS (WHO ARE ALSO THE DESIGNERS) ARE "LIVING LIFE TO THE FULLEST." DESIGNED BY MARY BREUER AND T. OLLE LUNDBERG, AIA, OF LUNDBERG DESIGN. PHOTOGRAPHS BY JON D. PETERSON.

A SONOMA COUNTY HILLSIDE is the perfect location for a few days away from the office in San Francisco. Architect Olle Lundberg never fails to mix the unanticipated, the beautiful, and the refreshing into his designs. Olle and Mary's cabin is on 16 acres of redwood forest facing northeast over a pristine river canyon. The site and the cabin design are all about the view, and the house opens up toward it. The deck projects itself and its guests out into the air, and the pool is the magic touch, allowing bathers the ultimate luxury of swimming 20 feet in the air—literally "in the treetops."

The main level of the cabin is 900 square feet with a 150-square-foot bedroom loft overlooking the living room and the distant valley. A large 1,500-square-foot deck runs from back to front along one side of the cabin, enclosing a spa and the 25-foot-diameter swimming pool. This extraordinary feature—typical of Lundberg's playfulness—is a reclaimed redwood water tank that is fourteen feet deep. The tank is built into the hillside and is structurally supportive of the deck and cabin.

The exterior siding is redwood, the roof is standing seam copper, and all of the windows are reclaimed from remodeled buildings. The main floor is Chinese slate and

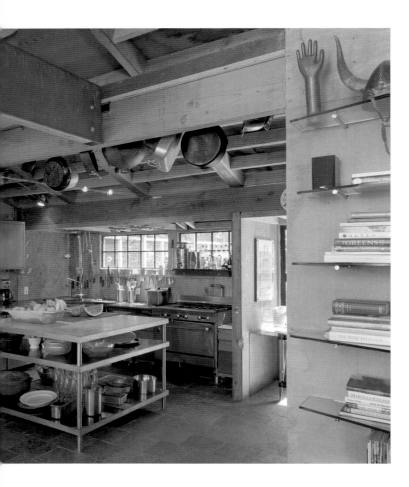

the bedroom floor is maple. The kitchen cabinets are steel file cabinets on coasters for easy cleaning and mouse-proofing. The kitchen island, the dining table—which is made from a single slab of redwood—and the circular-steel firewood holder were designed and fabricated by Olle's firm, Lundberg Design.

Behind the cabin is a fenced vegetable garden occupying 3,000 square feet. Mary tends the garden, which produces lush vegetables and "glorious" tomatoes each year. Just to get to the garden every weekend is Mary and Olle's "weekly dose of sanity."

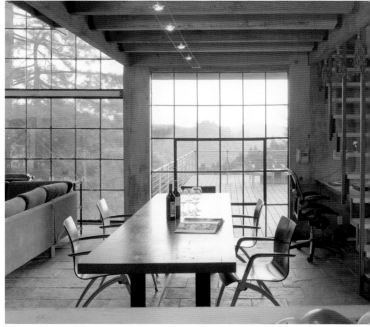

A broad sweep of Chinese slate tiles are used throughout the main cabin level. The brushed stainless steel kitchen island and appliances have a utilitarian—and festive—look (ABOVE); the dining table is steps from the kitchen, tucked under the sleeping loft. Outside, the deck extends into the treetops (RIGHT); attractive glass panels create the illusion that the living room is floating in the trees. The absence of a deck accentuates the drop-off from the bottom of the window. The wood-storage "wheel" was designed by T. Olle Lundberg (OPPOSITE).

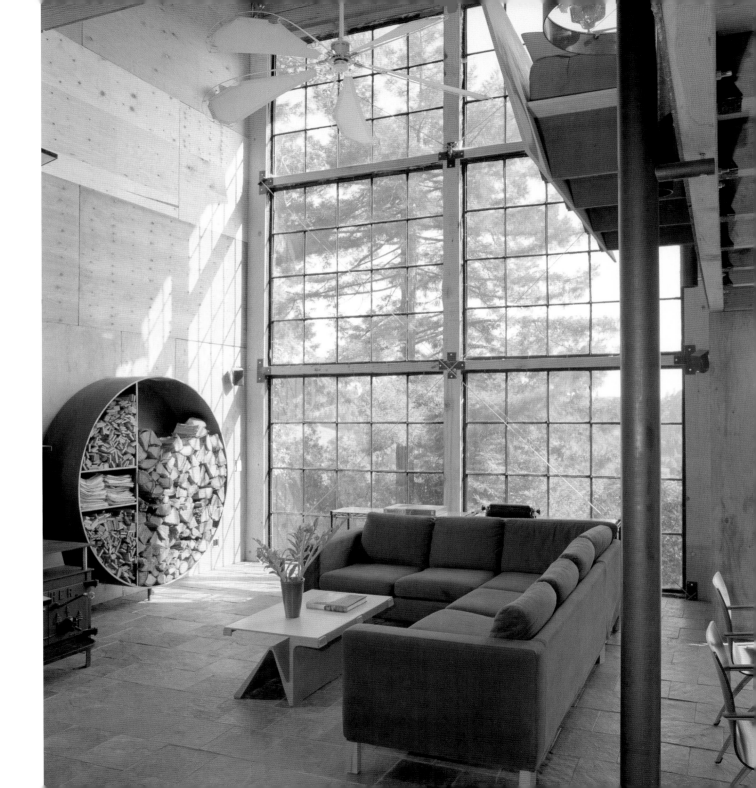

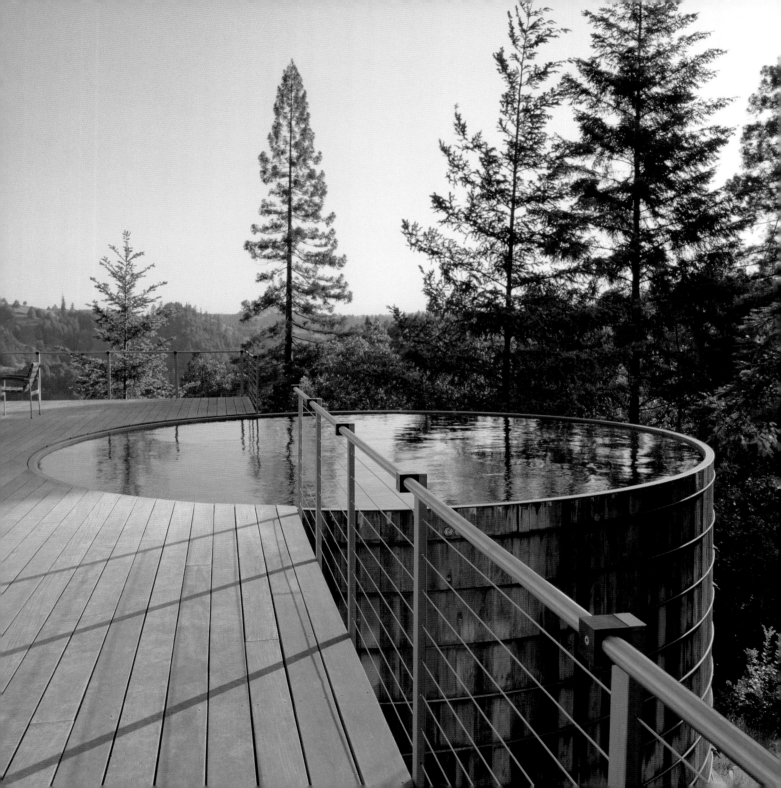

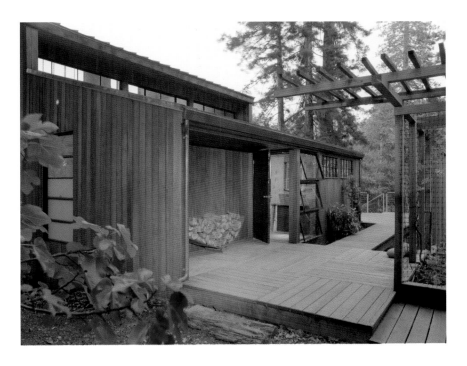

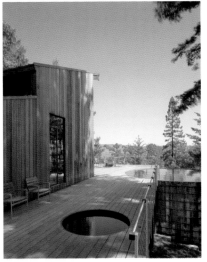

*An irresistible plunge: the swimming pool made from a reclaimed redwood water-tower tank (**OPPOSITE**); walkways connect the entry, side and front decks, and garden. The plane of the shed roof is altered by a clerestory (**TOP LEFT**); entry details: the wood-storage receptacle and outdoor sconce were designed by T. Olle Lundberg (**TOP RIGHT**); the length of the deck including spa and pool (**LEFT**).*

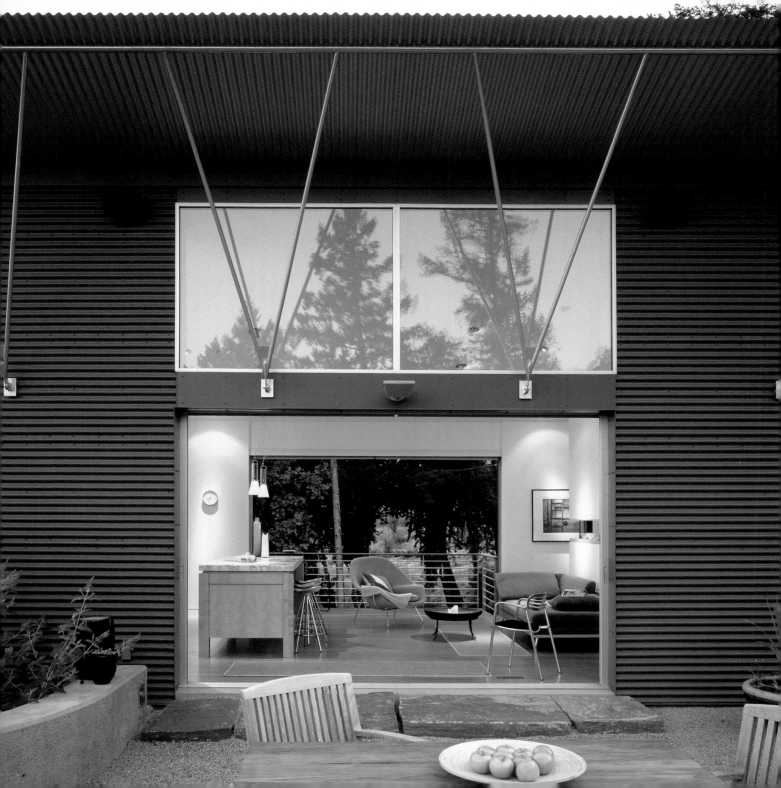

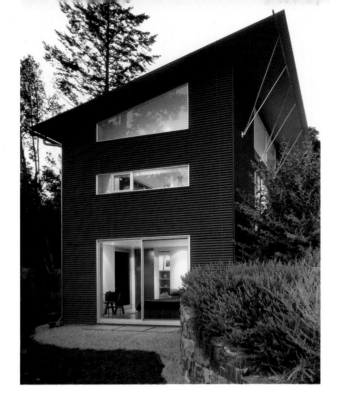

CARLISLE CABIN

GRACEFUL AND ELEGANT SIMPLICITY IN A REMARKABLE SETTING IS THE HALLMARK OF THIS ARCHITECTURAL FIRM'S WORK. DESIGNED BY MARLEY + WELLS ARCHITECTS IN PETALUMA, CALIFORNIA, AND OWNED BY TOM CARLISLE. PHOTOGRAPHS BY TIM MALONEY, TECHNICAL IMAGERY STUDIOS.

Large sliding doors on each side of the great room create a see-through design; they open to decks for convenient dining and entertaining (OPPOSITE); a sumptuous evening in a remote and wild mountain landscape (ABOVE).

IN A REMOTE AREA OF THE COASTAL mountains west of Healdsburg, California, Tom Carlisle dreamed of experiencing a bit of refined modern architecture in a natural, even wild, landscape. The architect was confronted with numerous constraints and restrictions for designing and building in the area, not the least of which is the ever-present threat of the ferocious California wildfires.

The cabin sits above the Mill Creek watercourse on steep terrain. The 850-square-foot design was determined by zoning codes, and materials were dictated by additional California-disaster restrictions. The primary living spaces in the small, compact design are on the upper level and were blended together. Fully pocketed, oversized slider-door pairs on opposite sides of the living area allow the area to be doubled with little effort. The "doubling" served to convert an exterior terrace with a sandblasted and serpentine concrete wall into an alfresco dining room. The added pleasures of dining on the terrace are unimpeded views of Mount Saint Helena to the east. Scattered across the fertile fields out below the cabin is a California landscape of another kind: the Dry Creek Valley and its rolling rows of grape-staked vineyards.

The architect accomplished an aesthetic and utilitarian feat with one solution: addressing the high risk of fire while at the same time paying homage to the architecture of Glen Murcutt; he employed the extensive use of metal siding. Because Tom has plans for the uphill portion of the site, the cabin height was kept as minimal as could be with the structure well founded into the hillside. This resulted in the bed, bath, and a small, secluded garden being located on a private level. The foundation was left fully exposed with carefully cast-in-place niches designed for the pleasure and enjoyment of art and votives. Ah, California.

Pocketed living room walls open to increase the living space into the serpentine, sandblasted concrete terrace. (**BOTTOM LEFT**); *at the opposite side of the great room, large walls open onto a small balcony in the trees* (**RIGHT**).

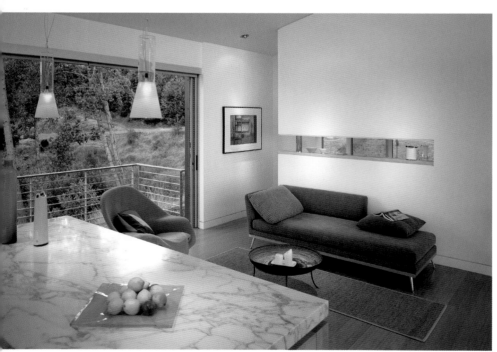

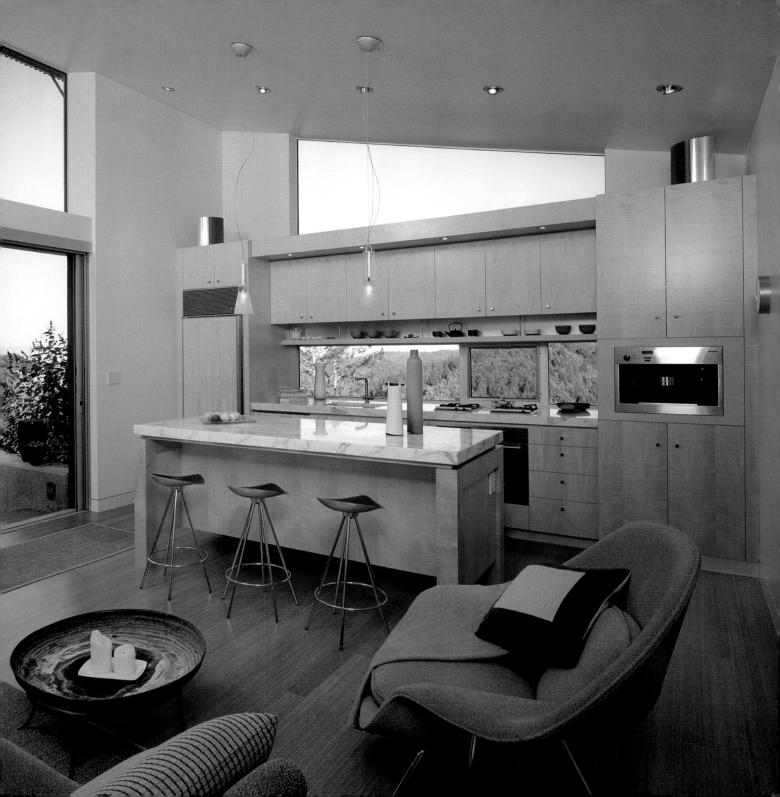

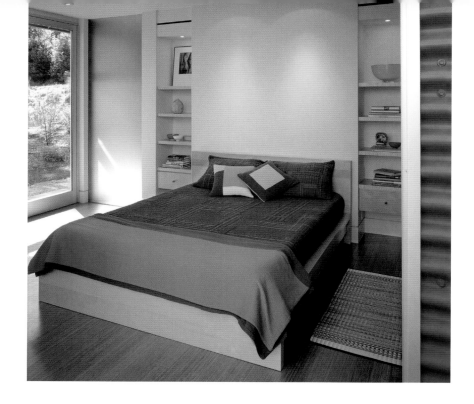

The bedroom is on the ground level. Slider doors open into a small, land-scaped garden (**TOP LEFT**); niches of differing shapes are carved into the concrete wall of the long hallway, which is at ground level (**BOTTOM LEFT**); all of the cabinets, shelves, and vanities are of book-matched, English sycamore, which maintains its delicate whiteness (**OPPOSITE**).

RIDDELL CABIN

A FORESTED RETREAT, WHERE THE NATURAL FORCES OF WYOMING ARE SEEN AS COLORS, IS REFLECTED IN THE FORMATIONS AND MOVEMENT OF CLOUDS AND AUTUMN LEAVES. DESIGNED BY WILL BRUDER, WILL BRUDER ARCHITECTS, LTD., WITH THE DESIGN TEAM OF RICHARD JENSEN AND MICHAEL CROOKS. PHOTOGRAPHS BY BILL TIMMERMAN.

The tracery of this cabin's tailored geometry emphasizes the delicacy of the natural environment in which it is placed (OPPOSITE AND ABOVE).

CELEBRATING THE NEEDS of a painter, a photographer, their dog Willow, and a shared passion for the outdoors, this modest wooden sculpture is a refined, simply organized pavilion for life, work, and leisure on forested land in Wyoming.

This crisp and tailored plan was conceived and developed from the outside in and the inside out. The taut surfaces of one-inch by three-inch resawn cedar boards, with their subtle shadow joints, are left to weather—like the simple quiet of a Wyoming shed or the severe rigor of an Anges Martin painting. Set into the cedar siding, flush, polished stainless-steel-framed square windows emphasize the tautness of the exterior surface and hint at the refinement of the interior finish. The reflections of the forest on the glass balance and counter the play of shadows on the texture of the aging cedar skin.

The interiors are finished with smooth, off-white walls, complemented with black slate and maple-strip flooring. Details such as custom-finished maple cabinets, translucent fiberglass shoji screens, and a hot-rolled, black steel-plate fireplace are a part of the architecture. Space is divided between the private and the common. A compressed entry is a gallery of maple, which extends on a diagonal geometry through the house to the living, dining, and kitchen areas. In the entry gallery area the vertical scale opens, and large windows frame the striking verticals of an aspen grove beyond the glass. Off the long corridor gallery, blind maple doors conceal private sleeping suites for the owners and for guests. Innovation and detail in spatial arrangements begin at the ridge cap of the cedar-shingle roof and are considered everywhere. The owners' landscape architect, Mother Nature, cherishes the cabin that disappears into her and reflects her best.

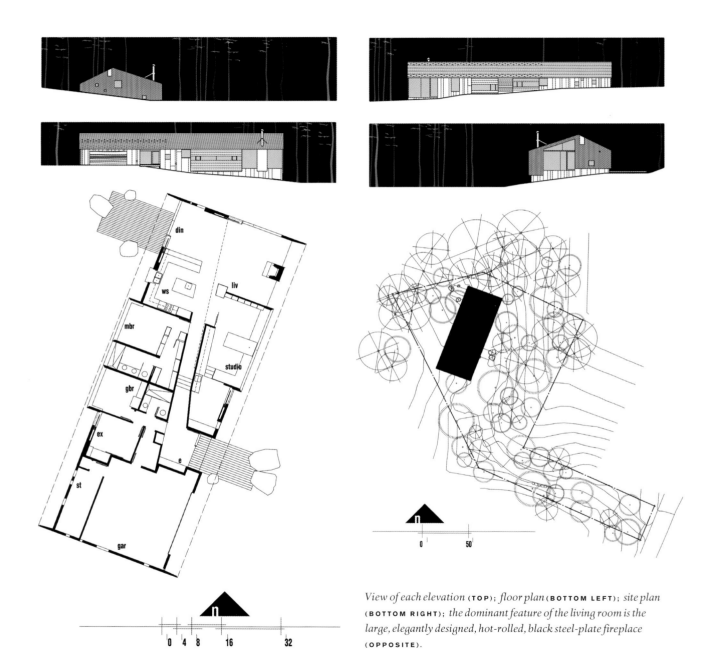

din

liv

ws

mbr

studio

gbr

ex

e

st

gar

N

0 4 8 16 32

N

0 50

*View of each elevation (**TOP**); floor plan (**BOTTOM LEFT**); site plan (**BOTTOM RIGHT**); the dominant feature of the living room is the large, elegantly designed, hot-rolled, black steel-plate fireplace (**OPPOSITE**).*

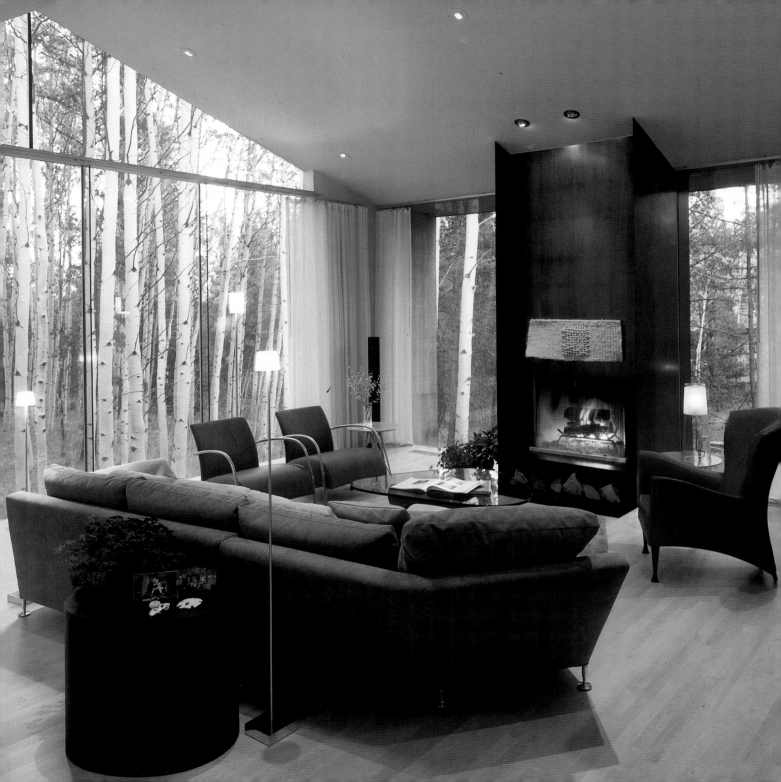

The "compressed" gallery of maple paneling is a diagonal path from the main entrance through the house to the kitchen, dining, and living room areas (**LEFT**); precision is the main feature of the maple and stainless steel kitchen and work island (**BOTTOM LEFT**); a private studio is concealed behind custom-made translucent fiberglass shoji screens (**BOTTOM RIGHT**); the entrance is a balanced composition of volumes and planes (**OPPOSITE**).

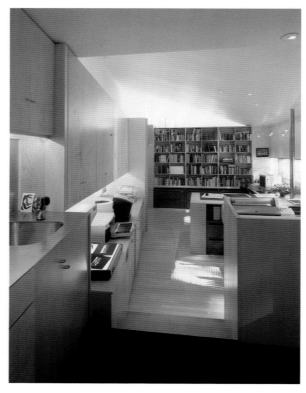

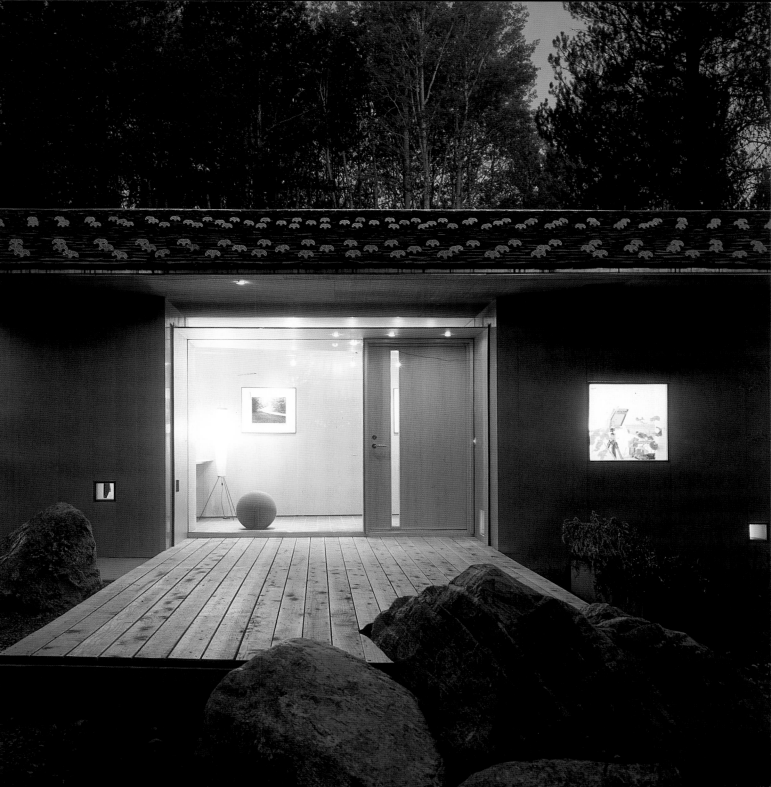

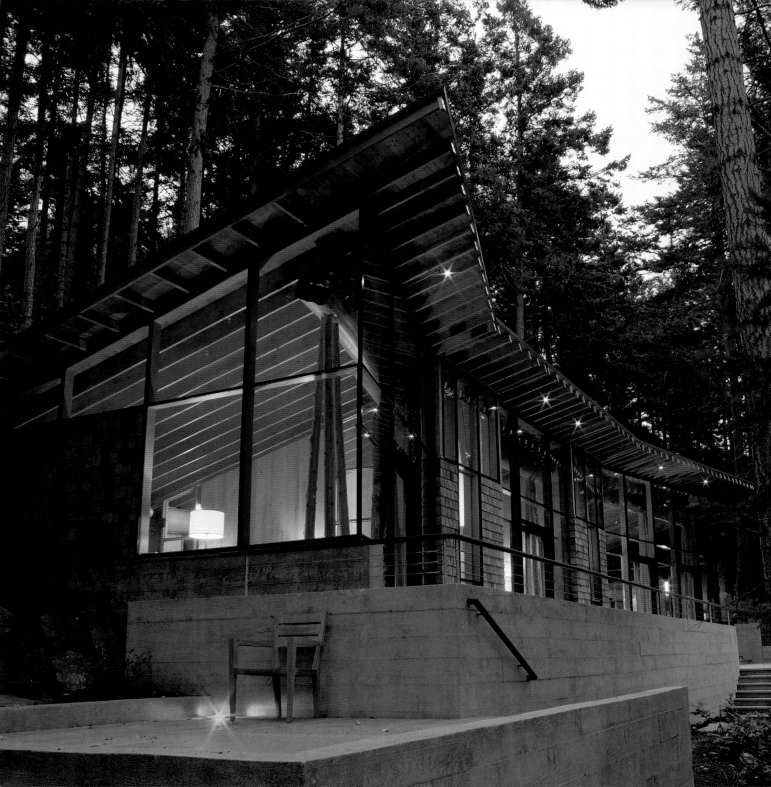

LONG CABIN

A LOVE OF WOOD AND ITS COMFORTING STRENGTH IS EXPRESSED AS STRUCTURAL AND DESIGN ELEMENTS IN THIS STUNNING HOME SET NEAR AN OLD-GROWTH FOREST. DESIGNED BY JIM CUTLER, AIA, CUTLER ANDERSON ARCHITECTS, AND OWNED BY DIXON AND RUTHANNE LONG. PHOTOGRAPHS BY ART GRICE.

IN AN OLD-GROWTH FOREST on the north shore of a saltwater channel is a wonderland getaway for this California couple. The interior and exterior design is made to emphasize natural materials, views of the channel, and the tree-lined shore on the opposite side of the passage. The log tripods and beams on the interior are

Cedar-log tripods are aesthetically pleasing but, more importantly, serve to withstand the lateral loads behind an envelope of glass (OPPOSITE); the shed roof almost meets the ground at the rear of the cabin (ABOVE).

western red cedar, and the exposed framing is Douglas fir. The simple shed-roof system is composed of exposed Douglas fir rafters with rigid insulation and a metal roof. The cedar-log tripods are designed to withstand lateral loads; the log beams and two-inch by twelve-inch rafters resist gravity. The entire wooden support system is encased in a glass and cedar-shingle shell. The shell is a protective barrier but at the same time reveals the internal workings. To further exhibit the structure and its relationship to the surrounding forest, the cedar tripods are used in front of the uphill windows to introduce the overall concept as one approaches the main entry.

The interiors are open and light-filled, with white-washed tongue-and-groove southern yellow pine. Ceilings are one-inch by six-inch tongue-and-groove Douglas fir; the flooring is a lovely European beech. Furnishings tend toward a subtle mid-century modern style, mixed with custom-made wood pieces. Interior half-height tripods near the back of the cabin, where the roofline descends, are bolted into the concrete foundation that surrounds the structure. In the front of the cabin, the foundation becomes a long, broad deck, perfect for dining and relaxing. The simplicity and elegance of this superb hillside cabin is a constant voice in the wilderness.

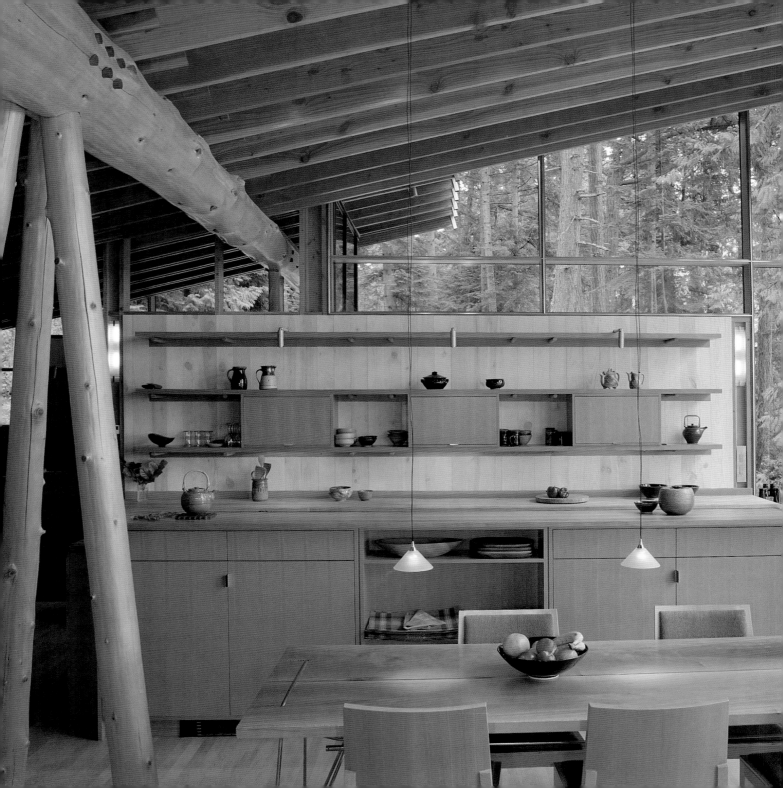

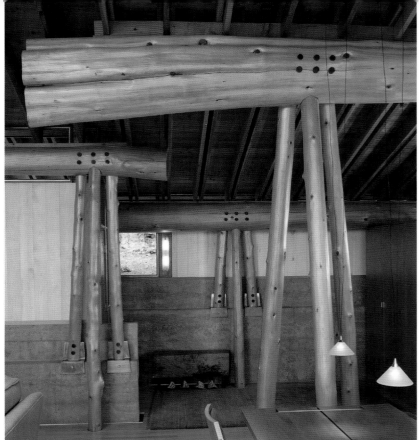

Kitchen, breakfast nook, and dining areas occupy a coveted, sunny corner. Cabinets are Douglas fir; flooring is European beech (**LEFT**); breathtakingly beautiful cedar tripods create an asymmetrical, lyrical balance in the interior (**ABOVE**); site plan (**RIGHT**).

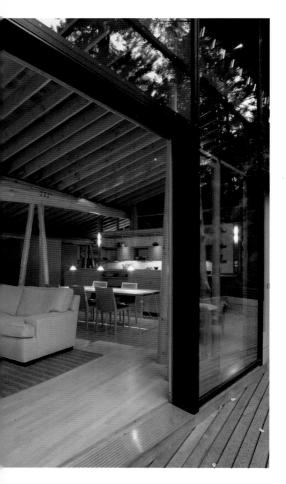

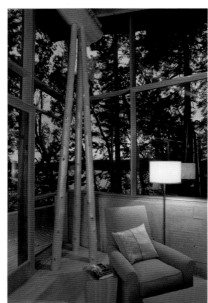

*A shed design offers an expansive open face and clerestory (**ABOVE**); striking detail of the cedar tripod and beam in a glass corner (**TOP RIGHT**); a shed roof of metal and blue cedar shingle siding are exterior finishes (**BOTTOM RIGHT**); the deck and open walls create cabin living at its best (**OPPOSITE**).*

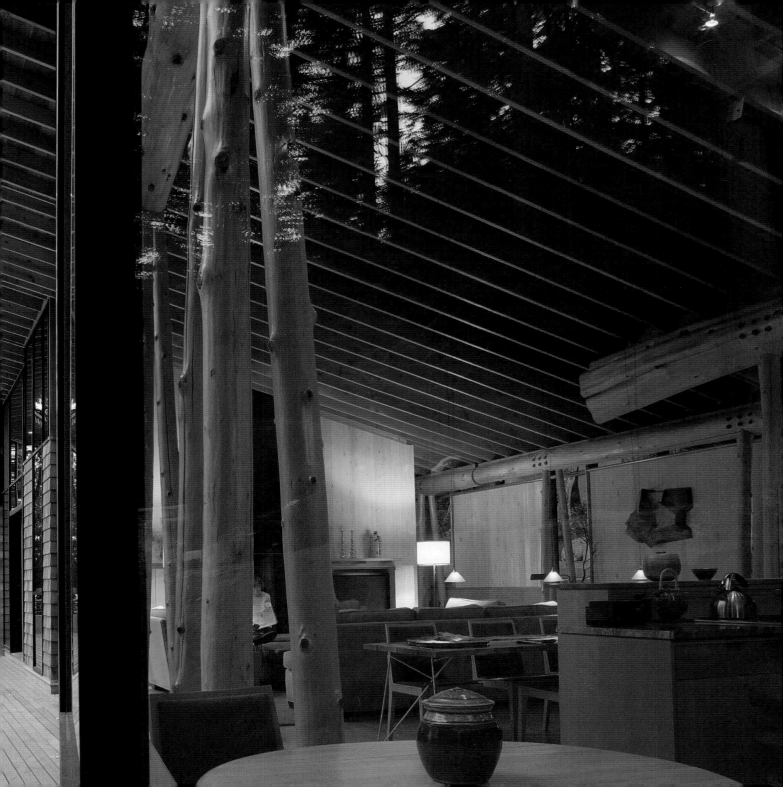

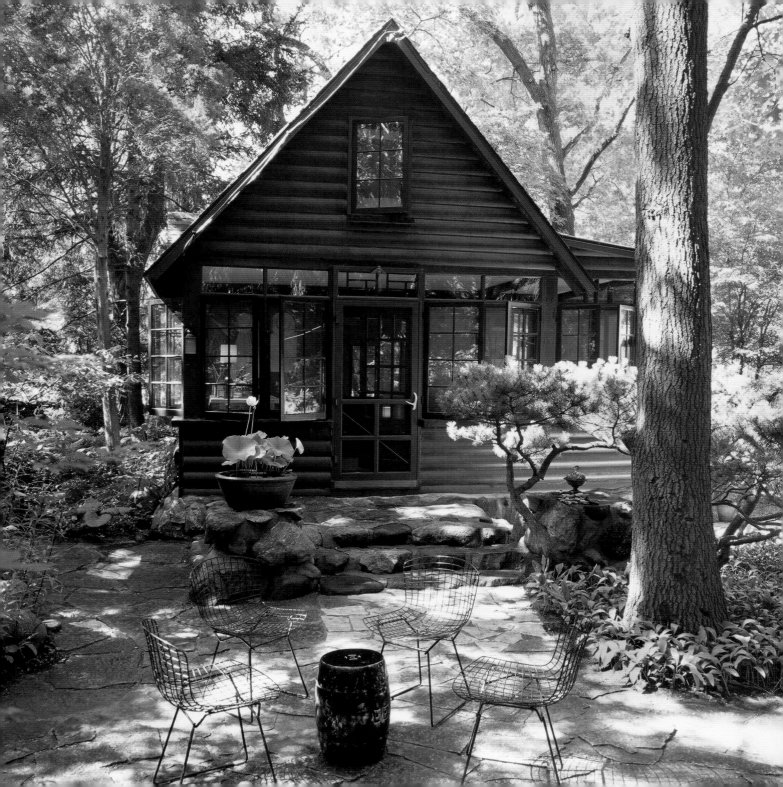

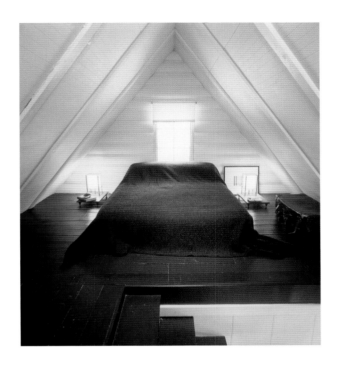

FOR THE SAKE OF US ALL, finding the "perfect place" usually translates into making the best of what you've got. Both Russ and William are design professionals who had an idea of building a small, sleek, weekend house. Instead, they found an old cabin on a large, lush lot that needed every loving thing they were well prepared to do. This inspirational getaway an hour from Chicago is an example of ditching certain preconceived notions and turning your reality into a haven.

The tiny, dark interior was stripped down to its cleanest lines, where the possibilities began to emerge. Walls and paneling were polished and floors were redone to open the cabin to its maximum interior space, which includes a sleeping loft above. A little brown shed in the back became a part of the extended living area by converting it into a detached meditation-gallery space. Both buildings have lovely vertical, open, wood-framed, and paned windows that add a graceful country touch. The two buildings are connected by a flourish of stone terraces and walkways, which are the foundation for the surrounding gardens and the basic element of future landscaping.

The magic of this refuge is the way the old and the new are perfectly balanced between iconic and modern. The furnishings selected for the living room convey the sensation of being in a modern European château of indeterminate spaciousness. A large, overhead light fixture mysteriously makes the room seem bigger. The optical illusions of spatial largess are the work of a master, or two. The design secrets employed in William and Russ's cabin are a gift. This is their heaven and it will be forever. It is a work in progress, and we can't wait to see where these talents take us.

THE PERFECT PLACE

THIS ICONIC, DEPRESSION-ERA CABIN WAS RESTORED AND
DESIGNED BY WILLIAM ATKINSON AND RUSS RAMAGE. THE
BALANCE OF HISTORIC WITH MODERN IS A CELEBRATION.
PHOTOGRAPHS BY FRANÇOIS ROBERT.

An iconic log cabin in an ideal setting has it all (OPPOSITE); *a small loft was made spacious by paring down to the essentials* (ABOVE).

Refinished stairs and windows set the tone to complete an exciting and refined contemporary interior (LEFT); the large overhead light creates a balance of elements, giving a spacious feeling to the room (OPPOSITE).

The living room gives way to an upper level loft and main-level kitchen. The cool perfection is endlessly enjoyable (**OPPOSITE**); the chandelier and log walls make a romantic backdrop for entertaining close friends (**TOP RIGHT**); comfort, grace, and insight are found in every vignette (**BOTTOM RIGHT**).

*The composition is alluring and reflective, private and generous (**LEFT**); an exotic getaway from the getaway, the tiny teahouse and gallery studio is a travelogue of adventure (**OPPOSITE**).*

Restoration of the "shed" is a journey of perfection and fulfillment (**OPPOSITE**); *the fascinations of a studio are a meditation in themselves* (**RIGHT**).

COASTAL
RETREATS

INTRODUCTION

"I try to learn the densities of earth
and settle down with style;
An island in the mouth of the
Columbia arrows the way: west.
The pilot tells us 'there is some
weather between us and Seattle,'
terrifying to think of there being none."

—LISA M. STEINMAN,
"CALLING UPON THE NIGHT" [1]

THE PACIFIC NORTHWEST IS RARELY, if ever, discussed without considering its weather. Any suggestion of "there being none," as Lisa Steinman knows, is indeed frightening. Northwesterners are obsessed with the climate. On December 16, 1805, the explorer William Clark entered the following into his journal: *"The winds violent. Trees falling in every direction, whorl winds, with gusts of rain Hail & Thunder, this kind of weather lasted all day. Certainly one of the worst days that ever was!"* [2] Had Lewis and Clark stayed on, there would have been other days to compare that day to; perhaps it wasn't as bad as it seemed. Today, for instance, was a day just like the one Clark described, except that there were two inches of snow, too, and tomorrow is the first day of spring.

The term "vacation architecture" seems almost redundant in a place where day-to-day living is itself an outdoor adventure. Reaching most destinations without getting soaked requires dependable outdoor gear, and seasonal hibernations are as much a part of life as the quick exchanges of gear by which rock climbers, stream fishers, windsurfers, glider pilots, cyclists, snowboarders, beachcombers, and rain walkers undo themselves. Everyone, it seems, takes part in this year-round game of transformation.

The retreats featured in this book accommodate the shifting needs of people who travel from seashore to mountains or from islands to desert, and whose recreations change with the season and the altitude. Apparent in all of the houses is an unflappable respect for place. Designing shelter for the Northwest is as bold an adventure as any other exploration of its terrain, and herein lies a curiosity. How could one expect a single architectural "tradition" to derive from desert, rain forest, beach, alpine, and valley settings in the north temperate zone? One couldn't, of course. But there are traditions belonging to each setting and to the misty blue outlines in the distance.

Retreat architecture is absolution. It frees us to rearrange our thoughts about the measures of modern, period, or high-tech fashion architecture, and even of vernacular and indigenous codes of conduct. The Pacific Northwest is an immense realm containing much of this country's most raw and rarely seen land: ragged mountains, hot desert updrafts, spires of volcanic rock dating back 17 million years, 70 mile per hour winds, misty beaches, painted cliffs, and shaded forests.

Unlike the First Nation peoples—the Haida, Chinook, and Nootka—most of today's inhabitants of the Northwest do not have words to describe the green-gold-silver cellophane of sunlight that bounces back into the sky from the steaming hills behind a storm, or for the deep incense of sweet cedar-resin wood smoke in fresh, glittering mists. Nor is there a name for any one of the hundreds of shades of gray that reign over winter glimpses of that sometimes forgotten heavenly body, the sun. Such naming is the work of the first speakers, the poets and writers, and the architects of the Northwest.

One of the aims of architecture is to give form to the words of the poets, to respect the meeting of the land, water, and sky. The best Northwest architecture could exist nowhere else: it is *of* the terrain and designed to keep it within reach. Embodying the impulses of the Northwest, the architecture speaks to us in a language that has no need for words. It is designed for ritual.

An early piece of significant Northwest coastal architecture was the house built by Chief Weah, a Haida priest, around 1850. Designed and built to serve as a winter retreat

in Massett, British Columbia, it was the largest house in a sweeping beachfront village, protected by a copse of totems. First Nation structures were customarily located in unassuming places, similar to the locations we choose for retreats today. They were "hidden in estuaries, on bays, along streams, or on steep bluffs... along and immediately above the beaches, opening onto the beach or parallel to the water ... rarely were they placed well back from water."[3]

First Nation communities did not have the luxury of choosing a retreat location without regard to practicality. Views, ambience, and waterfront exposure were all important factors, but these peoples had more than relaxing in mind; their choice of location would require a measure of vigilance and resourcefulness. Good, broad beaches were necessary for pulling up heavy canoes, as well as for fishing from the shore. More private locations were sometimes chosen for defensive reasons. Carving embellished the totems that safeguarded houses and signaled which gods were in attendance. Totems also protected the large gatherings and ceremonies that took place inside houses. Chief Weah's house was nearly 80 feet in length. "Except for the roof, all integral pieces form part of an interlocking framework and wall structure... some parts would be difficult or impossible to remove without dismantling much of the structure."[4]

Chief Weah's builders used 20-foot peeled logs for vertical corner posts and two posts at the center of each end of the house. The central posts were several feet taller than the corner posts and determined the angle of the roof and the position of the gable. The exterior vertical wallboards were erected, followed by the roof, whose weight stabilized and held the interlocking frame in place. The roof was uniquely constructed. Each cedar plank was carved into a utilitarian U-shape and fitted together in an alternating pattern, one up, one down. This technique formed a seal and created shallow gutters that directed rainwater off the building. Another attractive feature of the roof was its convertibility. In good weather the large planks were lifted and moved aside—creating an early version of the modern skylight—with the aid of a long pole from inside the house, which opened the roof to welcome fresh air and available sunlight.

The interior exemplified what we now refer to as loft living: large and open with high interior volumes. Woven cedar screens separated private spaces from public. Furnishings were spare, a mix of simple carved stools, large worktables, and short, movable ladders. There were also some "imported" mid-nineteenth-century wooden English chairs, sometimes with arms. Racks for drying herbs and salmon were suspended by steel chains, which had been traded with Russian sailors. Round, machine-made metal poles, used as ships' railings, were installed on the upper platform as balcony handrails. The commons was an elevated shelf that surrounded the domestic fire pit area, nine feet below entry level. The first shelf—for social events—was four feet above the fire; the second shelf—for privacy—was about four feet above that at the level of the main entrance. This arrangement of planned space is perfectly workable for a contemporary house; a similar mix of minimalist and European furnishings are found in today's Northwest retreats.

The legacy of these First Nation peoples gives continuity to the short history of Northwest Coast architecture. The character of the region's interior and exterior architecture is still present in a style that insinuated itself into the landscape, featured Asian intricacies and simplicities greatly influenced by Chinese shipbuilders and carpenters who were active up and down the coast, and ultimately, due largely to advances in materials alone, focused on the availability of light. All of these elements could be found in Chief Weah's house, as well as in the work of influential twentieth-century Northwest architects A. E. Doyle, Pietro Belluschi, Roland Terry, Wendell Lovett, and John Storrs.

ENDNOTES
1. Lisa M. Steinman. "Calling Upon the Night," *All that Comes to Light* (Corvallis, Oregon: Arrowood, 1989), p. 50.
2. Stephen E. Ambrose. *Undaunted Courage: Meriweather Lewis, Thomas Jefferson and the Opening of the American West* (New York: Simon & Schuster, 1996), p. 318.
3. Thomas Vaughan, ed. *Space, Style and Structure, Building in Northwest America,* vol. 1 (Portland: Oregon Historical Society Press, 1973), p. 24.
4. Ibid.

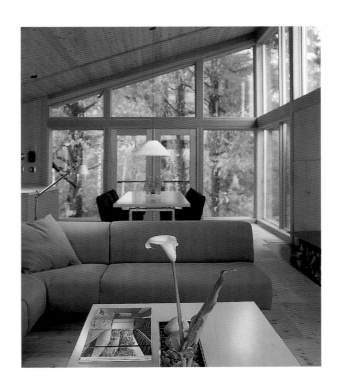

BOLES BEACH RETREAT

THIS REFINED MID-CENTURY OREGON RETREAT DESIGNED BY STANLEY BOLES, FAIA, FOR HIMSELF AND HIS WIFE, GENERATED SUCH A LARGE NUMBER OF VACATION HOME PROJECTS FOR HIS HIGHLY SUCCESSFUL COMMERCIAL FIRM, BOORA ARCHITECTS IN PORTLAND, THAT THEY OPENED THEIR FIRST RESIDENTIAL DESIGN STUDIO TO ACCOMMODATE THE NEW WORK. PHOTOGRAPHS BY LAURIE BLACK.

*Beyond the trees, the stone path leads to a courtyard and the weekend getaway (**OPPOSITE**); the Boles's sleek and serene living area (**ABOVE**).*

PORTLAND ARCHITECT STANLEY BOLES created this tranquil weekend retreat in the Oregon coastal community of Neskowin. The natural materials he used, as well as the transparency of the design, allow the structure to blend into the narrow, forested in-fill site. A stone walk leading to the house serves as a meditative path beneath a canopy of firs, moss, and boulders, culminating in a tiny moss and stone courtyard at the entry of the Boles's three-story beach house, a quiet counterpoint to the crashing breakers to the west.

The first two levels contain Wendy's studio, where she is currently working on large-scale still-life drawings of domestic items like clothing, shoes, and handbags.

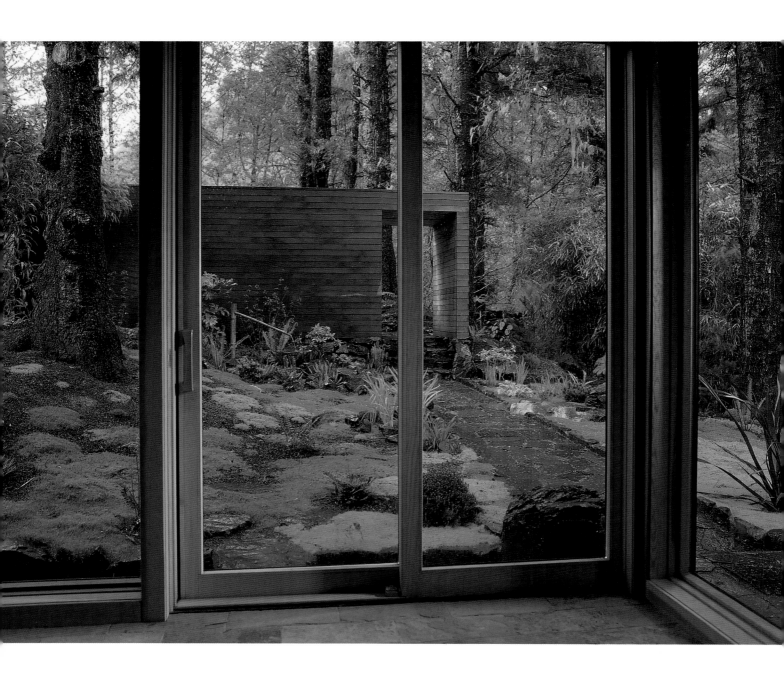

The second level also houses compact and genial guest accommodations, which can be secluded by sliding partitions. Additional sliding wall panels and doors of opaque glass allow interior spaces a flow-through translucency while providing additional privacy for the bedroom and bath spaces. The crowning floor of this sanctuary foregoes the anticipated open-beam ceiling for a trim, flush one, giving added dimension to the free flow of the living, dining, and food-preparation areas. Floor-to-ceiling windows in the main living space expand the sense of openness while framing ample ocean views. French doors on each side of the living area open onto small

The stone path to the entry is lined with moss and ferns (**OPPOSITE**); *craft and wood create an atmosphere of tranquility* (**ABOVE**); *the site and floor plan for a small parcel of land* (**RIGHT**).

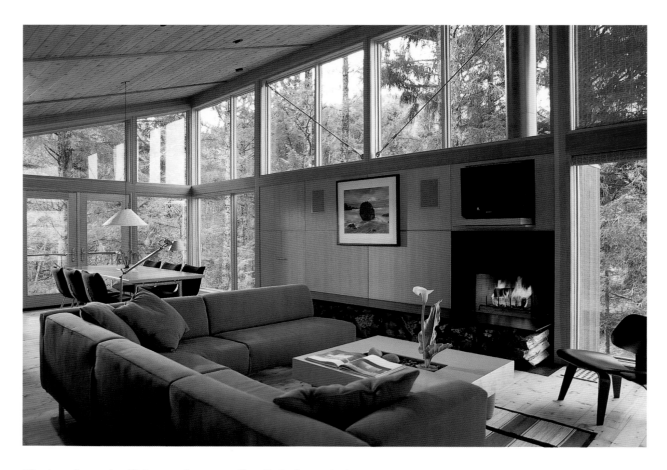

The elegantly appointed living room has one small "wall" that houses the fireplace, wood storage, and media cabinets within the larger glass wall on the south face of the house (**ABOVE**); *the living room and ocean beyond* (**OPPOSITE**).

terraces. The east balcony allows one to look directly into lichen- and moss-covered branches and enjoy the indelible scents of cedar-infused ocean air over a loamy courtyard. The west French doors open onto a balcony from which the sound of the ocean and the rustle of the treetops are heard. To invoke the liberating qualities of a weekend out-of-doors, Boles made the fireplace a focal point in the midst of the gardens, wilderness, and ocean seen beyond the windows. The slender and dramatic profile of this retreat in the evening light offers ample evidence of the magnificence and grace of thoughtful design.

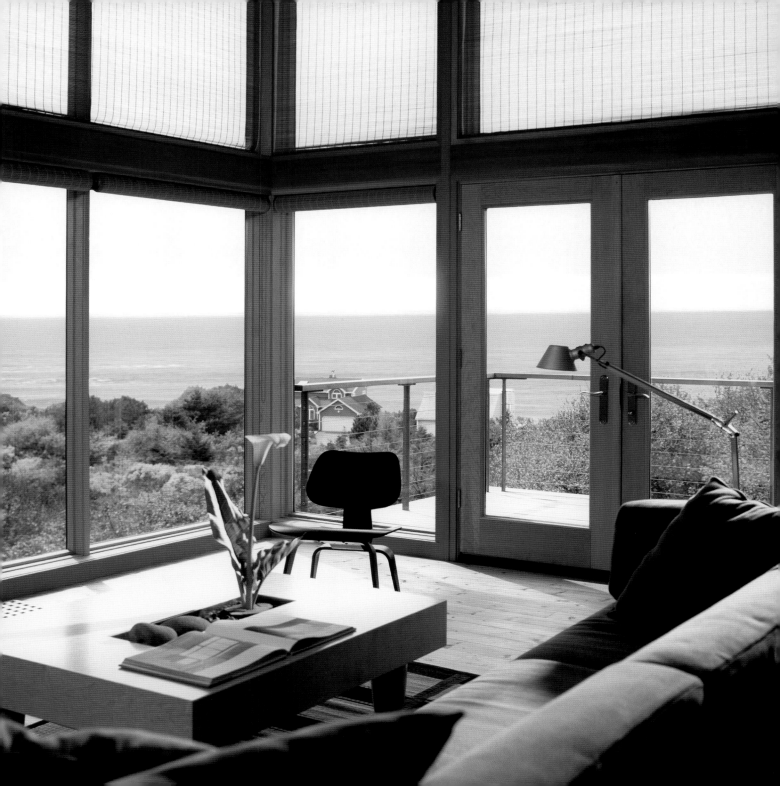

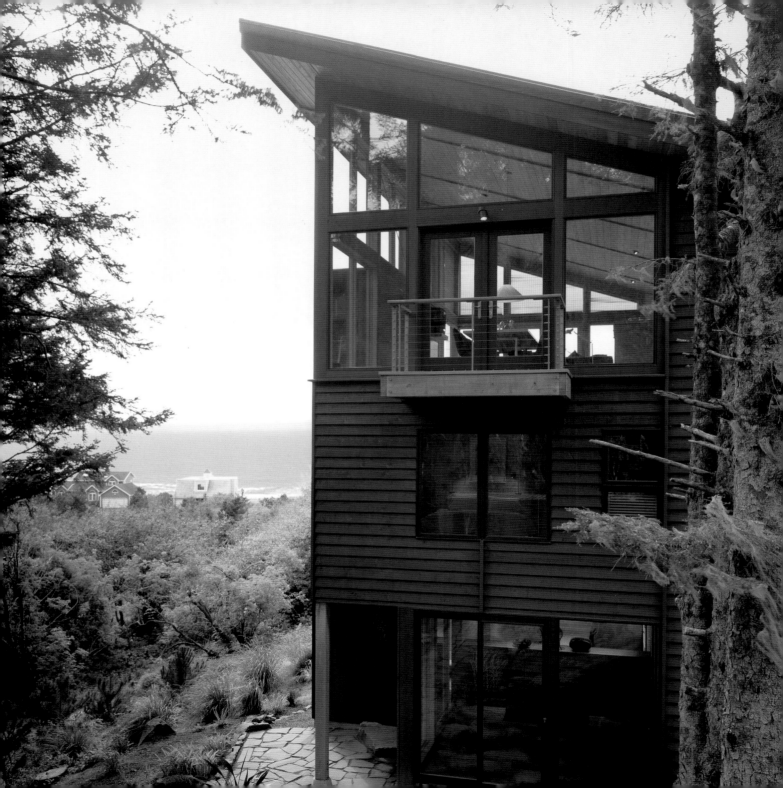

The daylight view shows the compact in-fill site and the limit of the design footprint (**OPPOSITE**); *the entry foyer at courtyard level* (**ABOVE LEFT**); *guest quarters on the other side of the entry. Wood panels close for complete privacy* (**ABOVE RIGHT**).

LONG BEACH HOUSE

THE ARCHITECTS CREATED A DREAM BEACH PLAYGROUND FOR
CHILDREN, WITH BLACKBOARDS, BUNKS, AND BALCONIES,
PULLEYS FOR NOTES, AND CONSTELLATIONS IN THE FLOORS;
AND ALSO A PLAYGROUND FOR ADULTS, WITH A GOURMET
KITCHEN, CROW'S NEST, GALLERIES, OUTDOOR ROOMS, AND
FIREPLACES. DESIGNED BY REPLINGER HOSSNER ARCHITECTS
IN SEATTLE, WASHINGTON. PHOTOGRAPHS BY MICHAEL MOORE.

Dusk and grassy dunes on the Washington coast (OPPOSITE);
along the colonnade, steps disappear into the sand (ABOVE).

AFTER FALLING IN LOVE with the silence of long,
solitary stretches of dunes and grass, a Seattle couple
decided to build a retreat on the Long Beach Peninsula,
near Willapa Bay, on the southern Washington coast.
Days away from the city are spent with their two young
children in this distinctive ocean setting, where the family
enjoys the flight patterns and landings of migratory birds,
the sweeping and changing beachscapes, and of course,
the coastal weather. Their three-acre seascape is a delicate
natural habitat, and the design of the house conscientiously
refrains from intrusion into the dunes. To preserve and
enjoy the ridge of eelgrass and dunes, the house was built
200 feet from the high tide shoreline.

A vivacious combination of style, purpose, and delight,
the house's charm begins inside, where playfulness and
inspiration await child, teen, and adult. A visit to the kitchen,
for example, offers a first glimpse of magic. Glass ceiling
tiles may appear to be placed in a random pattern. They are,
however, situated as Mintaka, Alnilam, Alnitak, Rigel, and
Bellatrix, the brightest stars in the constellation Orion. On
the other side of the ceiling, the shining lights perforate the
floor in the children's loft, creating an illuminated map of
the entire constellation. Another entertaining feature is the
hand-crank cable system, designed to ferry notes, toys, and
surprises from one end of the U-shaped loft to another. A
rescued blackboard, which is decorated with artwork, doo-
dles, and messages, forms one of the walls in the children's
loft. Hinged bookshelves, disappearing beds, peekaboo
openings, and a crow's nest all add to the pleasure of being
at the beach.

The house is designed as a large central cabin, from
which narrow hallways lead to private, detached sleeping
quarters at either end. The main section of the house

 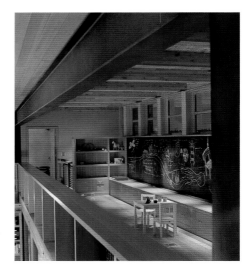

*The children's sleeping area (**LEFT**); a fun way to pass messages (**CENTER**); the children's loft, where the shape of Orion shines through the glass floor tiles from the lights in the kitchen below (**RIGHT**); the living room with the children's loft above, the crow's nest at the end of the loft, and the kitchen area below the loft (**OPPOSITE**).*

contains the entry, kitchen, dining, and living areas, each delineated by subtle use of stairs and slight dais appointments, ceiling heights, and cabinetwork. The owners' choice of furnishings and art reveals a stylish sensibility alongside their whimsicality.

The design follows through to the outside spaces, which are equally marvelous and where gatherings on the terrace often take place. A large part of being at the beach is spending time out-of-doors in every sort of weather. This carefully conceived exterior is composed of a series of spaces easily converted to "rooms." Two 16 x 20-foot courts on the ocean side of the main building are enclosed by walls on three sides, opening toward the dunes and the ocean. The courts, which are linked to a long, open colonnade, become enclosed private spaces through the use of large, rolling shutters that are similar to old warehouse or barn doors. They offer a perfect solution for either screened privacy or protection from the wind. Clearly, the owners worked with their architect to design the setting for a lifetime of cherished adventures and memorable days and nights. The steps disappear into the sand. This is a home of engaged appropriateness and convenience, with an immeasurable knack for knowing what it means to get away.

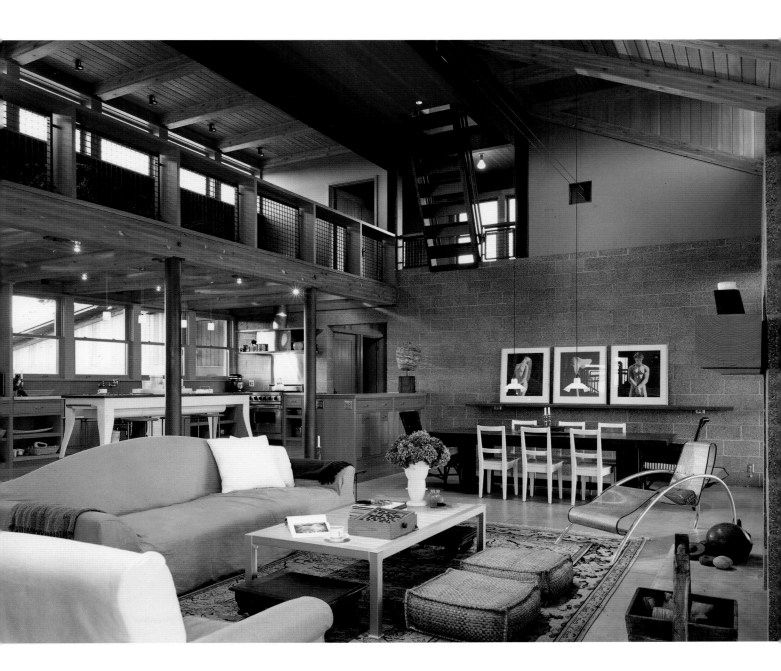

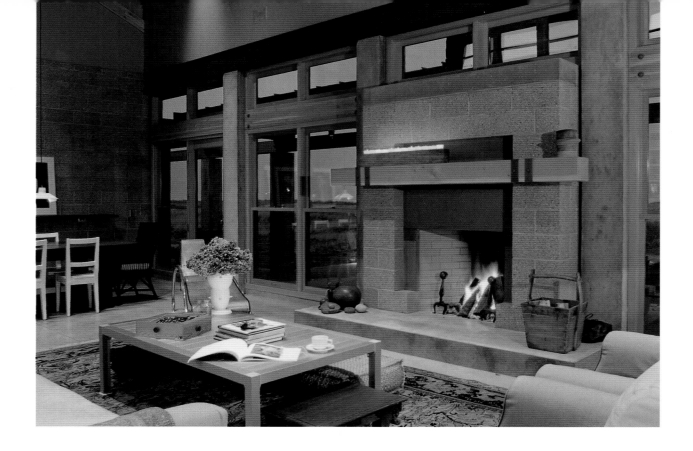

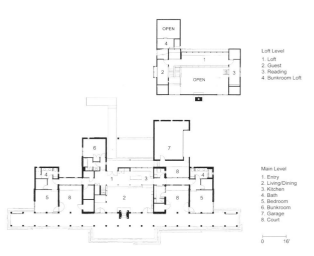

Loft Level
1. Loft
2. Guest
3. Reading
4. Bunkroom Loft

Main Level
1. Entry
2. Living/Dining
3. Kitchen
4. Bath
5. Bedroom
6. Bunkroom
7. Garage
8. Court

0 16'

*The living room, designed for casual recreation and relaxation in front of the fireplace (**ABOVE**); the floor plan showing the central living area and two sleeping cabins at either end of the main structure and a bunk room behind it (**LEFT**); the exterior fireplace on the colonnade between patio courts (**OPPOSITE**).*

*The open kitchen plan steps down into living area (OPPOSITE);
the crow's nest with trapdoor and surrounding views (LEFT);
views from the crow's nest (BELOW).*

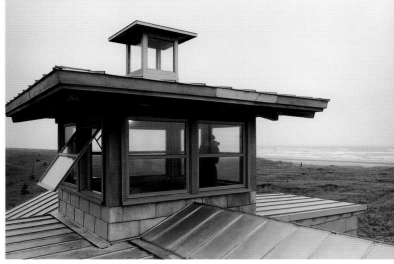

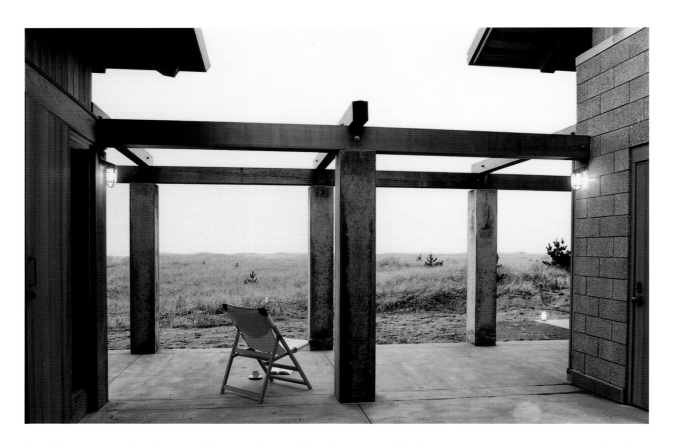

One of the two courts along the colonnade between the central living/dining area and the sleeping areas (**ABOVE**); *the vast expanse of sand dunes and grass between the retreat and the beach* (**OPPOSITE**).

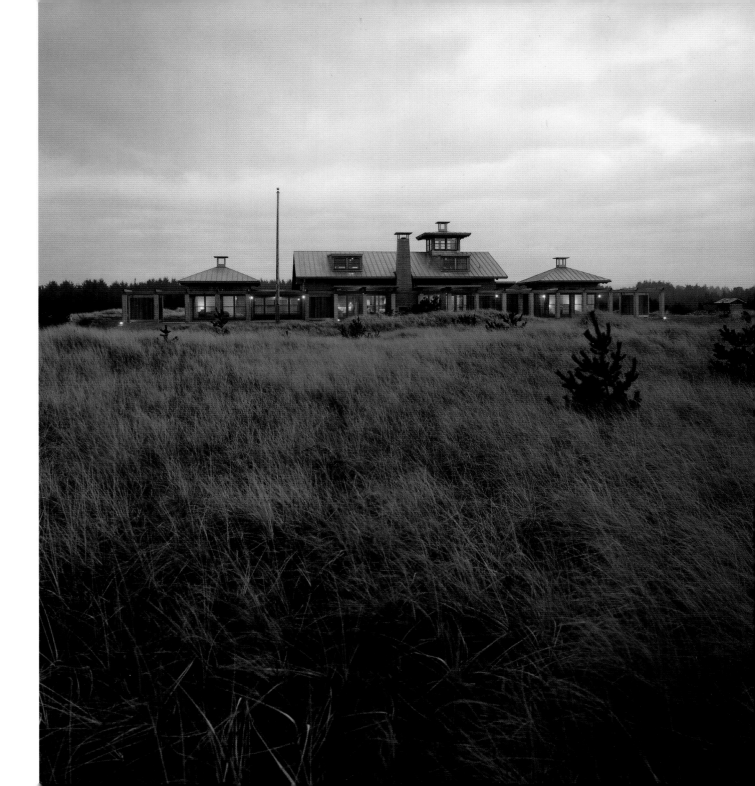

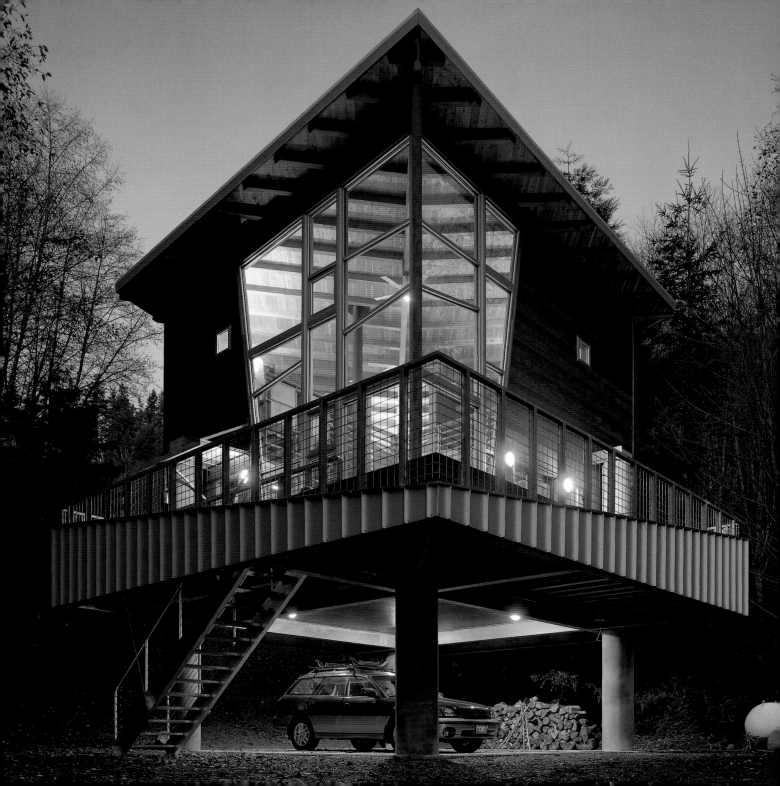

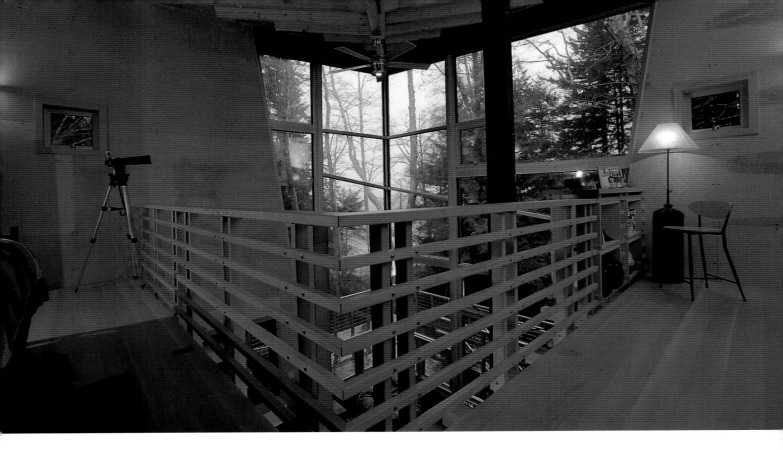

HOOD CANAL CABIN

THIS SMALL WONDER IS A SPORTS GETAWAY THAT HOUSES ALL THE AMENITIES AND IMPULSES OF THE PACIFIC NORTHWEST. IT IS A SELF-CONTAINED ART-BLAST THAT CAN BE CLOSED UP TIGHTER THAN AN OYSTER SHELL BY THE PUSH OF A BUTTON TO MAKE THE MECHANICAL STAIR DISAPPEAR INTO THE BASE OF THE HOUSE WHEN THE OWNERS LEAVE. DESIGNED BY CASTANES ARCHITECTS IN SEATTLE. PHOTOGRAPHS BY MICHAEL MOORE.

*This cabin sits on a 45-acre site (**OPPOSITE**); the loft bedroom and "study" offer a bit of privacy in the tiny cabin (**ABOVE**).*

PERCHED HIGH ABOVE THE GROUND in its lonely habitat, where it resembles a large-scale sculpture in the landscape, this cabin is reached by a gangplank that can be raised and lowered. The many window angles of this tiny 800-square-foot house allow light to enter the living space through as many as 16 different directions. This Mondrian-inspired design of the windows creates a sunlit corner in the main room and offers various snapshots of the outdoors, from the busy waters of the canal to the heavily crusted bark of nearby cedar trees. The cabin was designed for a couple who are avid lovers of the outdoors and participate whenever possible in vigorous sports like mountain biking and track cycling. As the architect points

CENTER OF GRAVITY

A sketch of the "gear" that raises and lowers the ladder (TOP); a model of the design, showing concrete pilings, ladder, and wraparound deck (ABOVE); the interior first-floor living room is bright and airy (OPPOSITE).

out, "Their escapist yearnings are reflected in the unusual material choices they've made."

A clearly visible example is the clear-sealed exterior cedar siding alongside eggplant-colored fiber-cement panels. Inside, the rich color is an ideal choice to offset the clear-sealed birch surfaces. A galvanized-steel stair wraps around a central column, leading to two sleeping lofts, and behind the column a secret sleeping nook awaits special visitors. A two-story bookcase and the kitchen casework reflect the lines of the maple railings.

This house is a carefully placed gem on a 45-acre site that runs along a quarter mile of waterfront. Tucked deep into a ravine, the cabin faces west with a view to the Olympic Mountains. Held aloft by four massive concrete columns, the positioning works to solve several design concerns. The columns are designed to function as steel and wood pilings do when under forces that accompany the impact of swells and churning waves. Although the cabin isn't constructed over water, it is in the midst of large, imperceptibly moving land masses similar to ocean swells. Eventually, the land will push against the concrete pilings, which are braced for this inevitable meeting of nature and architecture. The structure is designed to respect both the geologic timeline of the earth's movement by the use of the more permanent materials in its base, and also, the more fleeting timeline of individual human occupancy, as represented by the small, fragile use of wood above the pilings.

The open space below the structure creates a convenient place to park a car, and the elevated design provides a simple and elegant solution for the security and protection of the building. At the close of each holiday here and in preparation for departure to the city, the motorized exit stairway is lifted, drawbridge fashion, sealing the unit until the next visit.

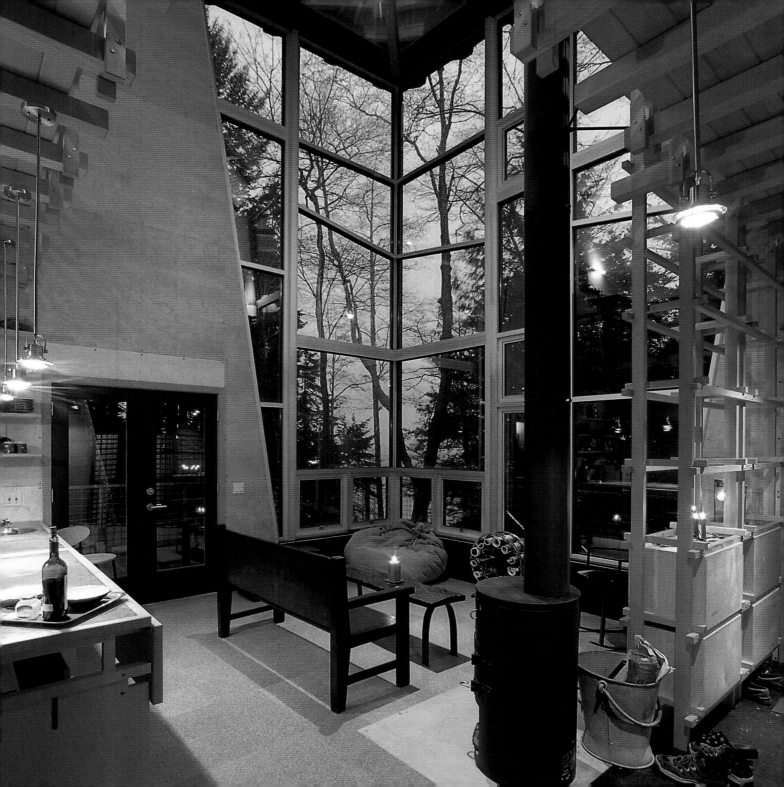

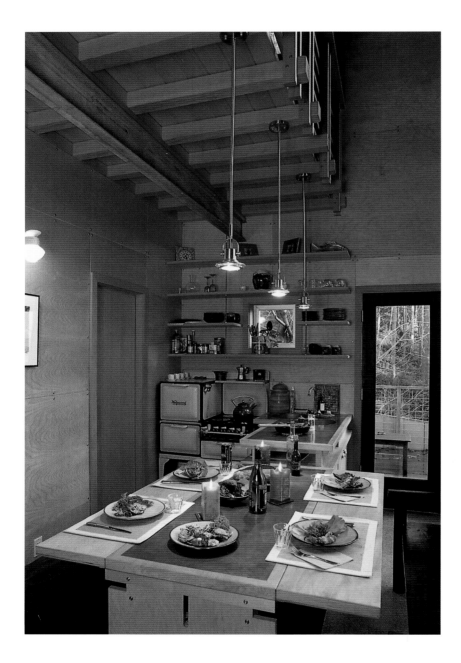

The kitchen counter converts to a table for four (**LEFT**); *angular windows frame trees and water views* (**OPPOSITE**).

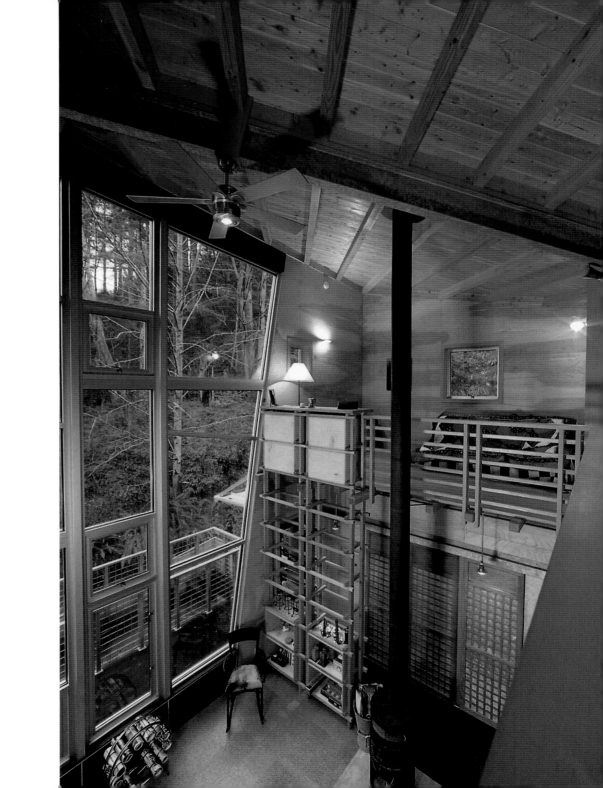

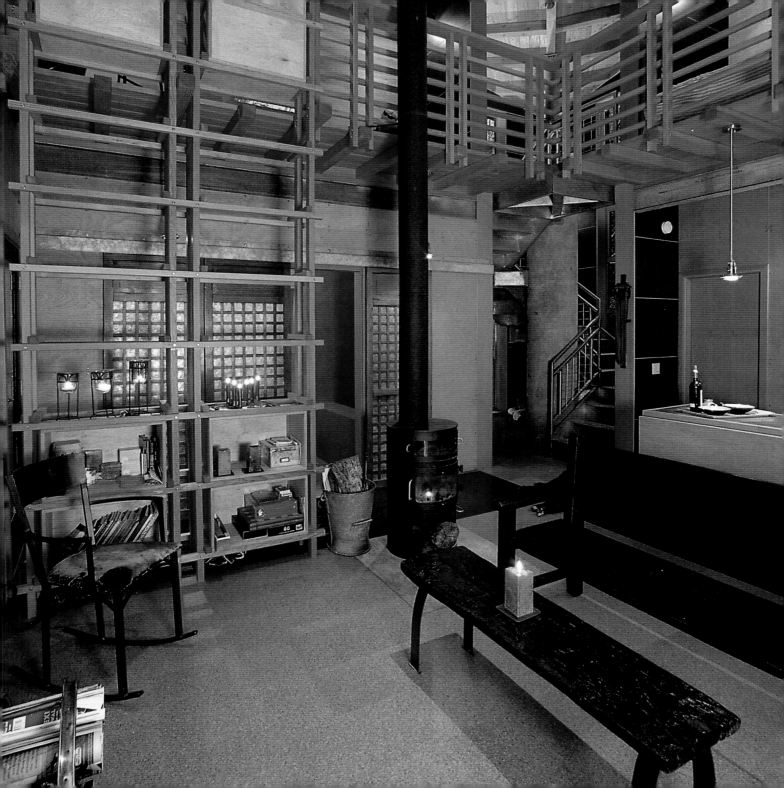

*A small wood stove warms the cabin (**OPPOSITE**); morning espresso and a journal at the writing desk (**RIGHT**).*

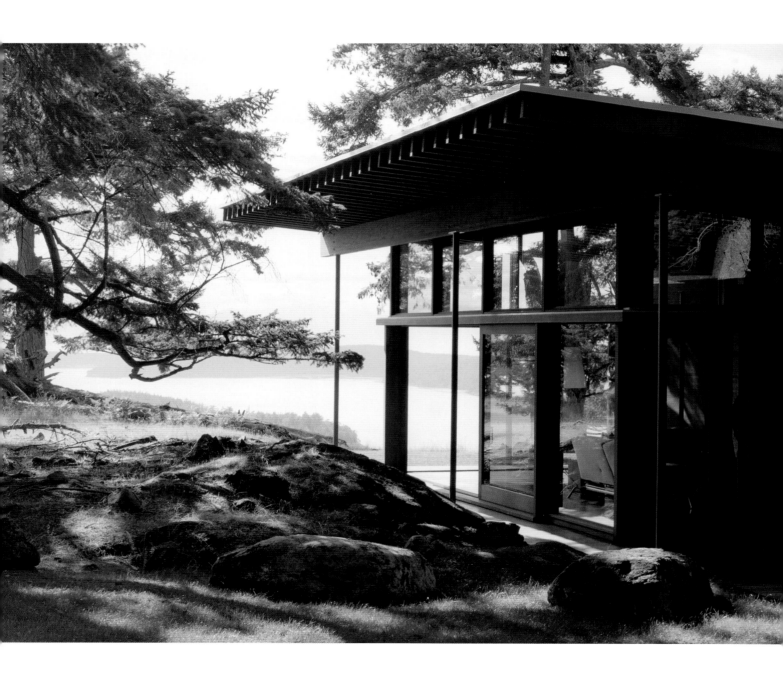

DECATUR ISLAND HAVEN

**THE ARCHITECTURE AND SITING OF THIS MODERNIST HOME
ENHANCES VIEWS AND NATURE. OWNER-INTERIOR DESIGNER
CHRISTIAN GREVSTAD OCCASIONALLY REFRESHES THE
INTERIORS WITH STYLISTIC CHANGES IN FURNISHINGS.
DESIGNED BY GEORGE SUYAMA ARCHITECTS OF SEATTLE.
PHOTOGRAPHS BY CLAUDIO SANTINI.**

*The cabin nestles up to rocks for a spectacular view of the San Juan
Islands* (**OPPOSITE**); *the approach to this dream house with the shed
on the left and the cabin on the right* (**ABOVE**).

IN THE MID-1990s, while flying over the San Juan
Islands, designer Christian Grevstad's instincts led him
to alert his pilot that they were off course and lost. As the
pilot corrected the flight path, Grevstad glanced down at
a flowering meadow sitting atop a high bluff. Below him
lay the site he had envisioned for his ideal island getaway.
He headed for Seattle, where he did the necessary foot-
work, and found that the price was right. He later realized
that years earlier he had hiked up the face of the very
mountain that led to this meadow, but he had not ventured
over the top where the meadow flourished. Having spent
much of his life in the San Juans, Grevstad can navigate
both the air and waterways of the islands with ease. This

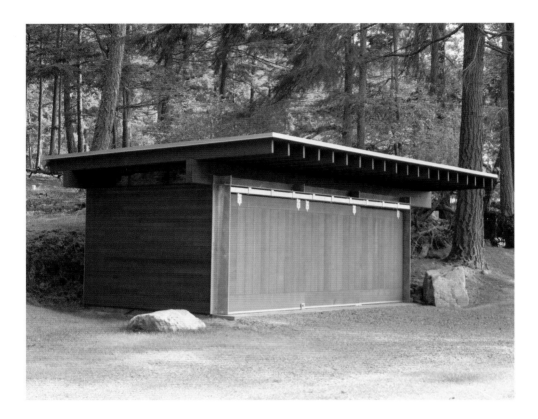

The large sliding walls, broad overhang, and narrow clerestory windows make an attractive shed structure.

is where he goes to simplify his life, when he can free himself for a few days from the demands of an international design practice.

Grevstad's first step in creating his cabin was to choose an architect of vision, one who shared his belief in simplicity. His design requests were few: the house should mirror the surrounding landscape; it should exude a feeling of relaxation; it should allow for an appreciation of Asian art; and there should be a seamless blend of

interior and exterior when the doors open to the vistas under the floating roof.

Nestled atop a tree-covered ridge on Decatur Island, the 1,500-square-foot cabin is composed of three distinct boxlike volumes connected by a simple shed roof. One box structure contains the living room, kitchen, and family rooms; each of the other two boxes is reserved for sleeping quarters. Large windows framed with wood create heated living space between the three volumes

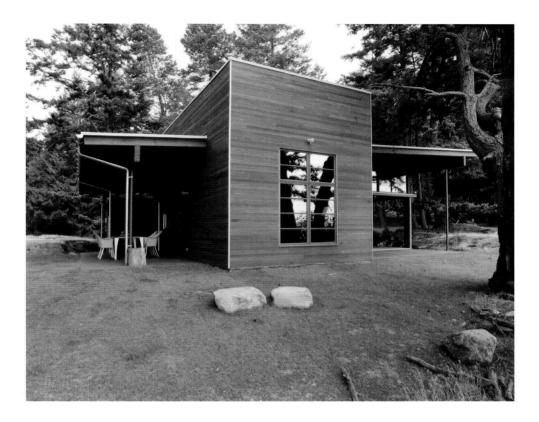

The largest of the three boxes comprising the cabin under a shed roof, this rectangle houses the dining room and outdoor dining area.

and camouflage the building amid the rocks and trees on the other side of the glass.

The liberties of island leisure complement the unadorned natural and stylized materials Grevstad chose. His selection of finishes is compatible with the natural palette: the concrete slab floor is stained a charcoal black; wood-beam ceilings and walls are stained with the tones of the bark of the trees outside. The tints on the exterior siding continue through the inside of the cabin as the

walls wrap around the three interior "boxes," whose walls are intended as a background for artwork. The voids and niches inside are for the display of sculptures. Together, the architect and Grevstad also designed a spiral staircase ascending to an open-roof terrace, referred to as the "martini tower," where guests often enjoy a tasty drink called a Lemon Drop.

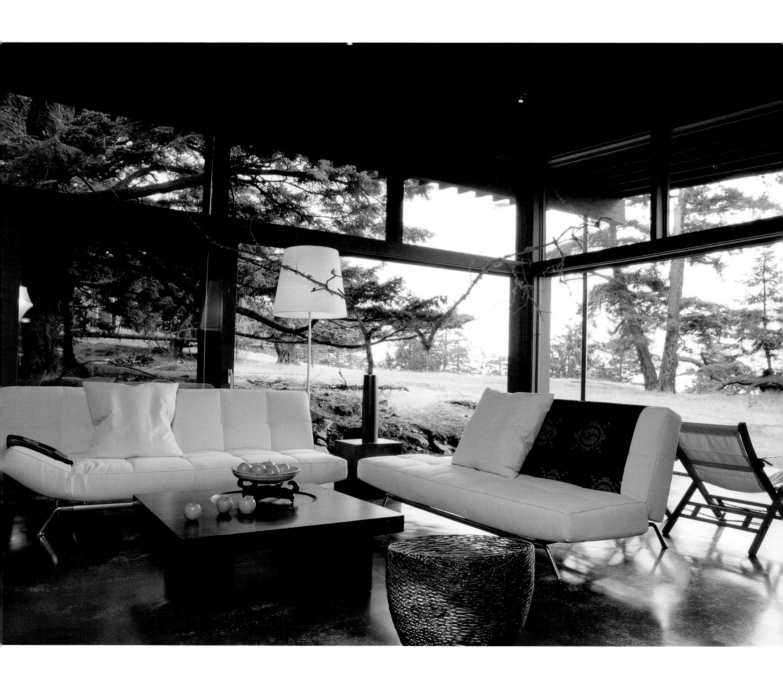

The design of the cabin and its furnishings does not overwhelm the beauty of the natural environment on the other side of the glass (OPPOSITE); the Asian tansu and basket collection (RIGHT); a freehand sketch of the cabin by the architect (BELOW).

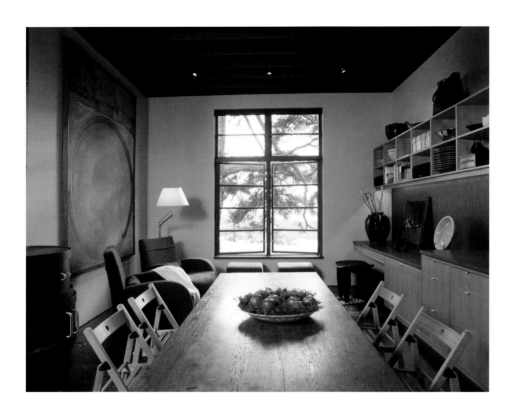

*The interior of the dining and sitting unit (**ABOVE**); behind the fireplace is a small interior box housing a bedroom and a hallway leading to the patio (**OPPOSITE**).*

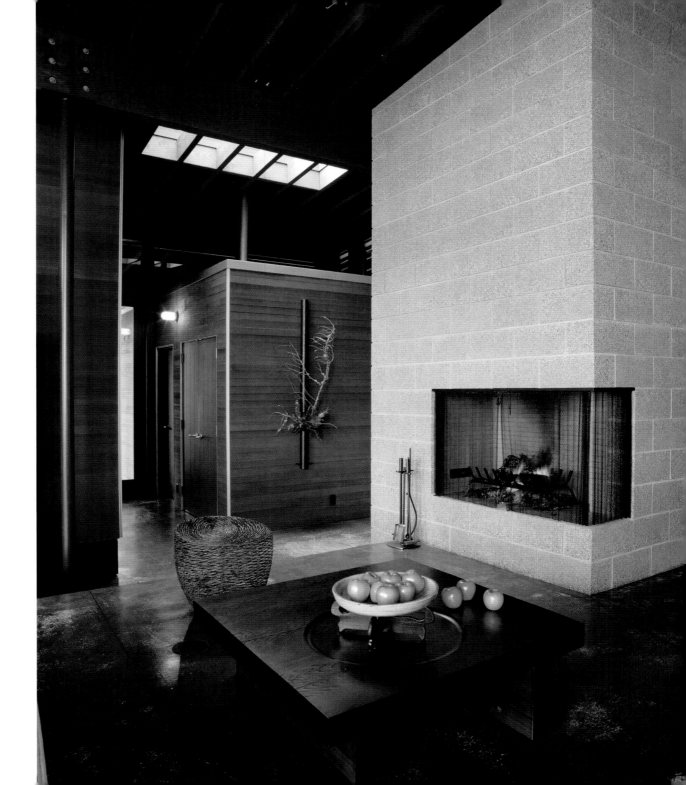

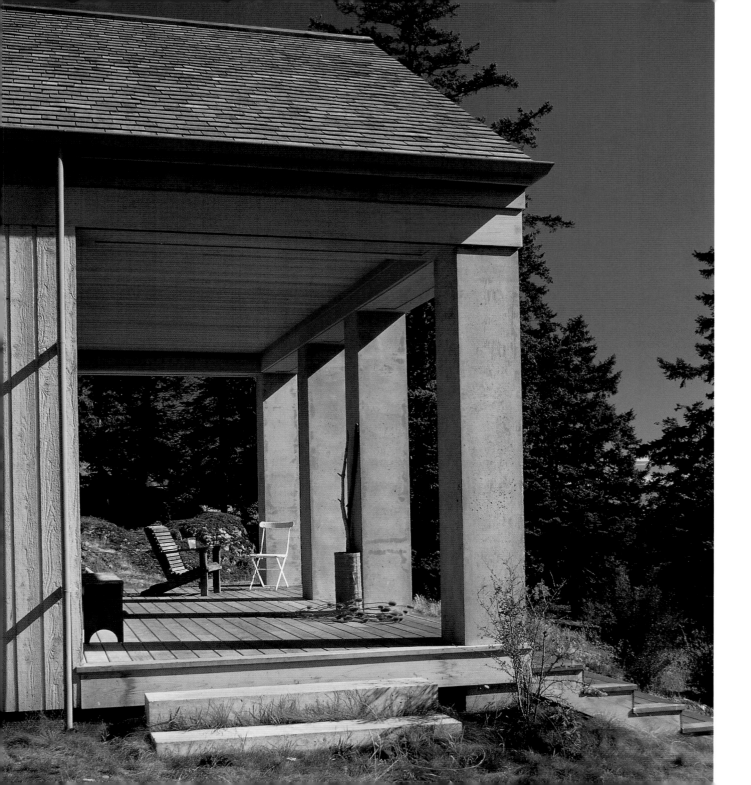

TEMPIETTO

THE CLASSIC STYLING OF THIS COMPACT VACATION HOUSE
AND GATEHOUSE COULDN'T BE MORE BEAUTIFUL. INSIDE,
DISTINCT PERSONAL AREAS ARE DEFINED BY WINDOW
PLACEMENTS AND THEIR NATURAL LIGHT-REVEALING
QUALITIES. DESIGNED BY THOMAS L. BOSWORTH, FAIA,
BOSWORTH HOEDEMAKER ARCHITECTURE OF SEATTLE.
PHOTOGRAPHS BY MICHAEL SKOTT.

The cottage is reminiscent of a classical Greek temple on a hill
(OPPOSITE); oversized 7½-foot windows emphasize the interior
appointments (ABOVE).

THERE IS A NATURAL CURIOSITY about the kind
of secret getaways architects design for themselves. A
solid architectural career—as well as a dedication to
archaeology, art history, and travel—reveal themselves
in Thomas Bosworth's simple and bold forms. When
Bosworth found a hill that seemed to be calling for his
retreat to be built upon it, he envisioned the classic spa-
ciousness of ancient Mediterranean temples. This might
be the king's hall, where the gods were welcomed with the
finest hospitality. Elaine Bosworth, an antiques dealer,
furnishes their homes with objects from the couple's
worldwide travels. They believe that buildings and forms,
as well as furnishings, can flourish through a state of
historical flux, changing with time.

The project consists of a traditionally framed 260-
square-foot gatehouse and a 1,050-square-foot vacation
cottage on San Juan Island. The narrow gatehouse forms
one segment of a thick "hedge" that separates the parking
area from the landscape around the cottage while provid-
ing a pedestrian connection between itself and the cottage.
Clad in tight-knot vertical cedar boards, the gatehouse
rises with the terrain, creating the perception of a forced
perspective along its surface and opposite the parking
area. A nine-foot-wide barn door slides open to reveal
a central entry slot through the building, a small guest
room to the left, and a bath and tool storage to the right,
all framed simply with exposed 2 x 4 studs, skip sheath-
ing, fir plank floors, and cedar shingles. As it descends
through this slot and toward the cottage, the site has
been preserved in its natural condition.

The 24 x 44-foot axial cottage was conceived as a
type of Greek *megaron,* which is simply a large room, and
was placed along a path between tall fir trees on the north

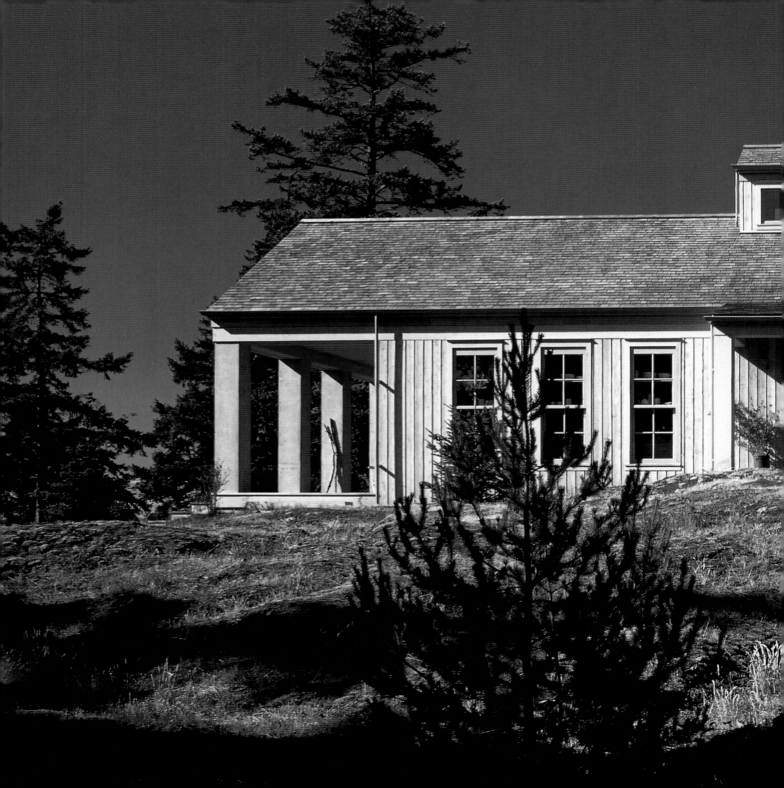

and the rocky, moss-covered slope rising from fields to the south. Broad steps lead to the porch and into a great room containing the kitchen, dining, and seating areas. Framed by bookshelves, paired window seats provide cozy spots for viewing the fields and Puget Sound beyond. Although modest in size, the cottage is filled with natural light from tall, true divided-light windows and from a generous light monitor placed in the hall connecting the great room to the private bedroom and bath areas. The cottage is constructed with 2 x 6-foot wood framing, poured-in-place concrete columns, standard wood roof trusses, and clad with 1 x 8-inch rough cedar channel siding and a cedar shingle roof.

There is a sense that from the portico, an offering is being made to the gods. Perhaps they will come down for an afternoon of frolicking.

Tempietto *is firmly placed on a stone ridge.*

*The cabin is appointed with items collected by the owners (**OPPOSITE**); a love of Shaker design influences the cabin's interior (**ABOVE**).*

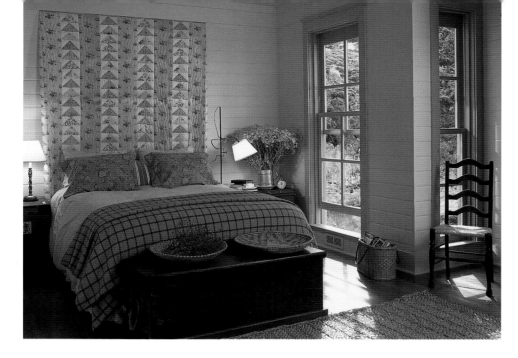

The sun bounces off
open shelving across large
windows (**OPPOSITE**); the
bedroom has a provincial
touch (**LEFT**); simplicity
in the bath (**BELOW**).

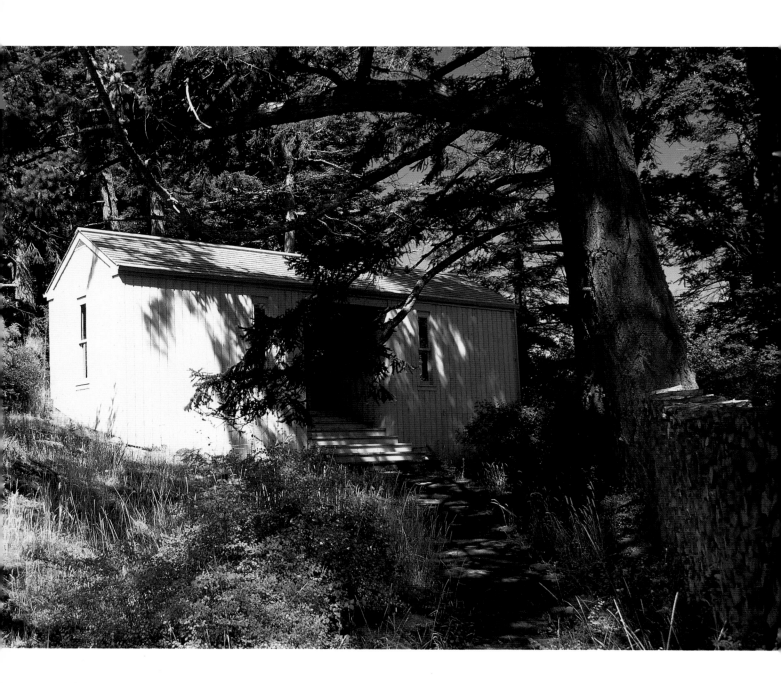

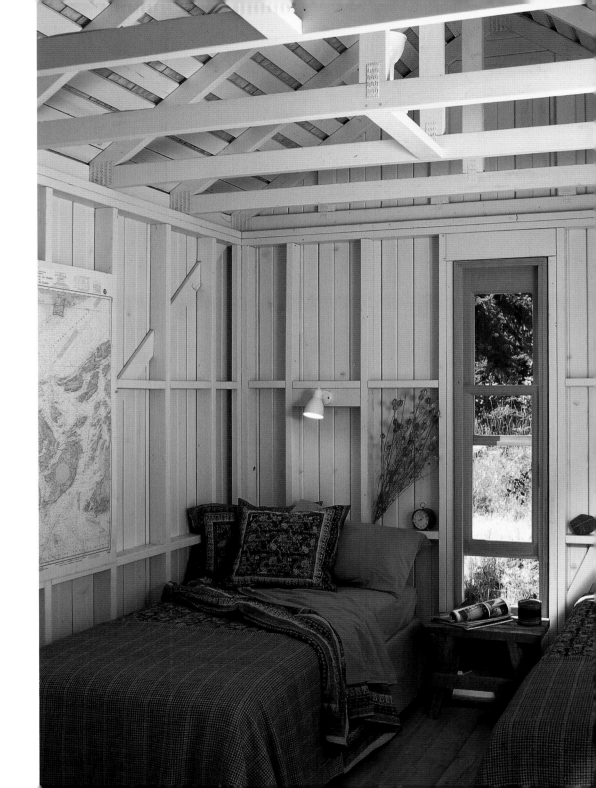

The gatehouse separates the parking area from the landscape surrounding the cottage (OPPOSITE); a well-equipped tool shed is part of the gatehouse, along with a guest room and bath (RIGHT).

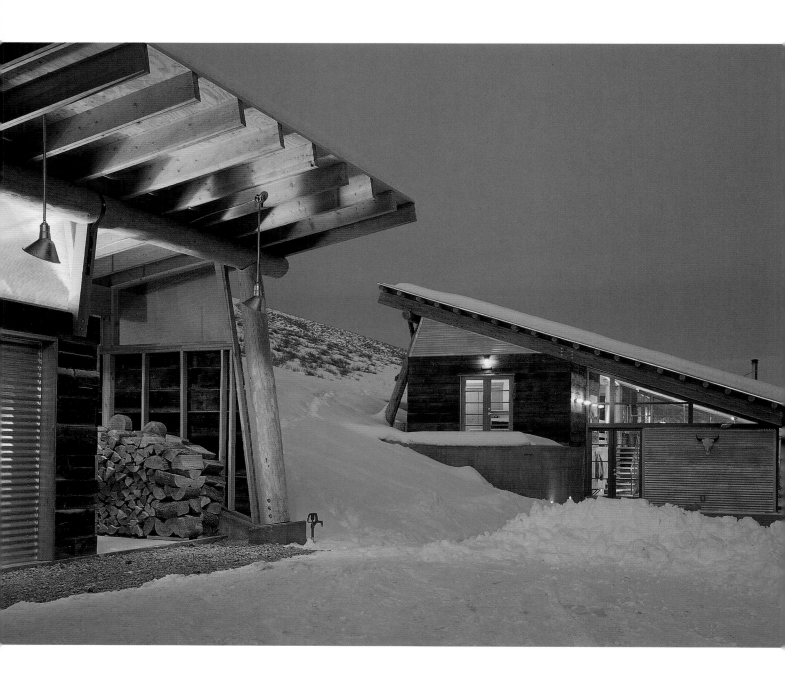

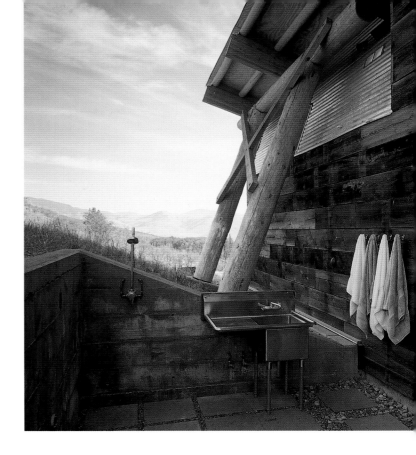

CABIN AT ELBOW COULEE

THIS WASHINGTON STATE CABIN IS EMBRACED BY THE RUGGED SOPHISTICATION OF ITS LANDSCAPE. EVERY ROOM OPENS TO THE TERRAIN WITH FRENCH DOORS, WINDOWS, OR THE LARGE SLIDING GLASS WALL TO THE MAIN FRONT TERRACE. DESIGNED BY OWNER TOM LENCHEK, BALANCE ASSOCIATES, ARCHITECTS OF SEATTLE. PHOTOGRAPHS BY STEVE KEATING PHOTOGRAPHY.

The cabin at Elbow Coulee is perfect for ski weekends (**OPPOSITE**); *in warm weather, the outdoor shower is an invigorating start to the day* (**ABOVE**).

IN SUMMER AND IN WINTER, this cabin in north central Washington is an all-around winner for welcome, comfort, sport, and adventure. The owner and architect, Tom Lenchek, gave special attention to details that more than make up for being away from the conveniences of city life. For example, he has incorporated both a sauna and an outdoor bath into the design of this 1,400-square-foot structure. Located in the mountains, the cabin sits on a south-facing slope with views to the south and east. In summer there are glorious wildflowers covering the meadow and sunsets over the mountains. Winter provides a landscape of powdery snow, ideal for skiing and sledding.

Lenchek used rough materials—logs, sawn beams, rough-formed concrete, and corrugated metal—to reflect the cabin's raw and untamed surroundings. The cabin is built on two levels. A lower terrace contains the living, dining, and kitchen areas in one open volume. The upper level becomes the back of the living area and the floor of the bedroom and bath level. Each bedroom has its own small terrace planted with wildflowers and herbs. Two 8 x 8-foot wood-framed sliding glass walls open the living space onto the terrace and the outdoors. The main terrace is planted with native wildflowers and has a small water garden with meditative boulders.

Lenchek designed the cabin with sustainability in mind, and his choice of materials reflects this. The house is sided with 1 x 12-inch boards, weathered more than 60 years, that were salvaged from a water irrigation ditch. Lenchek is confident that when cleaned and treated with a sealer, they will last another 60 years. The roof purlins are made from lodge pole pine logs, which come from forest thinning. Much of the remaining materials are engineered products used on the ceiling, wall finishes, and stair treads. Most of the high-performance glazing faces south and east to allow for passive solar heating. The east-facing glazing provides morning warming, which brings comfort even in the summer when night-time lows often drop into the thirties. Here in the mountains, what is considered essential are not the things you leave behind, but what is gained from simplicity.

A sliding wall converts living space to an outdoor experience with endless vistas.

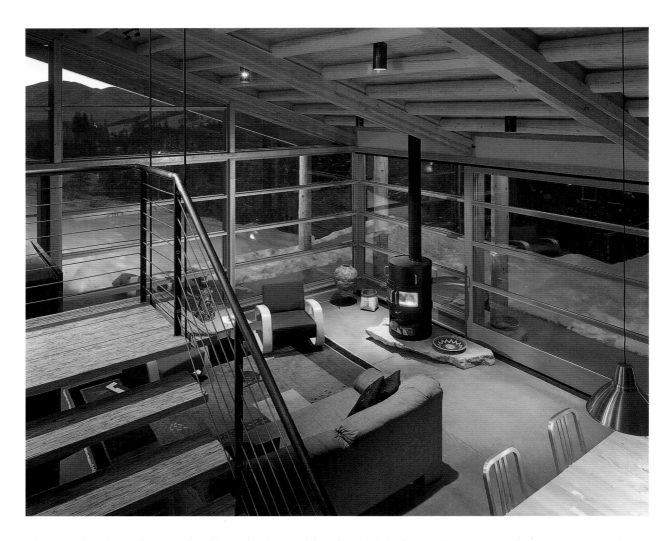

*Floor-to-ceiling glass walls surround the living and dining area. The wall to the right of the wood stove opens to the outdoors (**ABOVE**); the owner's choice of materials supports his belief in the necessity of sustainable architecture (**OPPOSITE**).*

*Each bedroom opens onto a terrace (**LEFT**); this terrace has an herb garden in the spring and summer (**OPPOSITE**).*

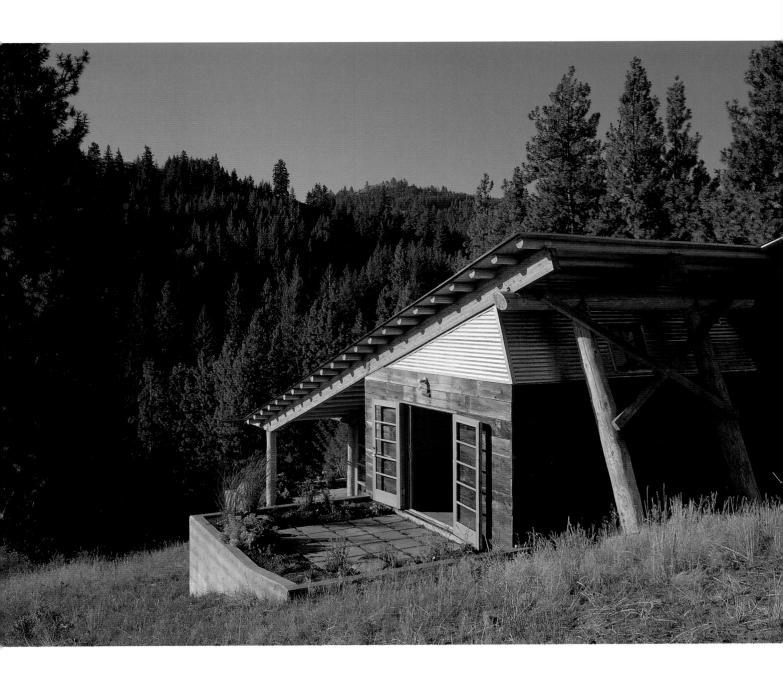

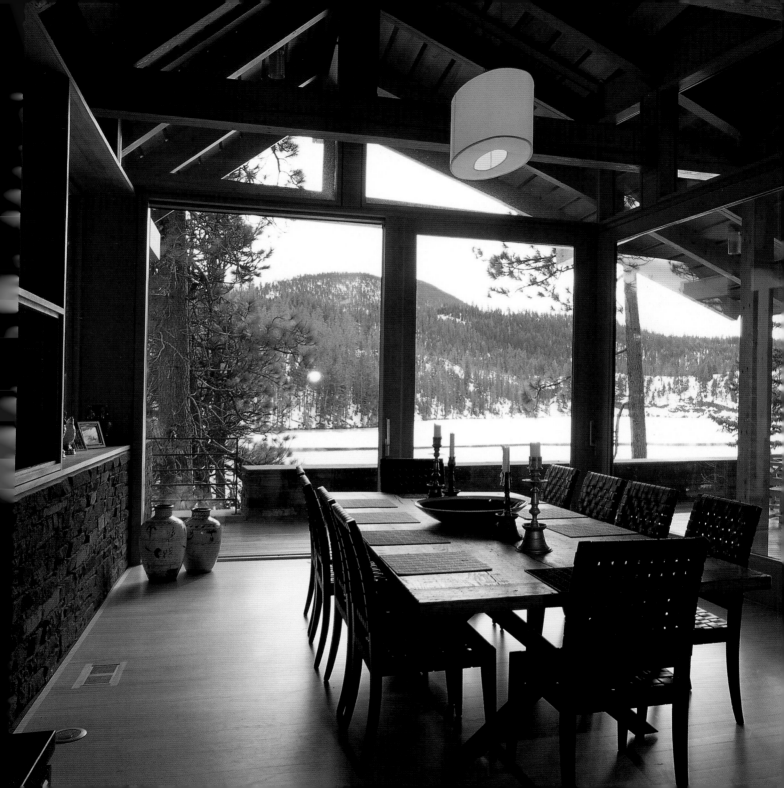

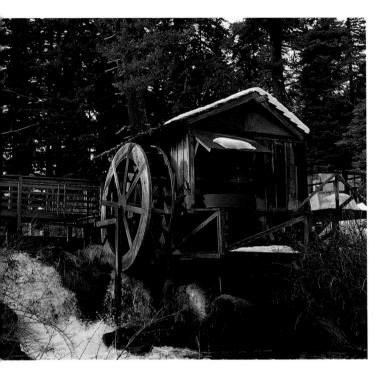

BLUE LAKE RETREAT

THE BOLD STRENGTH OF NORTHWEST STONE AND RECYCLED FIR TIMBERS ADD A PROTECTIVE QUALITY TO THE DESIGN OF THIS CENTRAL OREGON RETREAT. DESIGNED BY BRAD CLOEPFIL, ALLIED WORKS ARCHITECTURE, OF PORTLAND. PHOTOGRAPHS BY JOHN DIMAIO.

*The extraordinary view of Blue Lake as seen from the dining room (***OPPOSITE***); the old water wheel on the premises (***ABOVE LEFT***); pine needles cover the steps that lead to the entry terrace along the sandalwood stone wall (***ABOVE RIGHT***).*

IF THERE IS A FAMILIARITY about this retreat in the mountains, it is helpful to know to what extent our individual and collective consciousness has been influenced by its owner, Dan Wieden of the Wieden + Kennedy advertising agency. His are the ads that got us to "Just Do It!" and to contemplate exactly how to renovate a bath with tile and copper wash basins from Ann Sacks. Combine his vision with the architect's, and an unexplored tweak on traditional lodge materials, and the result is something we have never seen before.

Dan and Bonnie Wieden asked the architect to design an intimate space that would also allow for occasional large gatherings. The Wiedens enjoy a wide range of activities,

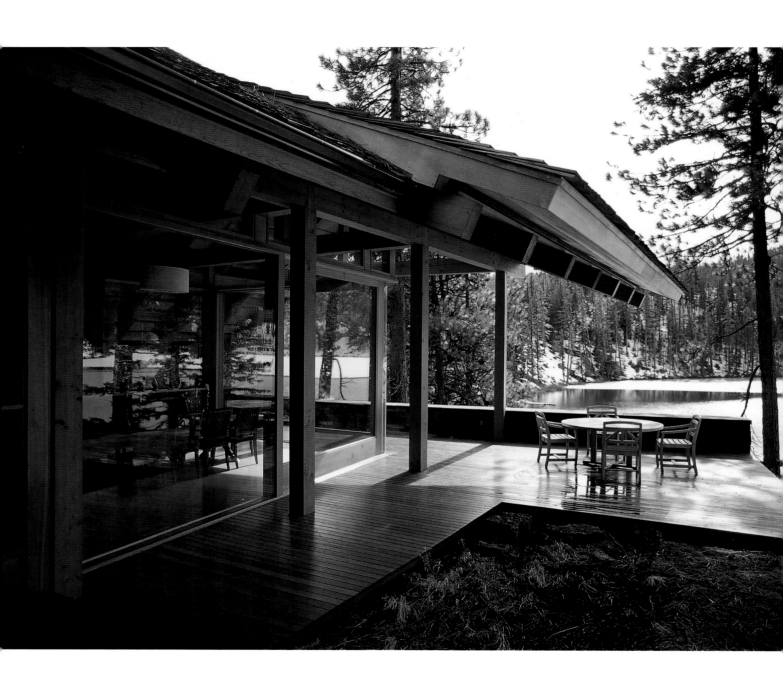

from weekends on their own to long holidays with lots of family and friends. Surrounded by 40 acres of Cascade Range foothills in central Oregon, the site overlooks Blue Lake, the caldera of an ancient volcano. The climactic changes in the region are severe. There are usually three to five feet of snow and high winds in the winter, and summers are so hot and dry that pinecones snap in the heat. The house was built 70 feet above the water, for southern light and spectacular views across the lake to Mount Washington's nearly 8,000-foot summit.

The entry is tucked into a recess, behind thick stone walls and beneath a heavily timbered, inverted umbrella space. Once inside, a turn to the right leads to a large living room and gathering space. The entire south wall of this room opens to views of Blue Lake framed in the nostalgic warmth of recycled fir timbers. In many ways this is the most important space in the house, with dining and cooking areas very close at hand, and terraces at every turn.

Local stone and recycled fir timbers are the primary structural elements. The heavy timber frame lifts the roof over the walls and creates the large overhang that protects the house and the interior courtyard from snow in winter and direct southern sun in summer. The wall of the courtyard is constructed of operable fir panels, fixed glazing, and huge sliding doors that animate the ambiguity between interior and exterior.

Wood flows from the interior flooring to the exterior decks (**OPPOSITE**); *the view of the court and outdoor deck* (**TOP**); *the first-level floor plan* (**RIGHT**).

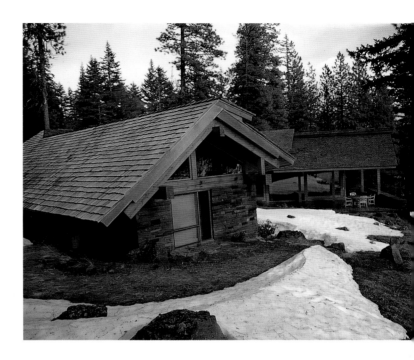

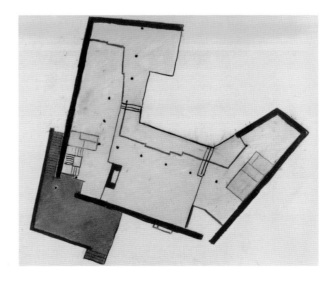

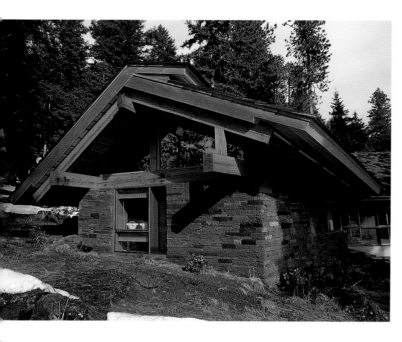

The bedroom window niche shows the depth of the stone walls and an extensive roof overhang (LEFT); the bedroom has flat sandstone walls and large timber construction (BOTTOM LEFT); the upper-level guest room with fireplace and sleeping nook (BOTTOM RIGHT); the living room and fireplace with the dining room and deck on the right (OPPOSITE).

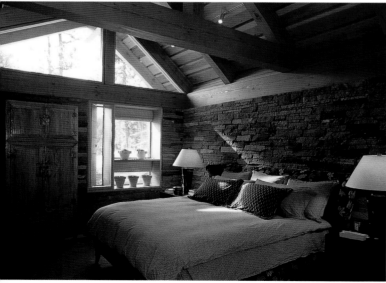

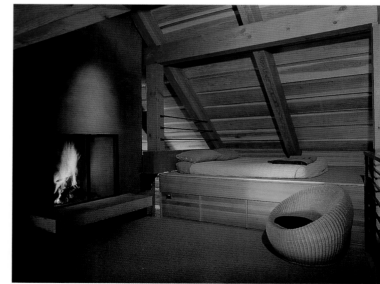

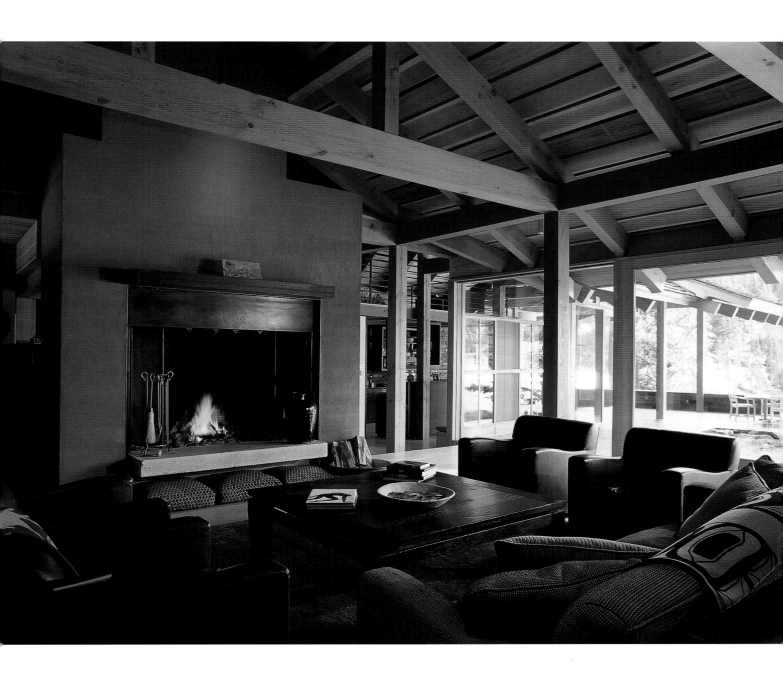

The unreserved hush of central Oregon's Blue Lake.

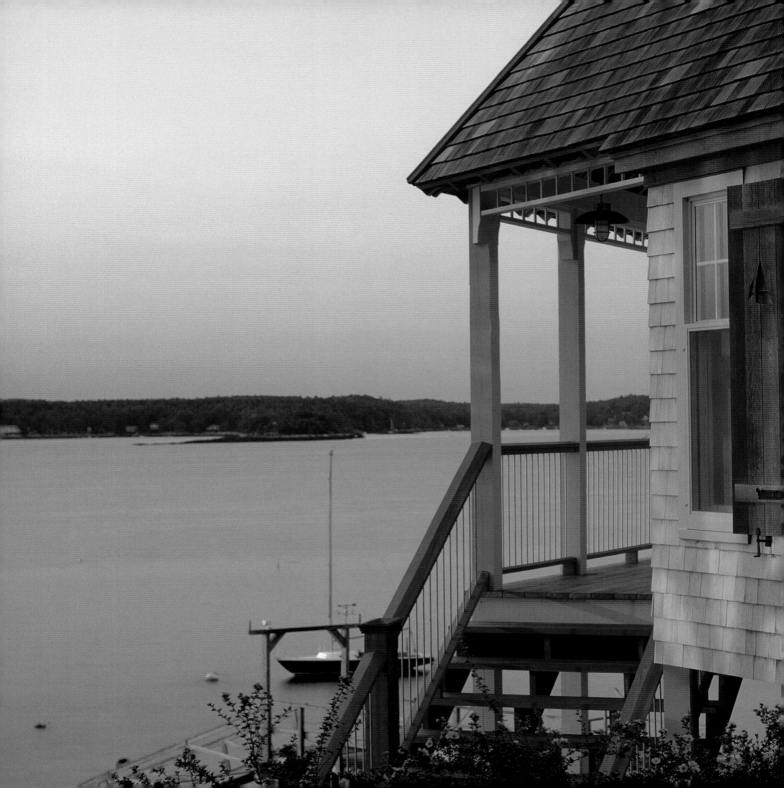

COTTAGES
ON THE COAST

INTRODUCTION

"…the slow float of differing light and deep …"
—EZRA POUND, *PORTRAIT D'UNE FEMME*

THE SEASIDE COTTAGE IS an inscrutable berth. The little dwellings adhere to the earth, braced against heavy seas, swelling tides, and unpredictable weather. Each small house is an emblem of simple courage one must have and of passion one must bring to live in it. And, like the cottages, navigational charts are as much maps of the psyche as they are of the courses around headlands, capes, and shoals; through straits; and into bays and harbors. The building and naming of such craggy and difficult places draws on emotions shaped by many departures and returns, the mastery of finding shelter and safety, and the thrill of escaping danger. Fearsome names—Destruction Island, Peril Strait, Wrath Cape—denote the arcs of shorelines. Cape Disappointment preserves the sentiment of the Corps at the end of Lewis and Clark's long journey of discovery. Yet other coastlines offer Fair Harbor, Port Protection, or Safety Harbor. And there are those that hint at spirited encounters: Dogs Keys Pass, Tortugas Harbor, and Alligator Reef.

The shoreline reveals its mysteries to those who are willing to live and spend time there, drawn to the challenging, soul-refreshing sea. What can be learned from the ocean? And more important, how can one learn it? An old house high on a bluff road is a telescopic pinpoint—a landmark—from the crest of an ocean swell far out at sea. It might be the cottage where a friend's aunt has lived for most of her 80 years. Her furnishings are the vestiges of the many lives that are her lifetime—journals, letters, postcards, books, the remaining bed of a set of two, a silk pillow. She is a bit of a collector and surrounds herself with anything written; and her collections speak of what she has learned from the sea itself. For a woman of the sea, it is said that a day spent near the sound of the waves is a lifetime. The ocean is a vast emotional heartland—its sorcery makes it one of the great touchstones of human passion and inspiration; there they are born and there they endlessly return. Passions are born in the deep, yet they are aroused by the smallest of impulses and impressions. Just as diminutive ripples on the surface of the ocean are driven over its surface by the wind to emerge as enormous waves, so do emotions and passions grow, swell, and return.

The smell of the ocean air, seaweed drying on driftwood, wood smoke blowing over the sand—these bring back suddenly the elation of a special moment. We may believe, innocently, that we are lured to the beach by a need for "a vacation." It is surprising, then, to learn that we are lured by a far greater need: a *prima materia*. It is more than the salt air, sea breezes, or wood smoke. Our "souls" are drawn to the ocean by more than a thought: we are drawn to it in the way wild salmon are drawn to return to their spawning grounds—by a sensual and delicious smell.

LEGENDS OF SCUTTLED CREATURES and sea monsters were invented to keep timid people on the shore. Fear and awe of the great waters, those bleak and hostile

regions notorious for their unpredictability, ruled people for centuries. Close to the sea, however, it is hard to resist the release and freedom that that nearness offers, as it heightens our enthusiasm and our knowledge of our own being—paradoxically, the fearsome sea can teach us to conquer our fears. The spellbinding glitter in flecks of light moving under dark clear summer waters, underwater fairies—so close, so elusive, so alive. Can we learn about our world from the adrenaline rush that comes from watching rhythmic huge waves tear and chisel the edges out of stone bluffs? Does it make us realize that the shape of a cliff is the result of the mute resistance to the forces breaking against it?

The idea may seem frivolous, so simple, so unsophisticated. Yet, can *you* imagine having learned nothing after a long day of *sheer joy*, spent barefoot on a glistening beach, coming home with a pocket full of seashells, agates, and sea glass to show for it? The sun, the wet sand, and slowly spreading sea foam lathering your feet; the smell of living and dying phytoplankton in the air; a cleansing breeze, the steep pine spice on wind and wave-carved bluffs—what could one possibly learn from that kind of sensory exhilaration? Philosophers say that emotions are too unpredictable; they are not under the control of the will and are thus unable to illuminate significant moral truths about human behavior. But as some have said, "knowledge of the heart must come from the heart."

We go to the beach to ask questions of ourselves, about what matters in our lives, and what does not. We may go there to paint, to write, to read, to think, or to play with our family and friends. We may go to be alone. Time spent at the ocean has long been like a secret companion, or best friend, giving rise to thoughts about how to live our lives (perhaps importantly, what to avoid in life). We often go in search of ethical models, comparing our own fragility to the sea's untamed sublimity.

BEACH COTTAGES EMBODY VALUES AND CHOICES. More than mere taste is revealed in favorite paintings and photographs, well-read books, welcoming furnishings, crab pots, and fishing gear. Sea coasts are places of revelation and of legends which wind through centuries—are these inventions or discoveries? Tempered by time, torrents, and the tides, every sea coast and legend harbors its unique treasures, and seasons them with the currents and the flavors of authenticity.

These beloved cottages express their own senses about what matters.

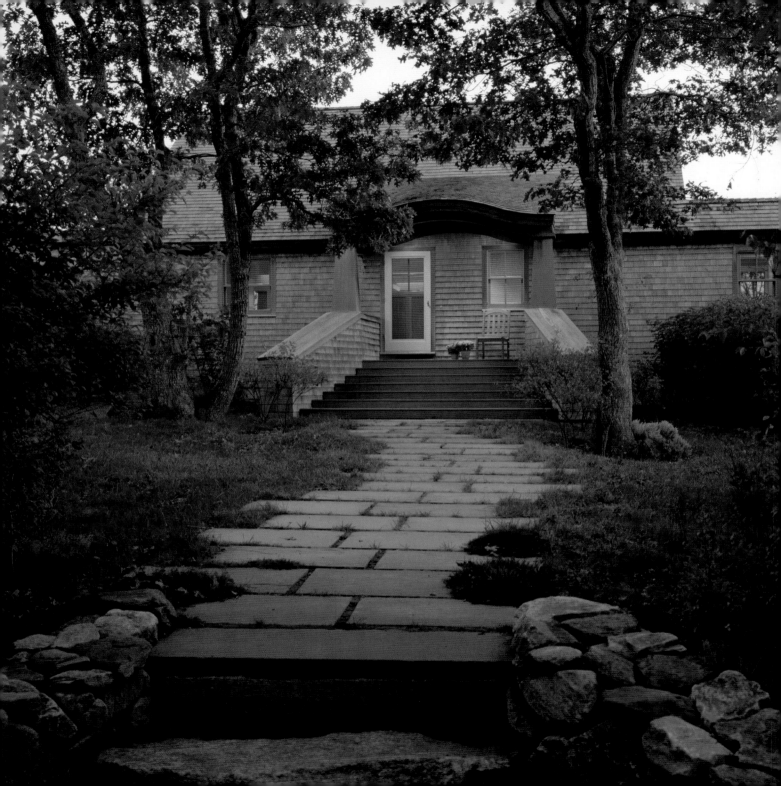

VINTAGE VINEYARD COTTAGE

A STEP THROUGH THE UNASSUMING FRONT DOOR EXPLODES INTO AN ARRAY OF FINELY STYLED ARCHITECTURE ON THE HIGH HERITAGE CLIFFS OF MARTHA'S VINEYARD. DESIGN BY STEPHEN BLATT ARCHITECTS. PHOTOGRAPHS BY BRIAN VANDEN BRINK.

Stone steps and walk lead to an unassuming entry that opens into an explosion of structure and form (**OPPOSITE**); *space and serenity above the sea* (**ABOVE**).

ON CLIFFS HIGH ABOVE THE WATER, six acres of giant oak and maple and open fields of a rare and eerie landscape have sat untouched forever. The sand and clay Wequobsque Cliffs are 140 feet high, with a steep drop to the private white sandy beach below. The view is all sand and beach for 20 miles and this Atlantic wonder rivals any ocean setting in the world. In addition to the seasonal beauty of Chilmark, Martha's Vineyard, the surrounding landscape emits a scent of ancient, rare field air. Meadows and moors are stitched together by low, dry stack stone walls, which make good neighbors and call on the ocean to be a boundary, where it's needed.

A favorite activity is a trip into Menemsha, a small fishing village that is part of Chilmark, to enjoy a spectacular sunrise or sunset. Shopping for what the fleet brought in today might include choosing from bluefish, scallops, tuna, or flounder. An exhilarating part of the day is bringing home a market basket filled with fresh *fruits de mer* and cooking them over a hardwood charcoal fire.

The cottage was built to heighten the experience of being away from the city; to let visitors enjoy the sense of an earlier era in relative quiet and peace, even during the height of the summer season. It was built to offer a separate world, where the noisiest neighbor is the ocean.

The house is a collection of buildings connected in the manner of early New England vernacular architecture, where additions were built as they were needed. The main house is a kitchen with a sitting alcove, called "The Nook." This is a favorite space, built of Douglas fir, with an arched wood ceiling reminiscent of a yacht and a fan-shaped entry. The beams were cut and milled by a close friend, who also carved the joints and brought the materials to the site by ferry. There is a barn constructed entirely with mortise-

and-tenon joinery—no nails at all—where gatherings take place for watching movies and playing music. The sense of the place is completely informal—country and seaside—and meant to show its forthrightness. The design borrows from a collection of architectural styles and ornamentation, which, with a few modern innovations and indulgences, expresses an eclectic charm, replacing formality with delight, warmth, and even mischief.

The noisiest neighbor is the ocean (**ABOVE**).

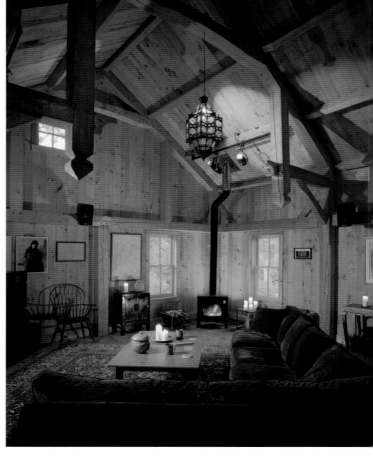

The sitting alcove, called "The Nook," is off the kitchen. An arched wood ceiling and a fan-shaped doorway create the sensation of being on a yacht (**ABOVE LEFT**); "The Barn" utilizes mortise-and-tenon joinery (no nails); Old World architecture meets high-tech toys (**RIGHT**); the main house is the kitchen with a sitting alcove; a perfect place for festive gatherings (**OPPOSITE**).

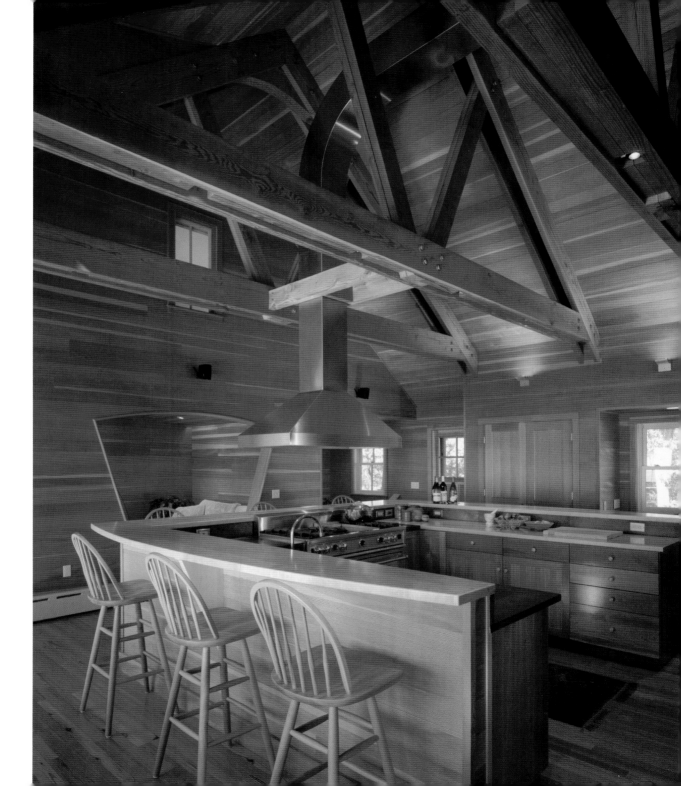

RABBIT RUN

THE QUINTESSENTIAL CHEER AND LIGHT ABOVE THE WATERS OF NANTUCKET SOUND PROVIDE A SPECIAL GATHERING PLACE FOR A FAMILY OF "BUNNIES" AT RABBIT RUN. DESIGN BY BOTTICELLI & POHL ARCHITECTS. PHOTOGRAPHS BY JEFFREY ALLEN.

THIS COTTAGE OF LARGE AND DYNAMIC spaces is intended to be enjoyed by the family and its future generations. The family matriarch is a painter; the patriarch and their three sons work together in the catering industry. This is a family that loves to work together and spend their leisure time together, especially when they are gathered in a place where there are lots of bunnies around ("Bunny" is a term of affection within the family). Deciding to build a new house on Nantucket Island, the family bought a set of cottage blueprints from a well-known architect. As discussions about the design progressed, it didn't take long to realize that a generic design would not satisfy, or, even with major modifications, be made to harmonize with the needs of a creative and active family.

In a little time, a new home adjusts to its "traditional" patina.

163

Botticelli and Pohl were brought in to consult on the changes. The "generic" plans were scrapped and a completely new design process began with an up-to-date look at the family's needs. The family had visited one of Botticelli and Pohl's Nantucket cottages and liked the open studded ceilings and the shingle style, so they started sketching a new approach.

The final design is a classic shuttered, rose-covered, shingle-style cottage that suggests late nineteenth- and early twentieth-century design. The open-vaulted ceiling spaces evolved from the idea of the open studs seen in the smaller island cottage. The large open spaces became the main design feature in and around which are arranged the living room space, a double staircase, and an open second floor landing with its dormer and the upstairs rooms. The interior floor plan vibrates with a contemporary flow. The main living area features three sets of French doors that open to the afternoon light. A large dining room holds a small, bright breakfast nook. Both lead directly into a crisp, blue and white 1940s-style kitchen.

Steps Beach is on the north shore of the island in Nantucket Sound. The water tends to be calmer and warmer than the south shore beaches, which are open to the Atlantic. The beach itself is flat and sandy with beautiful beach grasses. In the spring, the dunes are covered in fragrant *rosa rugosa*. Rabbit Run sits happily on a quarter acre of lovingly tended higher ground.

Rabbit Run is above the ocean; a walk to the harbor beach is nearby. The cut-out rabbit shape in the shutters was chosen from a family competition.

The front entry opens into a bright room under a double stair (**ABOVE**); *the living room is open to the landing and hallway above* (**OPPOSITE**).

Potted Roses

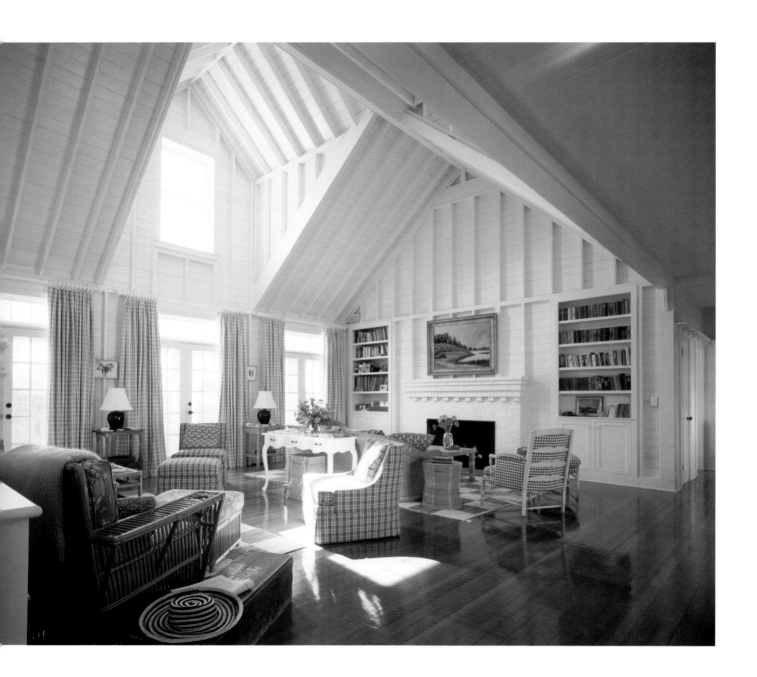

A contemporary openness featuring studded and vaulted ceiling spaces is refreshing and bright (**OPPOSITE**); the dining room is next to the kitchen and is open to the great room (**ABOVE**); crisp 2¼-inch blue and white tiles on the backsplash accent the kitchen (**TOP RIGHT**); a sunny breakfast nook exudes a stately inform-ality (**RIGHT**).

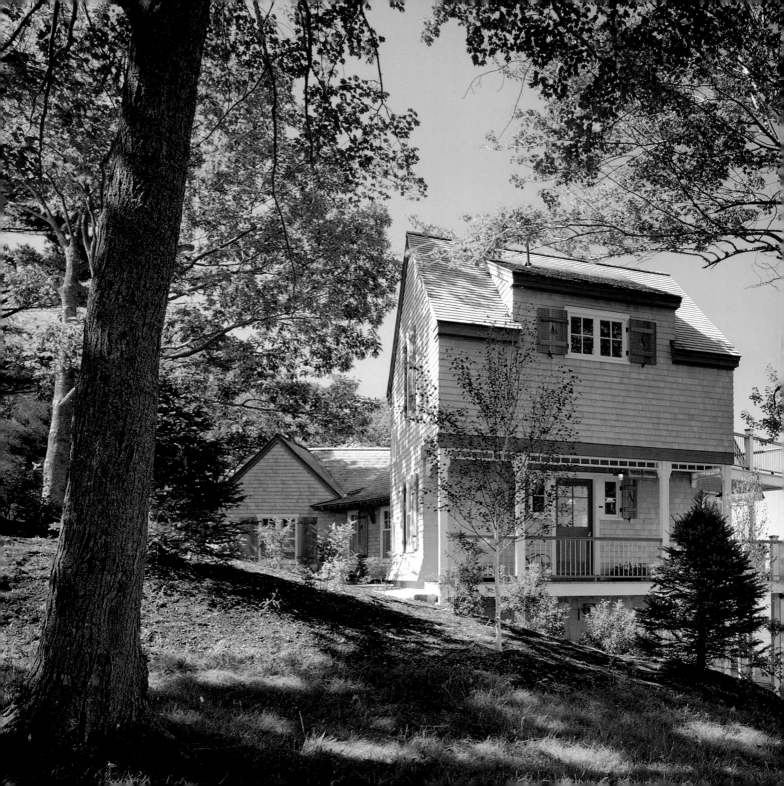

OCEAN POINT COTTAGE

THIS FOUR-SEASON COTTAGE IN BOOTHBAY BRINGS BACK THE COTTAGE VERNACULAR OF AN EARLIER ERA. THE SOUNDS OF BIRDS IN THE FOG, THE ONSHORE WINDS, AND THE ROCKING OF CHAIRS IN FRONT OF A FIRE CAPTURE THE TIMELESS MOMENTS. DESIGN BY WHITTEN ARCHITECTS. PHOTOGRAPHS BY BRIAN VANDEN BRINK.

THE SOUND OF RIGGING HITTING a sailboat's mast in Linekin Bay is all that can be heard here on a foggy day. Small islands to the north and south are hidden in the mist, and the sweeping views that the cottage at Ocean Point was designed to take in are obscured by weather. But this family is familiar with and comfortable in all of the changing seasons here. The owners are a couple in their mid-forties with two children. The husband spent 40 memory-filled summers just two doors down, at his parents' cottage. It was a natural blossoming of the family to purchase this seaside site when it became available.

The architect was engaged to carry out the clients' clearly defined ideas about the cottage. Designed in the shingle style, the new cottage is intended to restore a sense

The owners established a timeless quality with their new cottage architecture.

171

Simple lines, shingles, and authentic working shutters on all windows add to the authenticity of the style (**ABOVE**); *cedar posts and beams and brass fixtures give the cottage the flavor of an earlier era* (**OPPOSITE**).

of the old cottage vernacular to the area. In five years, exterior cedar shingles will have aged to a softer silver gray in the flourishing landscape. The cottage will acquire the patina of earlier eras and look as though it has been here for quite a long time. From their European travels, the owners collected ideas, such as the authentic working shutters that close and bolt over the windows. The door locks are brass boxes that have their tumblers external to the door itself and not inside the door like modern locks.

To balance the interiors with the aged feeling of the exteriors, the clients asked the architect to incorporate lots of wood and rugged materials such as cedar, heavy beams, rough-sawn trusses, and brass fixtures. A carver and woodworker himself, the husband takes great delight in returning from worldwide business travels to the dozens of species of wood used throughout: teak countertops, and teak and holly kitchen flooring such as that found in yachts; cedar

shutters and trim, and salvaged heart pine planks from a nineteenth-century warehouse; flame maple kitchen cabinets; and pine beadboard on every wall. Not one single sheet of drywall was used in the entire cottage. The wife, a schoolteacher, enjoys reading and writing, and, of course, having guests. Decks, patios, and seating areas allow for easy entertaining; separate clusters of spaces provide privacy as it is needed. The cottage is completely technology free: no television sets, computers, digital readout appliances, or apparatus. The attention to detail applies even to the wall thermostats, which are an old dial type; nothing with a red or turquoise glow to upset the balance of a night at the water's edge. Life here is always focused on the water. Boating and swimming and fishing are its essence. The daughter and son love to ride the speedy "inflatable," in which trips to the nearby town of Boothbay Harbor are more fun than taking the car (and just as fast).

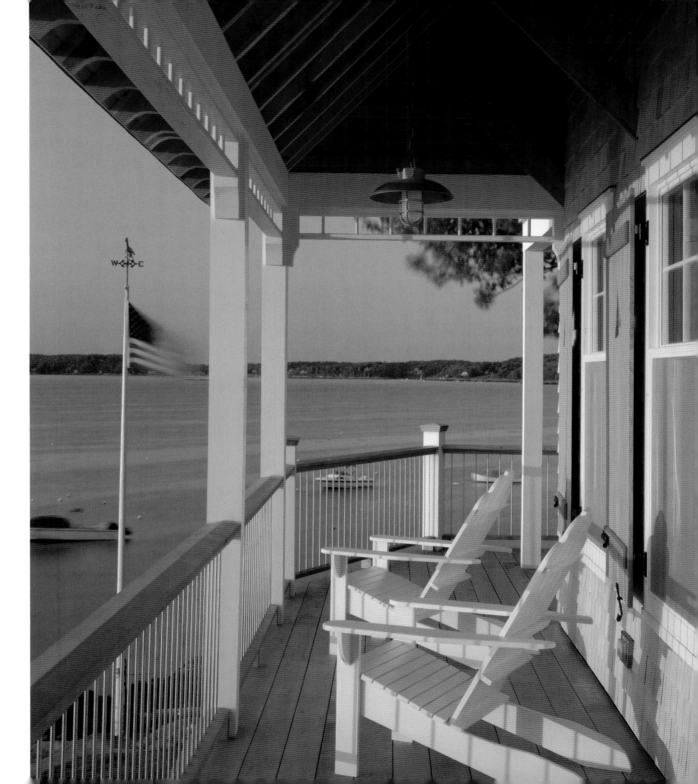

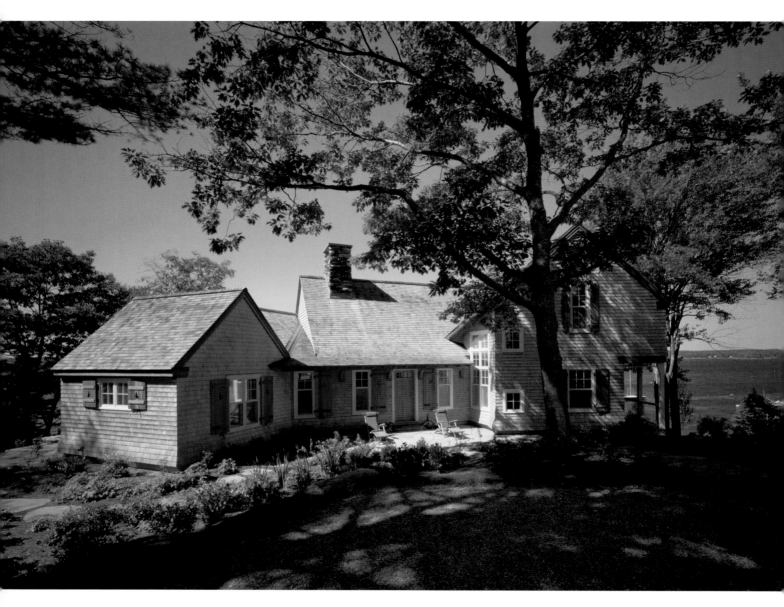

*The cottage ambles on the site, providing many private areas inside and out (**ABOVE**); the decks, porches, and stairs all lead to the bay (**OPPOSITE**).*

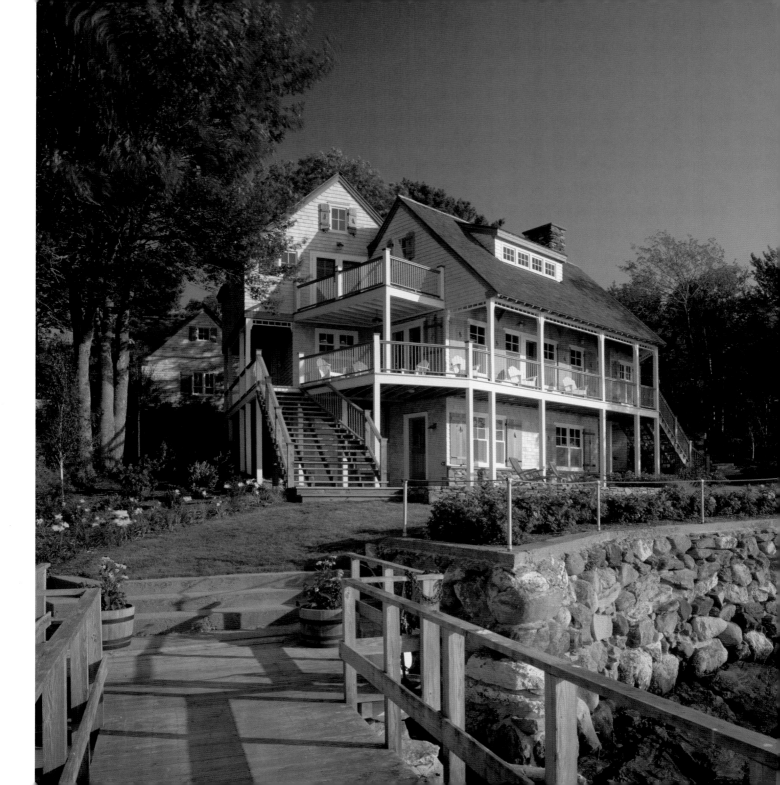

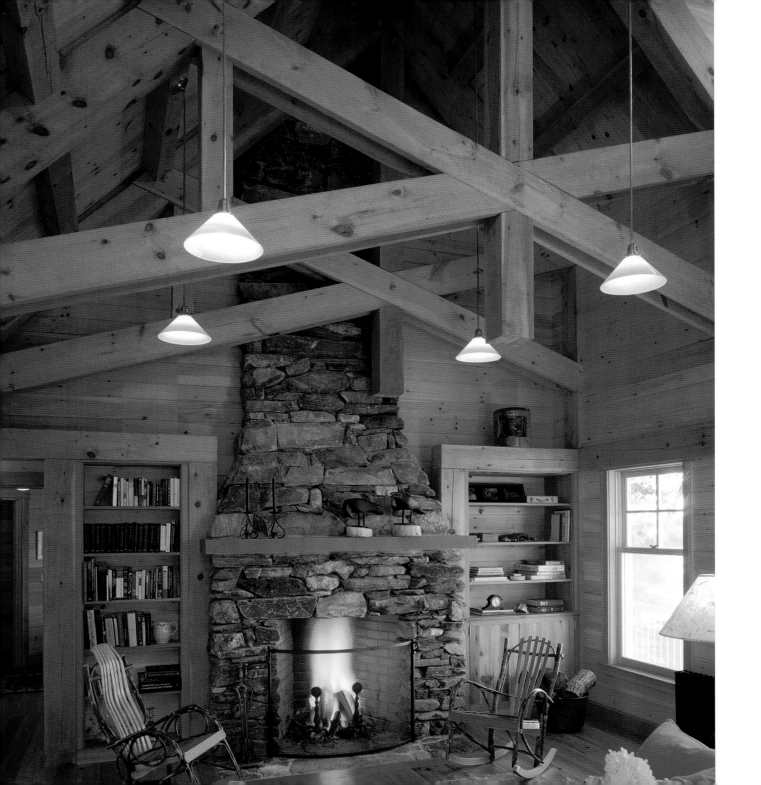

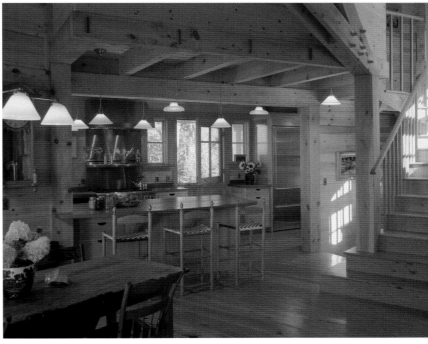

The owner is a lover of wood and requested dozens of species used with the ruggedness of stone (**OPPOSITE**); the stenciled armoire is a complement to the country furnishings (**LEFT**); teak counters, heart pine flooring, and flame maple kitchen cabinets keep the interiors warm and inviting (**ABOVE**).

Stair to beach (**ABOVE**); *Dexioma, the cottage's name, is announced on a shingle* (**OPPOSITE**).

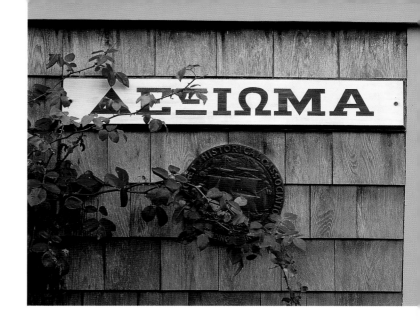

DEXIOMA

LIVING THE VILLAGE LIFE OF A WHALING HOUSE RESTORED IN THE VERNACULAR STYLE OF NANTUCKET, OWNERS MARY AND GEORGE WILLIAMS TRANSFORMED THIS SIASCONSET COTTAGE INTO A ROSE-COVERED BEAUTY. PHOTOGRAPHS BY CARY HAZLEGROVE.

MARY WILLIAMS SAW DEXIOMA for the first time when she was a girl of 13. Vacationing on Nantucket (the island was originally called Natocket, meaning, "the land far out at sea"[1]), she thought that the cottage was a kind of fraternity house because young men in sporting clothes populated the village, and, of course, the Greek name was painted on a shingle attached to the cottage. Five years ago, Mary was looking for a smaller summer place when she learned that Dexioma was available. She remembered the rose-covered cottage, so she sold her large, seven-bedroom ship captain's house on the Cape, which was almost an equal trade for the tiny place in 'Sconset.

Dexioma is one of the early whale houses in the village of Siasconset, a name thought to be derived from the American Indian *missi-askon-sett*, meaning, "near the great whale bone."[2] Maritime adventure was the underpinning of life in early Massachusetts. It is easy to think that when sea captains and whaling men spent time on land, they would build large houses as an antidote to the confinement of ship's quarters on long voyages. But not so in the whaling village of Siasconset, where seamens' homes took the shape of small shelters. Tidy little house follows tidy little house, each with a small front yard framed by a painted white slat, zig-zag, or picket fence. The lovely, early eighteenth-century rose-covered Dexioma is among them:

> *"One of the most perfect gems of all the 'Sconset whale houses, is Dexioma, from the Greek ... meaning 'a place of welcome' or as it is known today, the 'Friendship House.'*[3]

Small, timber-framed rectangular shelters—the posts, beams, and rafters of which were mortised and tenoned together to withstand the force of storms—were the mainstay quarters on land for a six-man boat's crew, where they were packed in like sardines. In true vernacular

cottage itself had not had many changes in its almost 200-year existence. Its past owners had all cared about the oldness of the place and had not changed anything that was original to the structure. Mary did little to change any of the old parts of the cottage as well. She discovered a round cobblestone pantry hidden under a trap door and restored it; she did open up the kitchen and sitting areas. She had the chimney inspected and found it to be in perfect condition, and finally, to get her sleeping quarters squared away, she asked a carpenter to cut seven inches from a favorite antique bed so that it would fit into one of the staterooms or cabins. Outside, the unused dory boathouse had the daylight sealed out, and in an innovative gesture, Mary converted it into a provocative period kitchen and patio with a lovely arbor.

For Mary and George, spending time at Dexioma is less about the cottage itself than it is about living the village life. She laughingly tells of George's friends, standing outside in the early morning and calling his name from the street, as kids do, to get ready for a morning of bass fishing. Village life is the story of being outside, talking and eating with neighbors, getting your messages at the post office, and trading news. Mary has furnished the cottage with objects that have been with her in other places in her life, even if it is only a corner of a tablecloth or one of a pair of beds. Her garden glows with foxgloves and hollyhocks, along with the roses. And George's patio is a place where he and guests unwind. It is a place of welcome: the Friendship House.

style, the cottage consisted of one central room, called the "great room," measuring roughly 11 x 13 feet. It was divided by partitions of wood panel, textiles, drapes, or, on one known occasion, a leather curtain, to create "staterooms" or "cabins." Hanging lofts, a space above a very small portion of the great room, completed the sleeping quarters for the tight-fitting interior spaces. The lofts were reached by crude, steep steps, similar to those found on the companionways of small schooners.

"The south portion of Dexioma is the original cabin, which comprised a small Great Hall and twin staterooms."[4]

Mary pitched in to set the cottage right. Daylight was coming through the shingles in the boathouse, and the

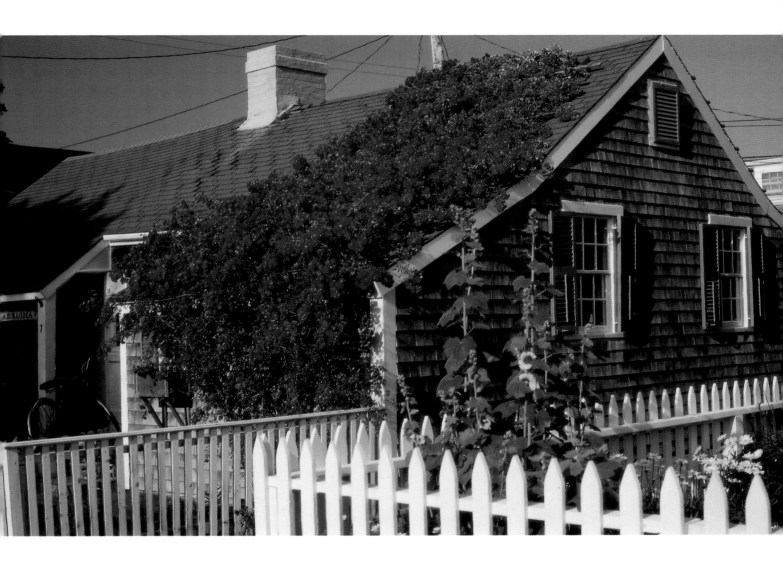

ENDNOTES

1. Henry Chandlee Forman, *Early Nantucket and its Whale Houses*
 (Hastings House: New York), 1966, p. 1.
2. Ibid., p. 8.
3. Ibid., p. 153.
4. Ibid.

An alcove for a guest and tea (**LEFT**); the diminutive painted cabinet, lace curtains, and pebble floor complement the sea breeze (**BOTTOM LEFT**); soft colors and painted furnishings are all small treasures (**BOTTOM RIGHT**); an unused boathouse was converted into the cottage kitchen (**OPPOSITE**).

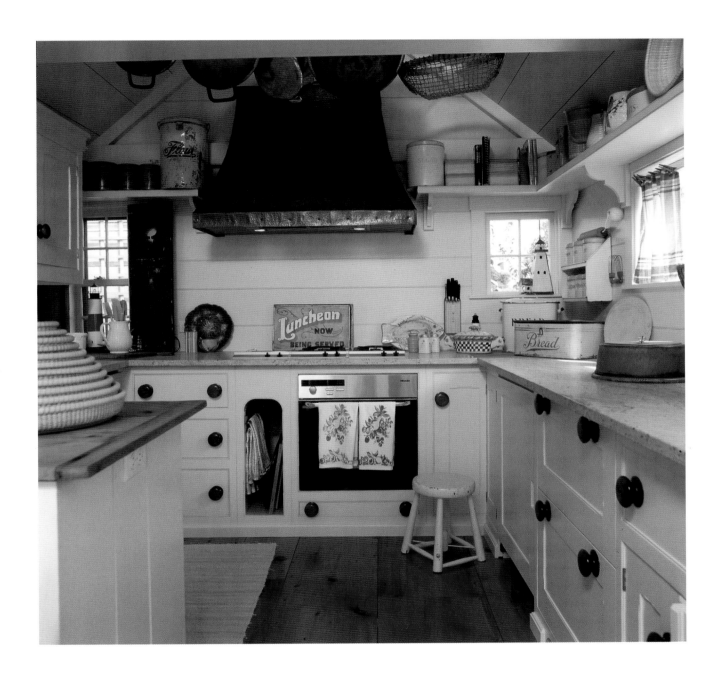

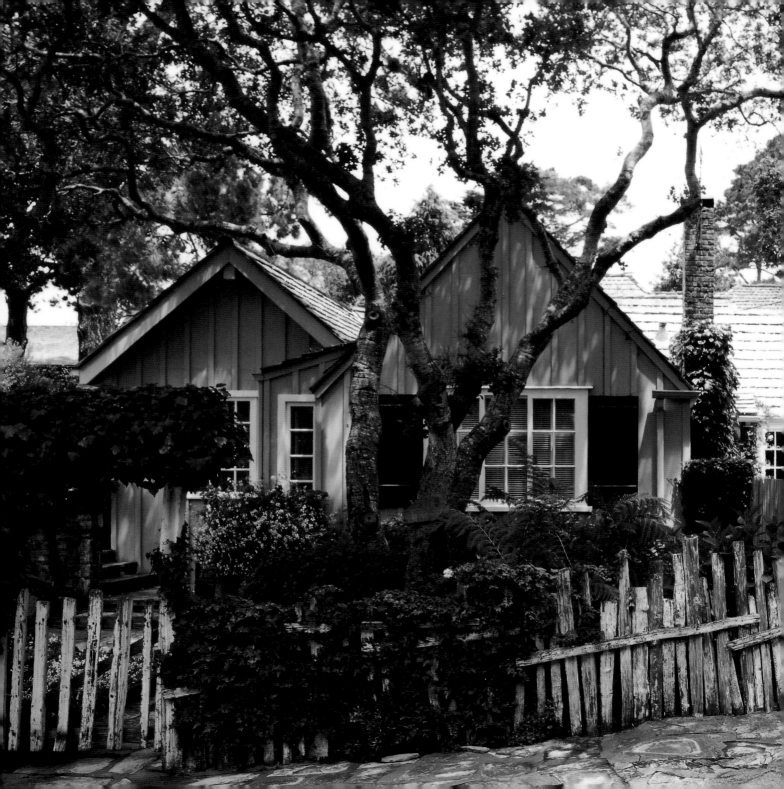

FAIR HARBOR IN CARMEL

BUILT BY RENOWNED EARLY CARMEL BUILDER M. J. MURPHY, FAIR HARBOR IS A TRUE TREASURE. SURROUNDED BY TREES AND MORNING FOG, THIS LOVINGLY TENDED COTTAGE IS CHEERFUL AND SPACIOUS, OFFERING CARMEL'S RESTORATIVE COMFORTS AT ANY TIME OF YEAR. PHOTOGRAPHS BY STEVE KEATING PHOTOGRAPHY.

STONE, BOARD, AND BATTEN and small shingle-style cottages are typical of the coastal communities that evolve on the oceans and gulf coasts. Carmel is a demure community; a walk along the dappled, tree-covered streets is an introduction to an unpretentious sensibility. It was part frontier and part euphoria when it was designed to become a dream in the making. The 1902 Carmel Development Company sales brochure was addressed "To the School Teachers of California and other Brain Workers at Indoor Employment" in the belief that they were most in need of a "breath of fresh air." Developers designed the lot sizes to be small and affordable. The little village attracted beguiling, well-educated world travelers, as well as painters, poets, and actors. George Sterling,

Behind a grape stake fence, along a stone walk, under an old oak tree is a quintessential seaside cottage.

185

the early-twentieth-century poet wrote: "Carmel was the only place fit to live—it was the chosen land."

M. J. Murphy was one of the first of the beloved Carmel builders. He built Fair Harbor in 1927 on two of the small Carmel lots. The cottage was a small 20 x 36-foot rectangle, built for a total cost of $3,300. The new owners, who purchased it in 1975, updated the cottage in 1994.

Fair Harbor is the exemplar Carmel cottage, lodged in the oaks on a lovely shady corner where the street jogs to the right before continuing down to the beach paths. Under the oaks, a cobblestone sidewalk is skirted by a crooked grape

stake fence that is a traditional style in the one square mile of Carmel-by-the-Sea. Inside the grape stake fence, a small stone path leads to a stone courtyard, where flowers flank a Dutch door entry on one wing of the cottage, and a brick chimney accentuates the steep pitch of the three peaks of the roof on the kitchen wing. Shuttered windows and window boxes of hydrangeas perfect the exterior.

The interior is a collection of elegant open spaces. The ceilings show open studs in vaulted spaces that mirror the inside dimensions of the roof's steep pitch. A white, gleaming pristine simplicity speaks of nothing more than privacy, peace, and promise.

The stone courtyard between the dining area and the bedrooms are where potted geraniums bloom (LEFT); small bedroom facing the courtyard (ABOVE); the benefits of a steeply pitched roof are evident: a vaulted ceiling with open studs and bright interiors keep the spirit joyful (OPPOSITE).

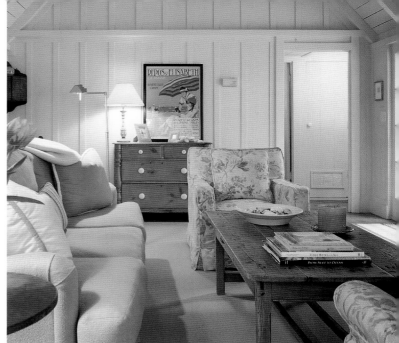

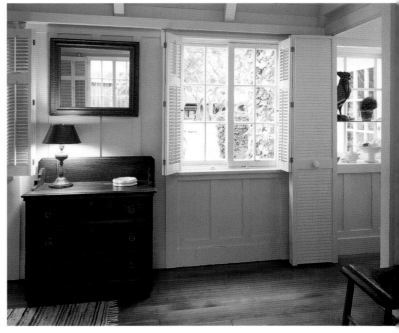

The large wood table, board and batten walls, and wood flooring and countertops warm the dining area which is flooded with sunlight (**OPPOSITE**); the entrance through a Dutch door from the stone covered courtyard is convenient to the bedrooms (**ABOVE**); board and batten walls add an element of comfort to the cozy furnishings of the living room (**TOP RIGHT**); cottage life requires a delicate balance of light and heavy to offset foggy days. Fair Harbor is a perfect example (**RIGHT**).

Sunlight floods the entry. Zinc cabinets are embedded in the wall six inches deep. The tutoring room is behind the entry; the living room is in the foreground (ABOVE); *a flower-laden circular arbor above the garden gate is a preview of the lushness of the grounds* (OPPOSITE).

CONNIE UMBERGER'S COTTAGE

A FAMILY'S LIFELINE OF ARTIFACTS AND TREASURES IS HOUSED IN THE LOVINGLY RECREATED VERNACULAR ARCHITECTURE OF A BARN, SHED, AND GARDENS OF A ONCE "SHAPELESS BARNYARD"—FROM THE STRENGTH OF A WOMAN WHO CHANGED LOVE AND PAIN INTO BEAUTY. PHOTOGRAPHS BY CARY HAZLEGROVE.

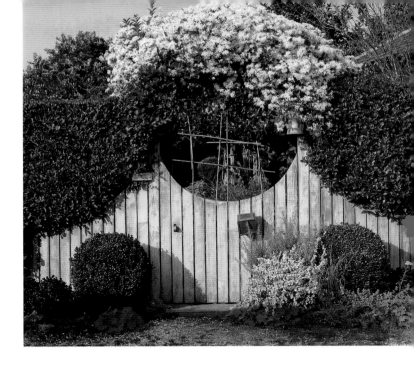

CONNIE UMBERGER'S EXPLANATION of the individuality and distinctiveness of her cottage can be very perplexing. "Some won't come here," she sighs, "It's too crude, too shabby." By her own description, when she first saw the Nantucket property, it was, she recalls, "a flat, shrubless, treeless, shapeless barnyard . . .with an existing house and a barn standing on it." An educator from a long line of men and women who saved everything in trunks, attics, and cellars, Connie houses a collection, if not an archive, of precious family treasures in her cottage.

No one would think of Connie's pilgrimage to Nantucket as part of a plan to fulfill a lifelong dream. Hers was a journey of extraction, a mutiny of the past. Her courage was embodied in the persistence of her youngest daughter, and together they explored Nantucket Island, one of the places where they found a warm familiarity. Connie looked at the barn and envisioned a seaside cottage for herself and her daughter. She began converting the old horse barn using very little money. She found old doors and windows and hired help to install them. The "lean-to" attic roof was raised, and the upstairs was turned into two rooms for additional space. To the right of the main entry was her small tutoring room. The first-floor living room and kitchen were separated by only the kitchen island. Progress was slow as she managed to work on both making a new life and a new cottage.

When Connie came to Nantucket, her life had changed dramatically—so much so that for the first couple of years she found it difficult to focus her attention on music or even on reading. In time, she grasped one end of a shovel, put her foot on the other end, and pushed. She dug and planted; she didn't need to concentrate. In the ground, in flower boxes around the old shed, she laid brick pathways and stone walks and raised succulents, irises, poppies, roses, and trees. The garden and the cottage began to flourish. The American Horticultural Society visited the garden; its wonder inspires others. Connie's cottage and garden are remarkable in that "it didn't take a lot of money, it didn't take knowing anyone, it only took trying to keep going forward," said Connie. Too "shabby and crude?" It couldn't be more elegant.

*The garden is a work in progress, a place for thoughts, moments, and doings (**OPPOSITE**); the half-arched windows were discovered by Connie, who had them installed to frame the furnishings (**ABOVE**).*

*Books are arranged by subject; this room holds history books (**TOP LEFT**); collections and fragments gather on an entry table (**BOTTOM LEFT**); Connie's grandfather made this dollhouse when he was a young boy, ca. 1890 (**ABOVE**); non-fiction books are arranged in the living room. The portrait over the fireplace is of Connie's father (**OPPOSITE**).*

TREASURE COTTAGE

OH HAPPINESS! OWNER AND INTERIOR DESIGNER MICHAEL PELKEY IMMACULATELY RESTORED THIS OLD KEY WEST COTTAGE. THE BIRDHOUSES, GUESTHOUSE, AND TERRACE CREATE A DREAM HOUSE. HIS PERSONAL COLLECTIONS APPEAR AS AN ART GALLERY. PHOTOGRAPHS BY JOHN DIMAIO.

MICHAEL PELKEY IS A PERSON WHO knows how to pull things together for a perfect reward. In the Conch Republic of Key West, Michael discovered a 1906 cottage formerly occupied by hunters and cigar makers and saved it from complete disrepair in the nick of time. Michael bought the 500-square-foot cottage about 10 years ago, while he was working as a personal chef and making frequent trips to Europe. He took advantage of his time in London and Paris to shop and look for antiques and his other favorite objects: ironstone and black basalt ware.

Vine-covered and gated arbors open into the tidy 30 x 50-foot piece of property. Nearly every inch of the cottage was rebuilt and restored by Michael with help from his brother, Larry, a contractor. Michael's designs and plans were faithfully carried out. The major floor plan was for four rooms in the tiny space, each measuring

The owner saved this vintage cottage from ruin and brought it back to life as Key West's best example of early vernacular architecture.

197

only 10 x 11 feet. Floor-to-ceiling cabinetry and a wonderfully unique double set of window seats with bistro tables give the rooms an added sense of spaciousness. Michael incorporated antique arched windows wherever possible above cabinetry that represents his devotion to his culinary past. The windows are also found in the guest house, above the front door, and above the bed. This subtle touch adds dimension, elegance, and light to all of the

interior spaces. Another of Michael's favorite features is the old wood flooring, which adds softness to the interior. The pattern was set at random using 3–10-inch pieces of Savannah heart pine. A large front porch, with its four columns, covered by a tin roof and shuttered windows, completes the stylish openness of the cottage.

Devoted to the community of Key West, Michael loves to entertain and loves to cook, of course. He has designed a picturesque pergola and picketed deck, 13 feet wide and 30 feet across. Two sets of French doors open onto the deck from the interior. One set of doors opens onto the dining area with seating enough for 10. The center area of the outdoor space is furnished with wicker and potted plants. At the opposite end of the deck is the guesthouse, another jewel in this Key West heaven. A paned glass door with another antique glass arched window above opens into the guest quarters. The entire deck area is surrounded by lush plantings that occasionally reach over the railing. Michael's talent for simplicity, economy, and more than a few brushstrokes of genius, blossomed into this dream-come-true cottage.

Double sets of French doors open onto the spacious deck, where a guest cottage sits (OPPOSITE, TOP LEFT); the compact guesthouse features an arched window above the bed and a square window set into the book-case for natural light. The precious pastel "peepers" hang above the bed (OPPOSITE, TOP RIGHT); this birdhouse, built by Larry Pelkey, is a replica of the guesthouse. Larry was the contractor for the restoration (OPPOSITE, BOTTOM LEFT).

Michael created a spacious 30 x 13-foot deck for his second loves, cooking and entertaining (RIGHT).

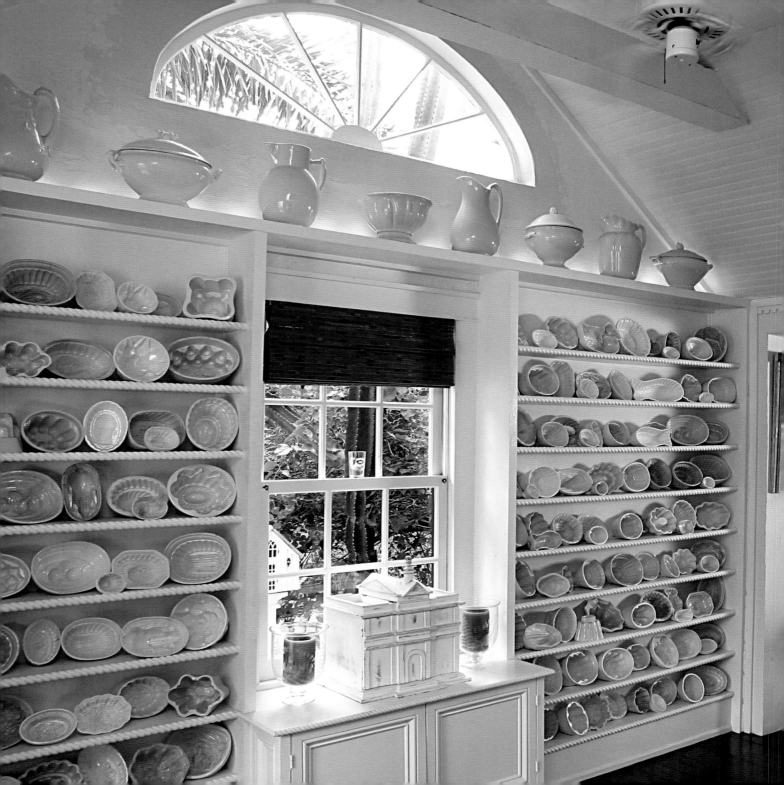

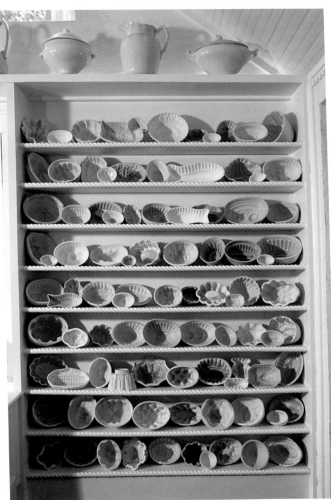

The wall opposite the living room area displays part of a larger collection of pudding molds. The soft colors add dimension to the space. Two bistro-style tables and window seats economize on space without giving up individuality (**LEFT**); unlimited shapes and patterns in subtle tones (**ABOVE**).

ISLAND LIVING

INTRODUCTION

ISLAND LIFE IS A DREAM of abundance, well-being, and perfumed air, an enchantment of orchestral bird songs in the twilight. Butterfly wings fan horizons into a shimmer in the cool of the dawn, and a wash of soft, bubble-fronted waves meets the day's first imprints in the sand. Every island is a vision of an edenic beach that sparkles with gems and eccentric vegetation, ripe with fruit that never falls. They are the homes of the gods and the Great Mothers of myth, the Blessed and the sprites. There we can yield to our impulses to be barefoot, get wet. And they, the islands, are the source of our exotic, undying wonder. They are the source of Henri Bergson's *élan vital*, the intuitively perceived and mysterious life force.

How did such dreams of heaven on earth emerge after centuries of stories of heathen lands where helpless souls awaited judgment or worse? Landing on an uninhabited island meant a life too far beyond the reach of civilization to be saved, a perpetual *New Yorker* cartoon of an unshaven man leaning against a lone palm tree. For a shipwrecked scattering of humanity washed up on a pebbled island shore, there could be only despair, loneliness, hardship, and death. Islands were home to the destitute, the diseased, the shanghaied, and the convicted. Surrounded by the cruel sea that took them there, and the horizon, in places unmarked on navigational charts, the castaways were in a prison and a struggle for survival: not a measure of time in paradise.

The horrible myths and dread of the old tales slowly faded when a restorative adventure began to work its way into the lore of the seafarers. One such story of salvation and redemption in an island setting tells of the shipwreck of the British ship *Sea Venture* in 1609. Its voyage to the New World ended when the ship was caught up in a storm and dashed onto the rocks near an island. All hands washed up on what was believed to be the most forlorn group of islands on earth, commonly called the Devil's Islands. They were known to be the homes of devils and wicked spirits. They were, in fact, the Bermudas. Navigators feared and avoided them above all others, as they would have avoided the twin pulls of Scylla (the monster) and Charybdis (the whirlpool), the two tempestuous forces described in Homer's *Odyssey* who faced each other in a narrow strait. After the loss of their vessel, the *Sea Venture*'s survivors salvaged iron, wood, and rigging from the battered ship and from them built a smaller one. The broken spirits of the shipwrecked crew were revived by a miracle of deliverance. They left the island after nine months of rebuilding—refreshed, comforted, and confident—to ferry themselves to their original destination, Virginia. Afterward, the ship's Captain Newport ("and Divers Others") wrote that despite their initial fear of a place the Devil himself would shun, they found the air sweet and the island full of all the necessities for the preservation and enjoyment of life: "It [was] in truth, the richest, healthfulest, and pleasing and . . . utterly natural land as ever man set foot upon." [1] Among testimonies from the survivors was a letter by one of the ship's officers, William Strachey. He wanted the truth about the Bermudas revealed, and with it, the lesson that with experience comes knowledge. He wrote:

"Truth is the daughter of Time, and men ought not to deny everything which is not subject to their own sense." [2]

Truth, time, and experience. These are the mysteries that begin to unravel as we learn to slow down, take a closer look, and listen to the sounds of nature. We once believed that the earth was very large, that we, its creatures, were very small, and that knowledge of the world was difficult to attain. Now, our pace has accelerated, we view the earth as smaller, and ourselves as larger; we must always be thinking and there is never enough time. The only way we can reengage with our surroundings is if we take a slower, closer look at them, and dwell in the soothing ancestral realm of our senses. We can be inspired to design and build, to write music, to paint, by what we look at and our way of looking at it.

SOMETHING AS SMALL AS A BUTTERFLY'S EGG can inspire a scientist, an architect, or a sculptor. The complex beauty of its luminescence; the narrow, slender flutes and the long rows of tiny French-button shapes; the egg set securely in microscopic, crinolated, crystalline fibers, is a model for space stations, haute couture, or ingenious architecture. The approach of a flock of scarlet ibis, signaled by the hastening sound of thousands of individual wings heard a mile away, alerts us that something rare and strange is about to happen: a crescendo, a landing, and the clash of cymbals can teach us to listen to the winds, the waves, and ourselves. Perhaps the ability to recognize individual birds or turtles, the sound of ibis or bees, is the same skill as running fleet-footed through a forest on no marked path, letting "your feet think for themselves, deciding where to land, what to go around, what to go over and under . . . the best route simply presents itself, without having to be thought out." [3] Running freely, calming the impulse to always be thinking, considering most carefully the world at your feet—these may be ways of getting to an island.

"He's being sent to an island. That is to say, he is being sent to a place where he'll meet the most interesting set of men and women to be found anywhere in the world. All the people, who, for one reason or another, have got too self-consciously individual to fit into community life. All the people who aren't satisfied with orthodoxy, who've got independent ideas of their own. Every one, in a word, who's any one." [4]

The owners of the houses presented in this section might be those very same ones who no longer wish to shine their internal lights on the orthodoxies of twenty-first-century life. No island is an island any longer, but I wonder, how could we ever have dared to think of disturbing this beautiful universe?

ENDNOTES
1. Sir Thomas Gates, Sir George Miers and Captain Newport, *A Discovery of the Barmudas, Otherwise Called the Isle of Devils* (London: John Windet, 1610).
2. William Strachey, *A True Repertory of the Wreck and Redemption of Sir Thomas Gates, Knight, upon and from the Islands of the Bermudas, et.al.,* (In Samuel Purchas, Purchas His Pilgrims: 1625) Part 4, Book 9, Chapter 6, pp. 1734 ff.
3. *Shelter* (California: Shelter Publications, 1973), p. 95.
4. Aldous Huxley, *Brave New World* (New York: HarperCollins, 1998), p. 227.

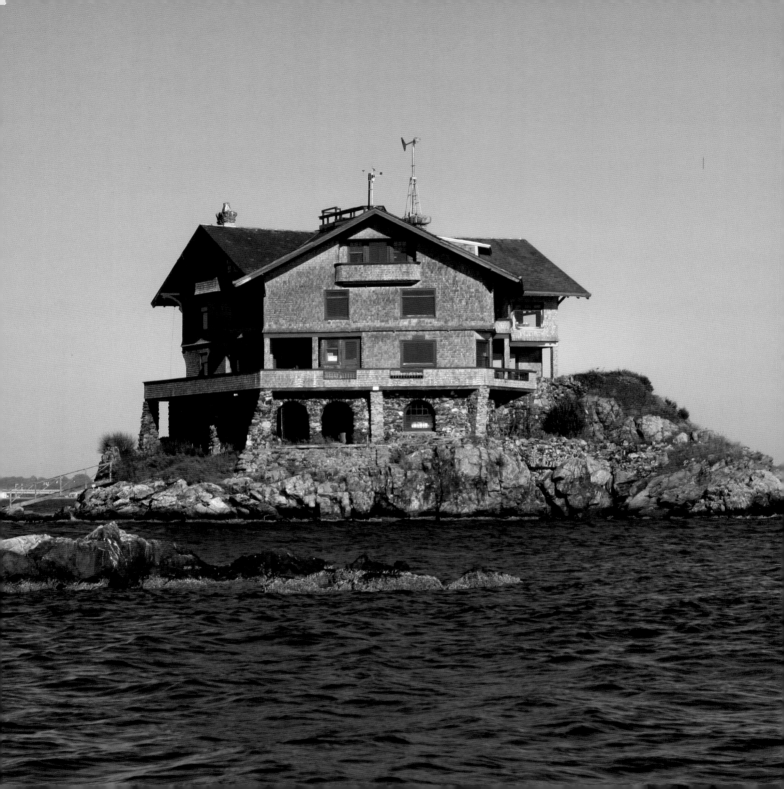

CLINGSTONE

THIS BEAUTIFULLY RESTORED SUMMER HOME HAS STOOD
WATCH IN NARRAGANSETT BAY, RHODE ISLAND, FOR THE
PAST 105 YEARS, AND WILL BE THERE ANOTHER 105 YEARS.
DESIGNED BY OWNER HENRY A. WOOD, FAIA, OF KALLMANN
MCKINNELL & WOOD ARCHITECTS, INC. PHOTOGRAPHS BY
JOHN DIMAIO.

Clingstone is built on the largest of the Dumpling Islands
(OPPOSITE); *A bust atop a cairn keeps watch over the bay and*
the Clingstone dock. (ABOVE).

THIS STRIKING SILHOUETTE, emerging from its rock, is
Clingstone. It is located on the largest of the islands known,
since the 1700s, as the Dumplings in the East Passage of
Narragansett Bay, in Rhode Island. Two miles from the
harbor in Newport, the house and its island are at the edge
of the main passage from the open ocean to the bay.

The house was built as a summer cottage in 1904–05
by Joseph Lovering Wharton of Philadelphia (a distant
cousin of Mr. Wood), after his own nearby house was taken
by the government to build Fort Wetherhill in anticipation
of an attack on Newport during the Spanish-American
War. It was designed by J. D. Johnstone, with much guid-
ance from luminist painter William Trost Richards and
Wharton himself. Richards's former house had also been
taken for the fort, and he first purchased this island as a
"favor" for Wharton; Richards's initials are carved in a
granite block in the stone wall to the southeast. Designed
in the shingle style, with heavy timbers, the house is unusual
in that its interior walls are also shingled. Each of its 23
rooms has a different tint. The shingles were thought
to eliminate the cracking plaster seen in many nearby
houses when the fort coast defense guns were first used.

Many utilities were installed in the house during
the Wharton period. Water was collected at the roof and
funneled into a large cistern. Tubs had a choice of fresh or
salt water for bathing; toilets were salt. Coal-fired steam
heat was provided after a coal barge broke up on the rock
and left its cargo behind. Electricity was installed in the
1920s, supplied by a diesel generator on the jetty.

The Wharton family summered in the house until
1941, and it lay vacant until Mr. Wood purchased it in 1961.
By then, the house had suffered damage from vandalism,
pigeons, and storms. It has been restored and preserved by

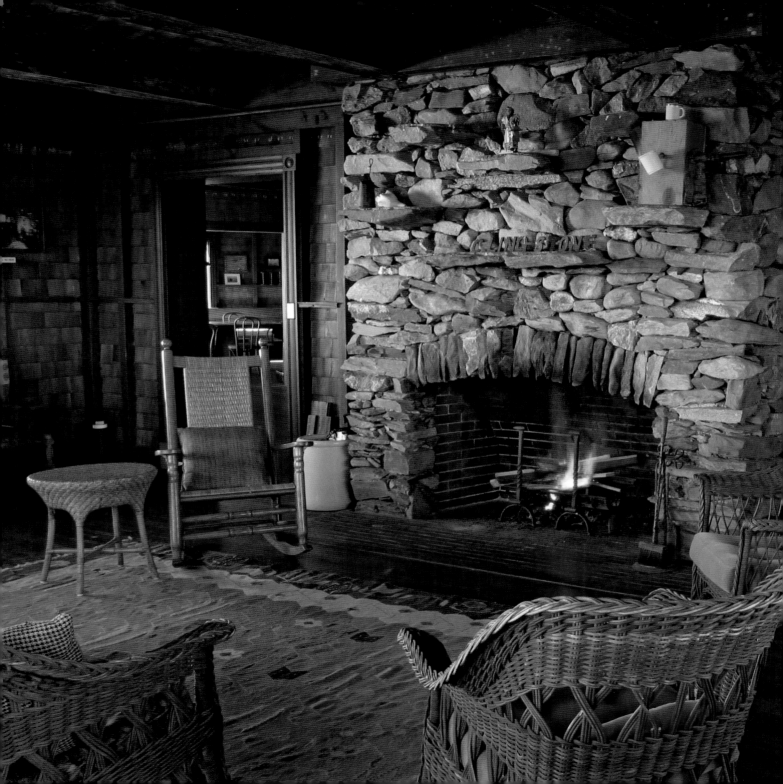

the Wood family over the past 44 years. The Woods' children spend most weekends at Clingstone from the beginning of May through the end of October each year. Their goal is to maintain and enjoy this 100-year-old treasure.

Eventually ownership will pass from Henry A. Wood to his sons. The three brothers work at retrofitting the house for future self-containment and sustainability. Fresh water is still collected on the roof, but it is now treated and filtered. There is a solar hot water system. Saltwater is no longer an option in the tubs, however. The saltwater toilets are being replaced by composting systems. Plenty of electricity is now being produced by a 1,500-watt windmill and photovoltaic panels, which are capable of running everything. Both DC and AC electricity are used. Propane gas is brought from shore for cooking, as is an occasional supply of potable water. The house is elegantly reconnected to its origins and its original purpose: independence. All it needs now, claims son Josh Wood, is an electric boat.

A massive fireplace faces into three rooms: the living room (shown), a billiards room (on the right), and the pantry and kitchen (to the left).

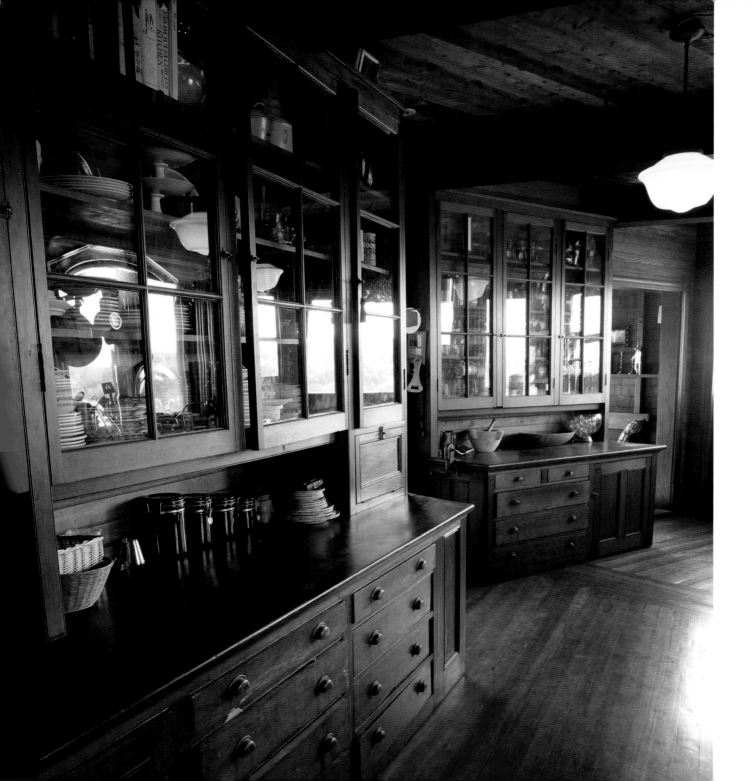

*Built-in wood and glass cabinetry line the walls of the pantry and dining room (**OPPOSITE**); a study and office for drafting and chart making (**RIGHT**); the view from the master bedroom over the bay (**BELOW**).*

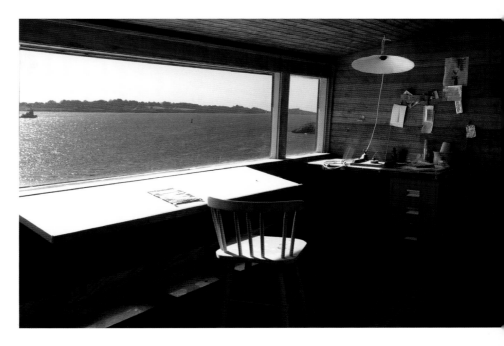

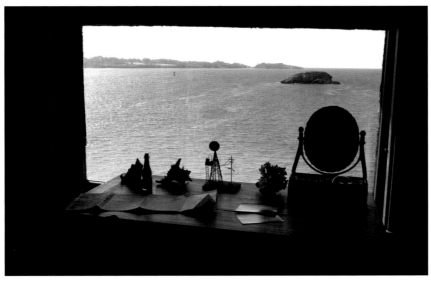

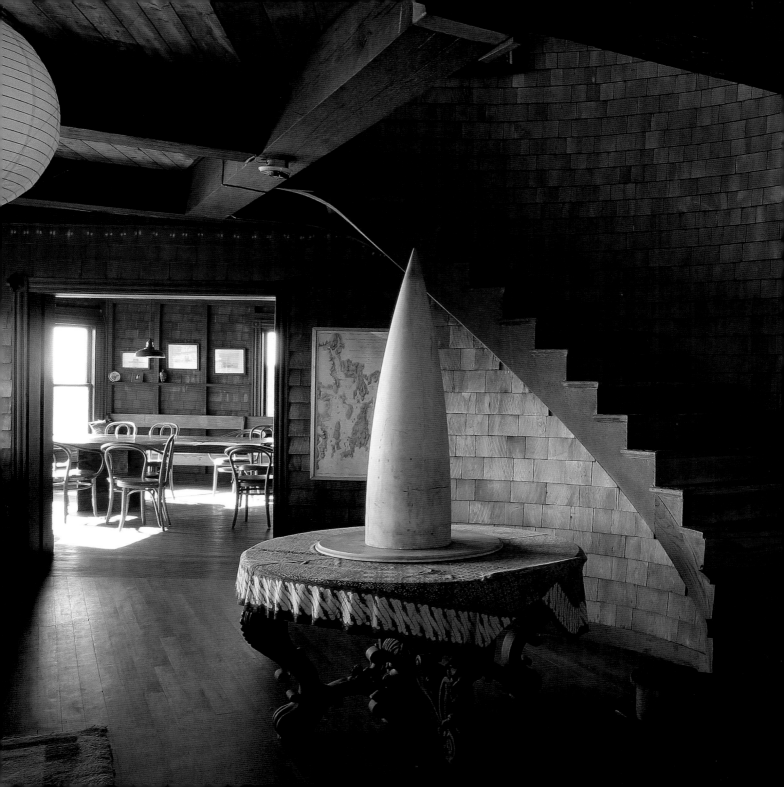

The main entry hall and staircase. Exterior shingles used on interiors were believed to deter cracking in the plaster walls. The "sculpture" is the nose cone from a minute-man missile.

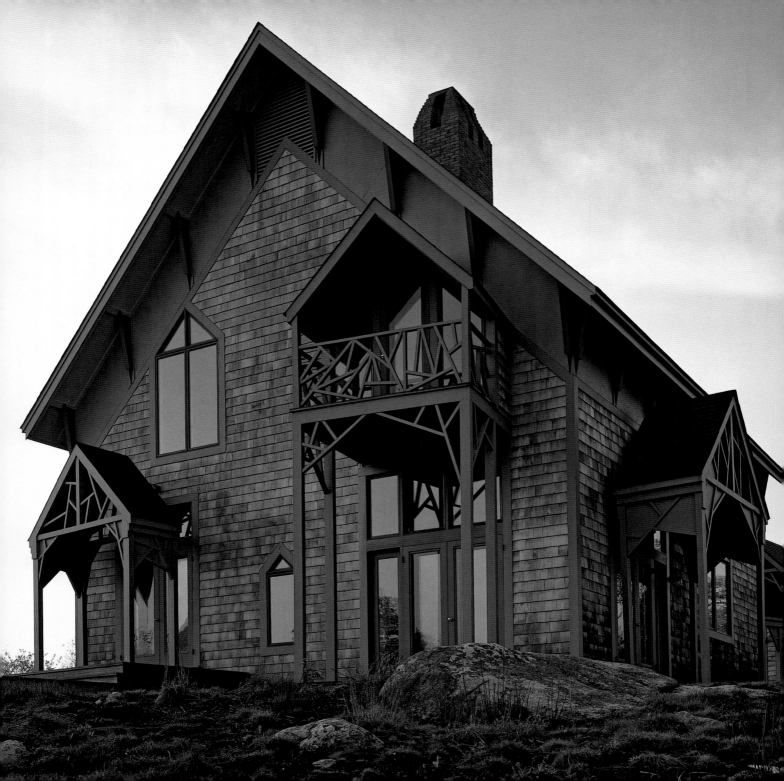

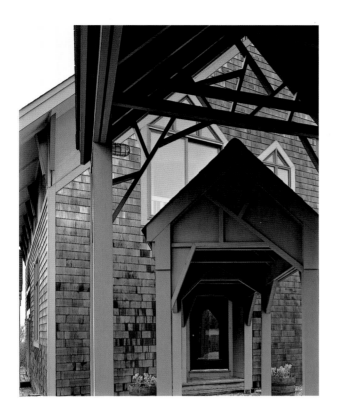

FISHERS ISLAND

A BOLD AND BRIGHT EXPRESSION OF GOTHIC REVIVAL,
CRAFTSMAN, AND NEW ENGLAND BARN VERNACULAR
ARCHITECTURAL STYLES IS CAPTURED ON A ROCKY AND
WOODED SITE. DESIGNED BY MARK SIMON, FAIA, AND
LEONARD J. WYETH, AIA, OF CENTERBROOK ARCHITECTS
AND PLANNERS. PHOTOGRAPHY BY TIMOTHY HURSLEY,
ARKANSAS OFFICE.

*This glorious Gothic Revival houses a collection of modern joys
and amenities* (OPPOSITE AND ABOVE).

THIS HOUSE REVELS IN ITS ECCENTRICITY, but with precedent: the Gothic Revival of nearby houses; American craftsman idiosyncrasies; and the rambling, connected vernacular farm buildings of New England. The house is a fusion of old and new, packing the traditional with a collection of modern volumetric surprises and new spatial relationships. These and the constantly shifting light and views of the interiors and the landscape keep this house good humored, and provide endless entertainment to its many guests.

The home enjoys a high, windswept site on Fishers Island, which has views to the north, across Long Island Sound to the Connecticut shoreline. Approached from the west, it appears as a tribe of connected buildings, a brood of structures surrounding a "mother house." They share a resemblance in their cedar shingle siding, dark gabled roofs, and the abstract stickwork. A porte cochere, created by the extension of the roof of the storage shed over the driveway, leads into a small gravel court where the main house faces a "drunken fence" to the south. The pickets here begin straight and then gradually stumble along. The house's gabled court face has windows that are also gabled, giving some order to their otherwise random placement.

There are six exterior doorways that are protected by roofed gates. Each gate has a variation of the stick design and sits next to the house in its own way. The meandering structures outside only hint at the colliding spaces inside. Here, within taut exterior walls, formally shaped rooms are placed in balanced chaos, shaken like toy blocks in a box. Cylindrical, elliptical, cubical, and rectangular spaces

are comfortable, functional, familiar, and easy to live within. The groupings offer unexpected spatial changes when moving from one room to another and a new landscape view at each doorway.

The circular entry hall leads to many directions. A crooked staircase painted cornflower blue, next to the front door, lets in daylight from above. Farther to the right, a tall hall descends to a tiny circular chamber, then into the rolling ellipse of the living room. This high-ceilinged space is countered with a cornice of stickwork several feet below the ceiling. The rectangular dining room is several steps above the living room. Snug in between the dining room and a square kitchen is a tiny library.

At the top of the stairs on the second floor is a circular antechamber leading to the oval master bedroom. Inside is a gabled alcove that pokes out of the house as the balcony gate, with views north to Long Island Sound. The master bed imitates tree branches. The house blends the designs of nature and the forms of geometry for a lively yet comforting meditation in the landscape.

Seemingly lonely and unfrequented in the muffled fog, the house is in fact eccentric and light in the interior.

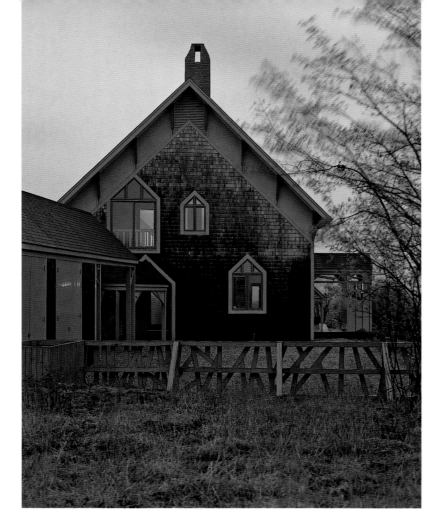

Two of the six roofed gates that protect each of the exterior doorways (**ABOVE**); the long roofed gate at the main entrance nestles into the porte cochere to offer shelter to guests (**RIGHT**).

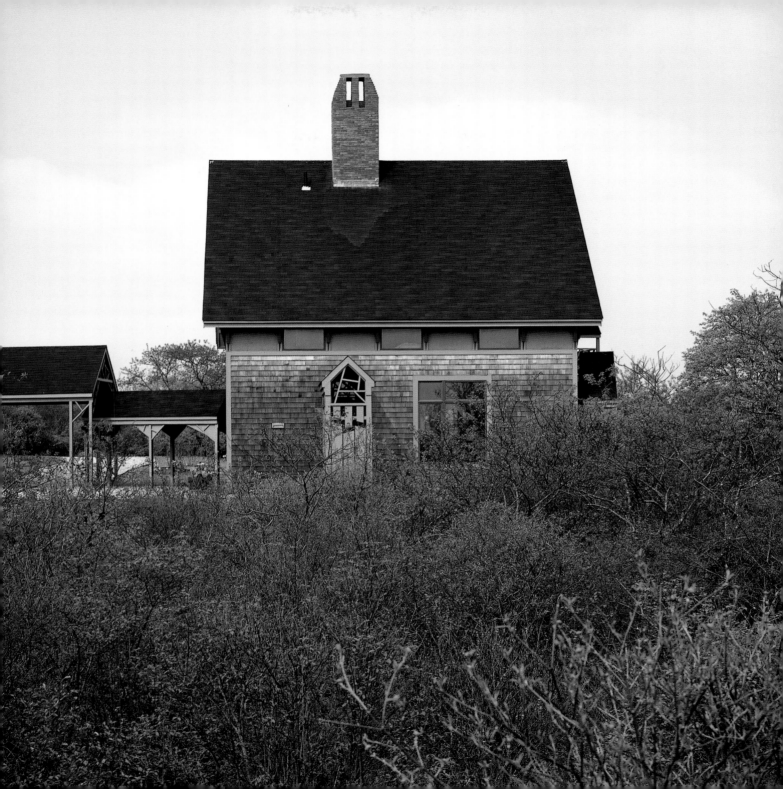

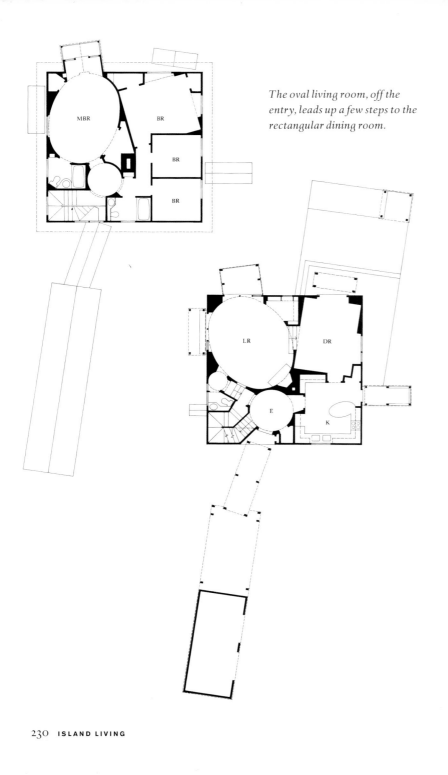

The oval living room, off the entry, leads up a few steps to the rectangular dining room.

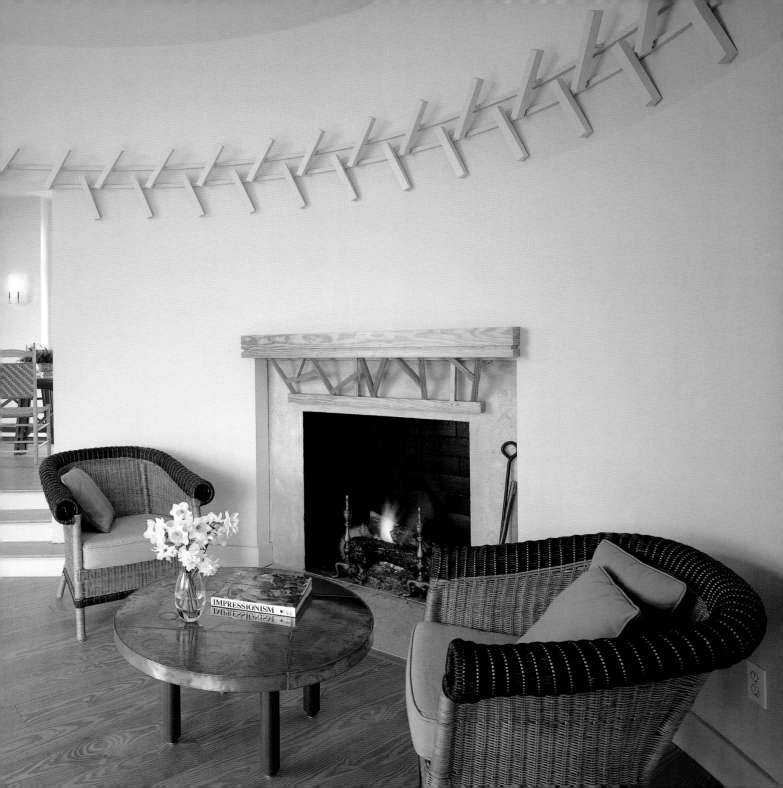

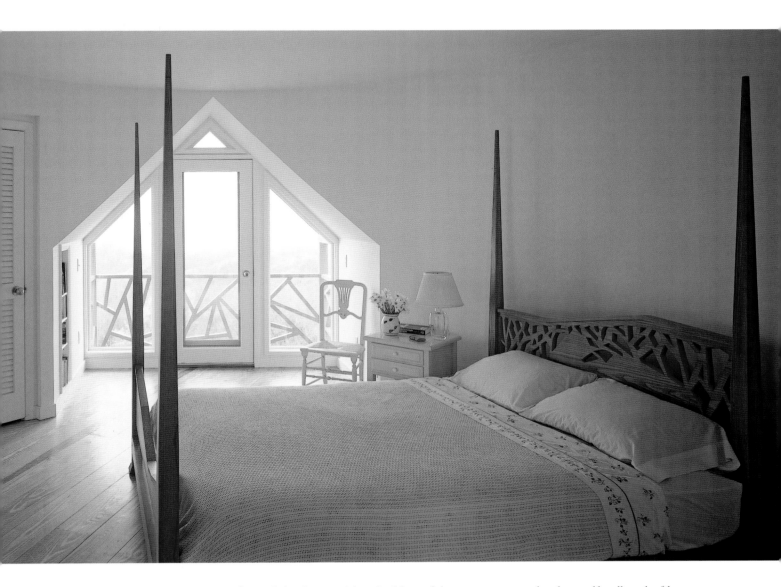

*The dining room opens to a view underneath the abstract stickwork of the roofed gate (**OPPOSITE**); a hand-carved headboard softly mimics the stickwork of the deck rail outside the oval-shaped master bedroom (**ABOVE**).*

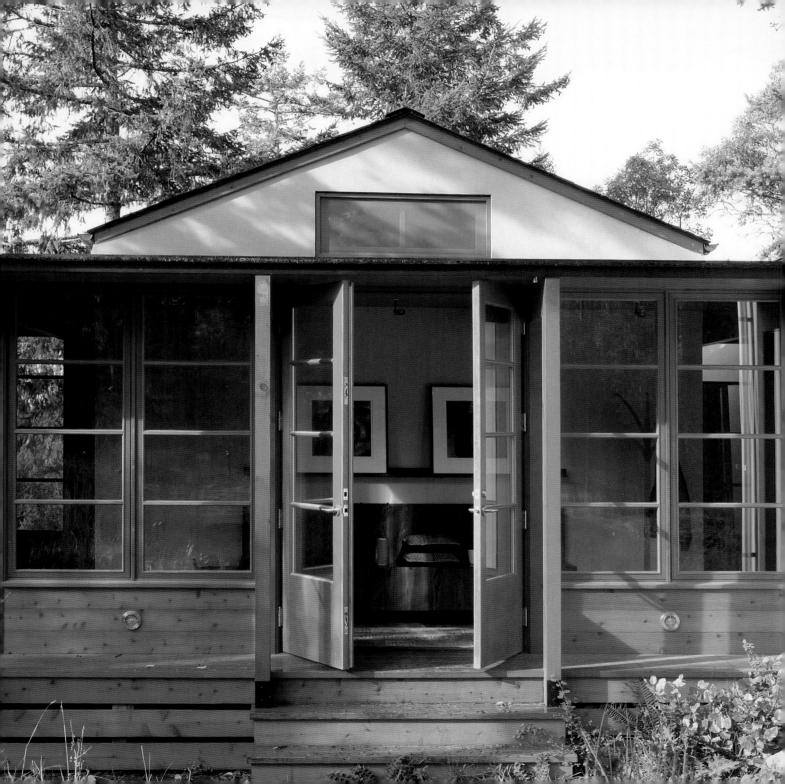

ORCAS ISLAND

A COMPACT AND PERKY DESIGN FEATURES A GALLERY
ENTRANCE, BOLD INTERIORS WITH INTEGRITY, DISTINCTIVE,
SIMPLE MATERIALS, AND WONDERFUL WOOD-FRAME TILT-
OUT WINDOWS IN A LUSH LANDSCAPE. DESIGNED BY DAVID
COLEMAN, DAVID COLEMAN ARCHITECTURE. PHOTOGRAPHS
BY CLAUDIO SANTINI.

*French doors of the main entry lead to the interior of the three
buildings* (OPPOSITE).

THE BUCHTERS WERE LIVING IN CLEVELAND, Ohio,
when they commissioned David Coleman to design
their Orcas Island home. In today's fashion, the entire
programming for the project, including initial meetings,
was handled by telephone. The first time the Buchters
met their architect was when they flew to Seattle to
review the design proposal. They moved to Washington,
where Carol is a cardiologist and Jonathan is the chief
financial officer for the Seattle Monorail, a year after the
house was finished.

This 2,000-square-foot home is located in a 15-acre
woodland, with large, charcoal-glacial boulders clad in
thick, green moss, abstract scrub pine, and captivating
madrona trees. The clients had long envisioned a cluster of
buildings delicately scattered on their land. Staying within
that vision, the architect created a modern rendition of
the "summer camp" concept: sleeping pavilions, a central
room for gatherings, and covered porches. The inspiration
came from turn-of-the-century platform tents and national
park lodges. And in that vein, the design is a discriminating
response to the light and heavy, the permanent and not-so-
permanent natural features of the site. The composition,
siting, and details of the house all reflect the unyielding
quality of a natural ledge and the vulnerable nature of the
adjacent pine forest.

A wide, timber-framed, enclosed glass porch spans
60 feet, providing the ordering element to the site and
offering a connection for the three pavilions. The buildings
are carefully placed atop the glacial field to preserve the
exceptional landscape. Each of the three buildings is posi-
tioned at an angle relative to the others and is oriented to
certain views or unusual features in the landscape. Two of
the pavilions are bedroom suites. The great room is in the

third, with 11-foot-wide barn doors that separate it from the porch. Interiors are finished with materials that again reflect the ruggedness and delicacy of the wildness outdoors. Airy cable lighting in the kitchen is offset by ground-face concrete block and ground-face concrete countertops. A warm, spacious interior literally brushes up against maple leaves that lean on the open windows. This house is perfectly in balance with its environment.

The three separate structures are tucked in and out of the landscape. They are connected by a 60-foot, glass-enclosed, timber-framed entrance porch.

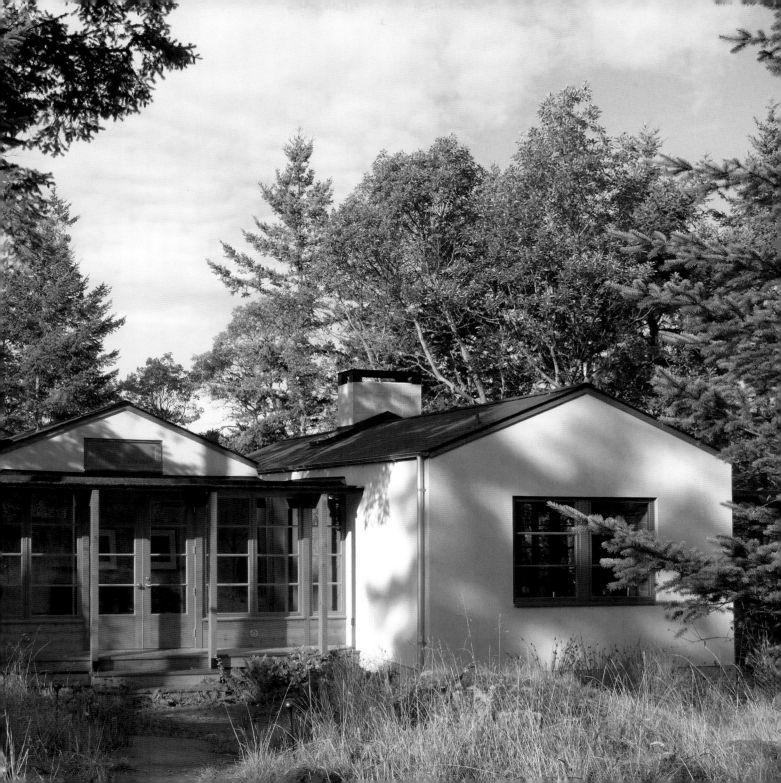

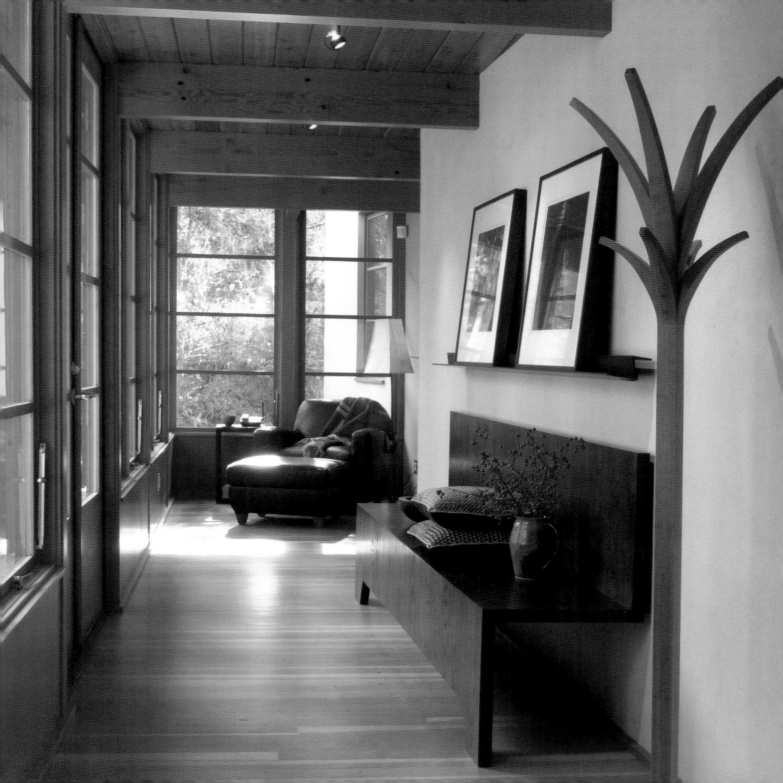

*A comfortable reading niche is tucked into the corner of the entrance hall (**OPPOSITE**); the open, light entry is used as a gallery space (**ABOVE**).*

The view from the kitchen table to the entrance hall on the left and into the living area on the right (**ABOVE**); the view from the opposite side of the kitchen table, facing the area at the opposite end of the entrance hallway, which is a glassed-in sun room (**RIGHT**).

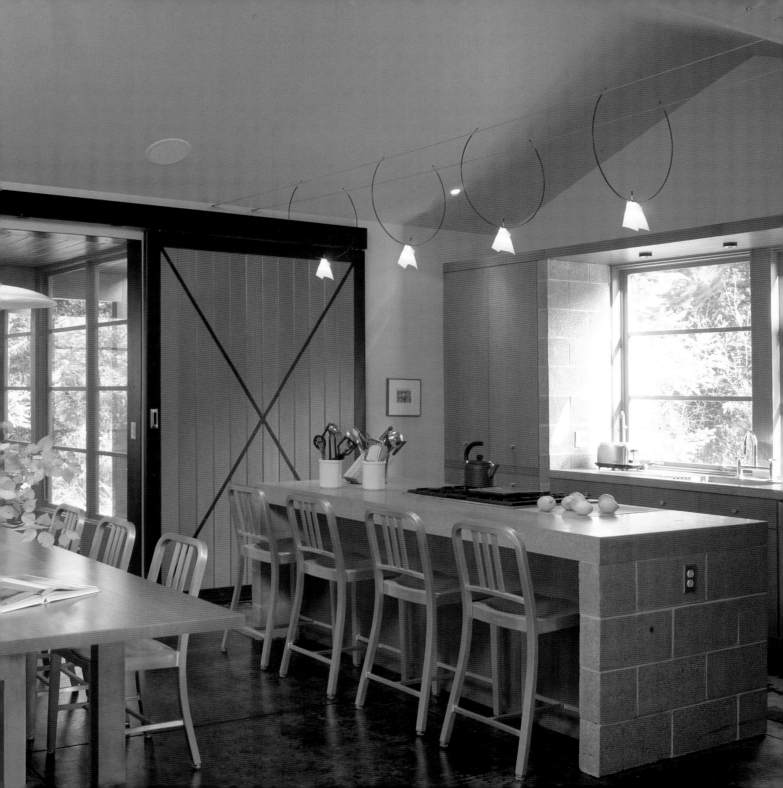

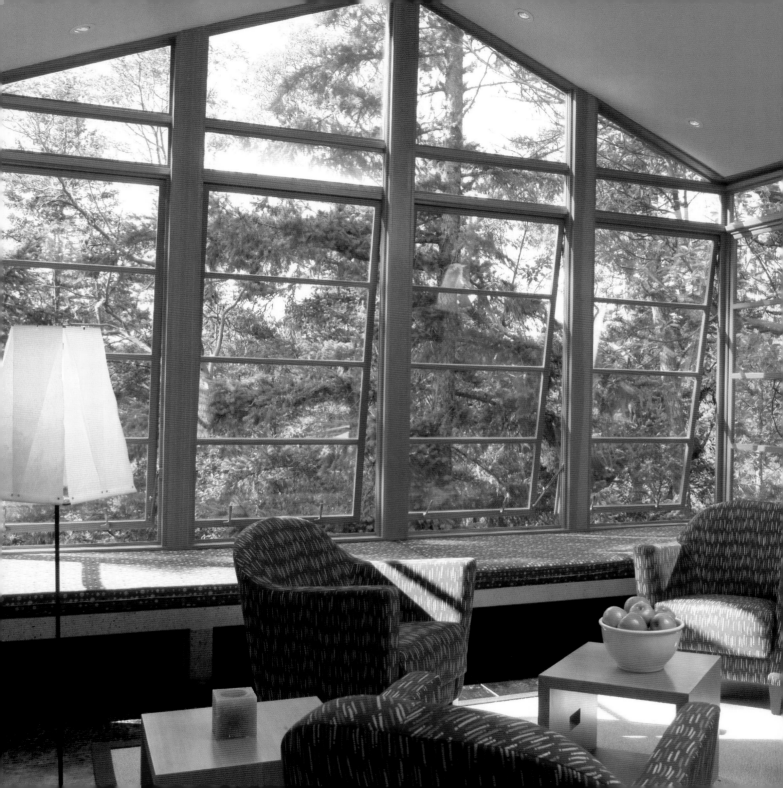

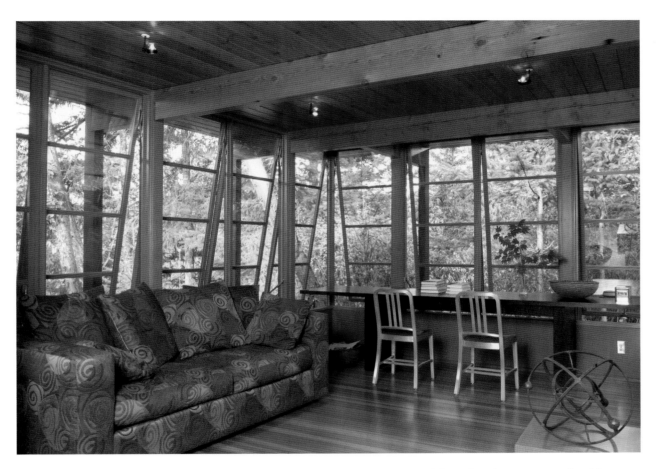

*The living room shows strong architectural features combined with the light tilt-out, wood-framed windows. It can comfortably accommodate a group of 12 to 15 (*OPPOSITE*); a bank of tilt-out windows surrounds the sun room at the end of the entrance hallway (*ABOVE*).*

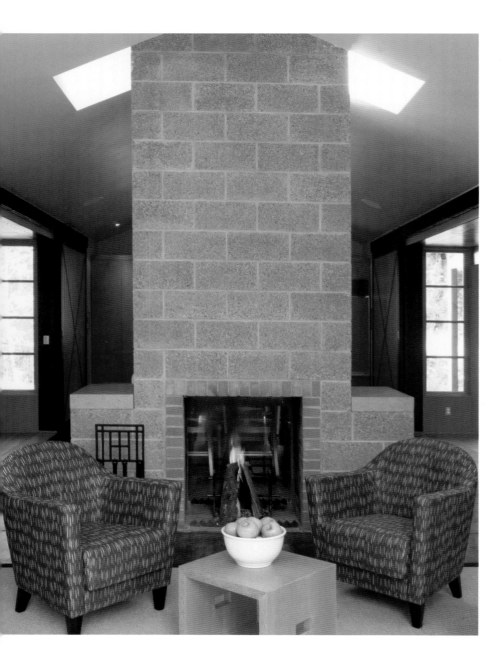

The floor-to-ceiling two-sided Rumsford fireplace of ground-face concrete block and red brick marks the center of the room and soars into skylights, creating a balanced mass, light, and a volumetric composition (**LEFT**); private bedroom suites are contained in two of the separate pavilions (**OPPOSITE**).

NANTUCKET

"SNUG AND SECURE" IS THE WAY THIS ARCHITECT DESCRIBES HIS OWN COTTAGE ON THE COAST. HERE IS A SECURE BERTH FROM WHICH TO ENJOY THE PASSING STORMY WINDS AND WINTER RAINS. DESIGNED BY LYMAN PERRY. PHOTOGRAPHS BY KRISTIN WEBER, BRUCE BUCK PHOTOGRAPHY.

THERE IS A WORLD THAT CONSISTS of nautical ways. Sea captains—men and women who live with salt spray in their faces—discover these ways through a lifetime spent on ships and smaller watercraft. Whenever there is time to spend on land, living within a contained and space-saving cottage is part of carrying out their nautical ways. Often theirs are ways of economy that brew in the soul and manifest in a daily routine of efficient activities. A balance of expertise and prudence always determined success on an island such as Nantucket. Maritime adventure was the underpinning of life there.

It is easy to think that when sea captains and whaling men spent time on land, they would build large houses as an antidote to the confinement of ship's quarters on long voyages. But that was not always so. Seamen's homes often took the shape of small shelters: tidy, compact houses, timber-framed and rectangular. Posts, beams, and rafters were mortised and tenoned together to withstand the force of storms. Lyman Perry, a naval officer, educator, and well-known Philadelphia architect, whose career includes having designed many island homes on Nantucket and elsewhere, has faith in the compact design of his home, about which he writes, "The wind may be blowing 40 to 60 knots, but I am snug and secure and I AM NOT offshore in the tempest. I am on 'my ship at sea,' the island of Nantucket."

The Perrys' "ship at sea" is a one-acre site rustling up against 100 acres of protected landscape flowing toward and ending at the shoreline. As is the tradition of true islanders, fiscal economy was a driving force when the land was purchased in 1979. The house was designed by Lyman

A traditional slope and form from the historical Nantucket whalers' cottages (OPPOSITE).

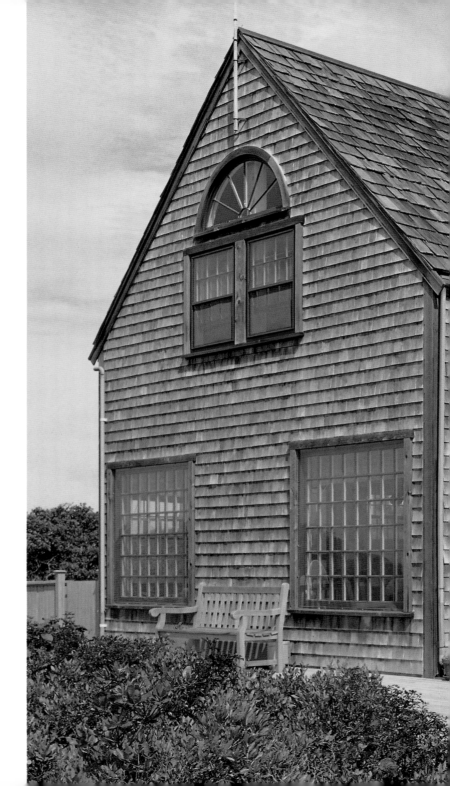

The large living area is clad in cedar shingles to blend into the simplicity of the surrounding landscape. The large living structure is connected by the deck to a studio.

for spatial efficiency, and was even prefabricated to reduce the costs of having building materials transported to the island. Lyman intended to build the smallest house possible with comfort and low maintenance in the style of the island's old whaling houses.

The compact first floor houses the living and dining areas within a 20 x 12-foot space, and an almost square 10 x 9½-foot kitchen. The second floor of the main house is composed of an open staircase that leads to two bedrooms and a bath. A pergola-covered breezeway connects the main level of the house to a guest house that has a bath and a half loft. Minor spatial adjustments in the past 25 years have increased comfort and improved utility amid the beauty of the views: the moors with the water and the town in the distance. Modesty, pride, and satisfaction mingle in the sea breezes as Lyman concludes, "The space and home feels appropriately efficient, small but functional and I am not, in nautical terms, 'over-boated!'"

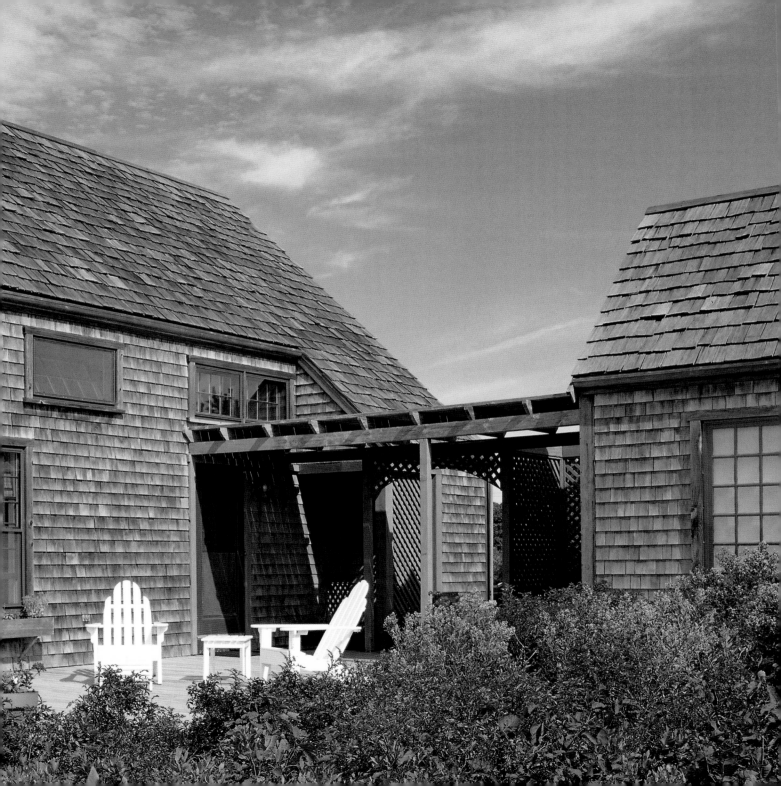

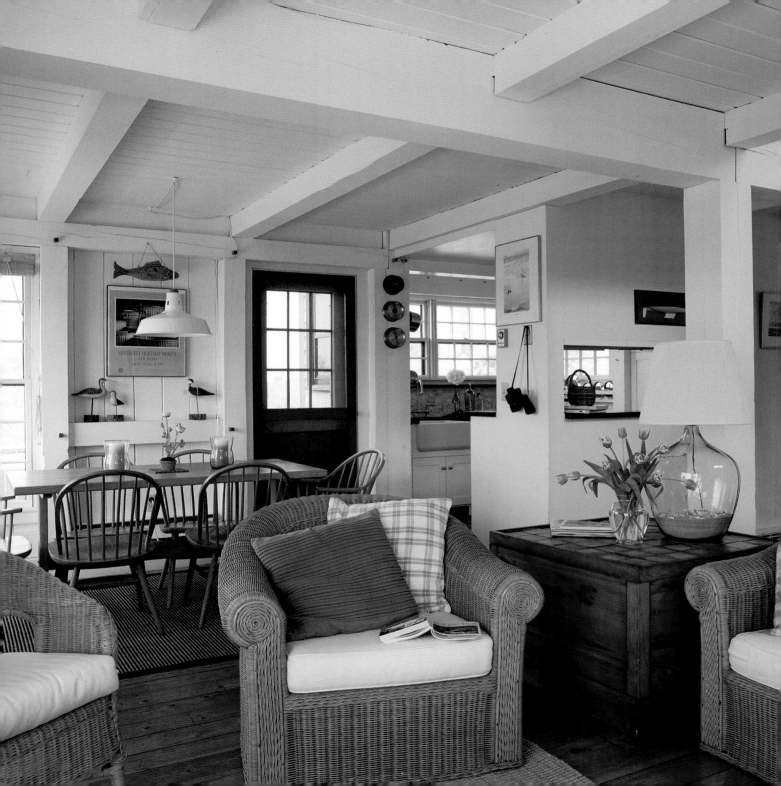

A love for the sea inspired the owner/architect to design the cottage "like an old wooden whaling ship where you can actually see the beams shouldering weight" (**OPPOSITE**); painted white interiors emphasize the heft of the posts and beams. The divided windows are particularly suited to Nantucket's style and protect against heavy winds (**LEFT**); casual comfort is found in a sunny corner (**ABOVE**).

The second-floor master bedroom is bright with light and warm with wood flooring and furniture. The fan-shaped window was custom designed to admit afternoon light and to add visual interest to the room (**ABOVE LEFT**); angular, useful niches are created by the large posts (**ABOVE RIGHT**); the entry is filled with marine and nautical mementos (**OPPOSITE**).

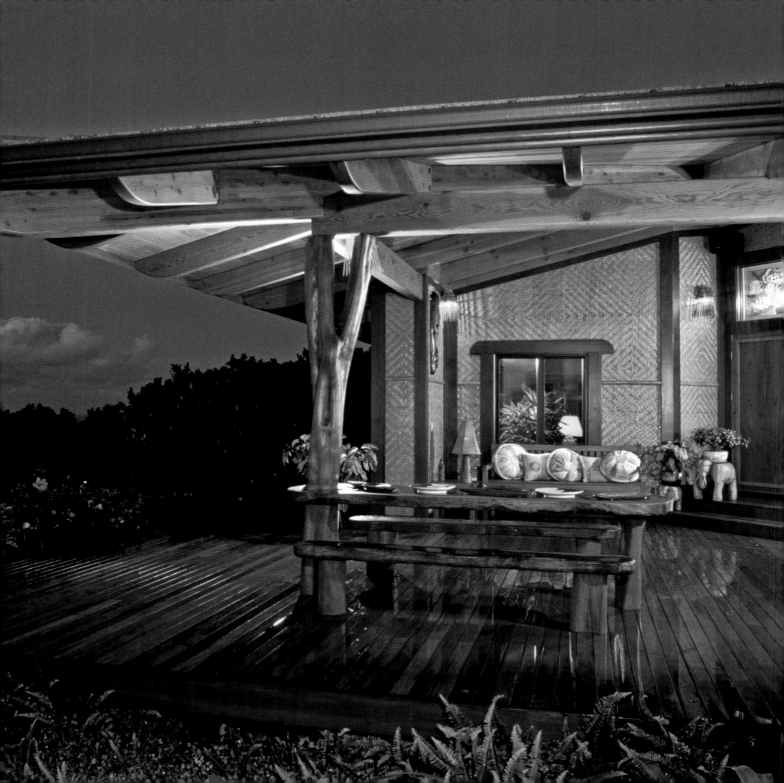

NORTH SHORE

THIS MAUI RESIDENCE EXPRESSES ITS POLYNESIAN
INFLUENCES IN THE EXTERIOR AND INTERIOR SPACES. THE
CEREMONIAL LODGE STYLING OF THE LARGE GREAT ROOM
PAYS HOMAGE TO HAWAIIAN HARDWOODS. DESIGNED
BY JIM NIESS OF THE MAUI ARCHITECTURAL GROUP.
PHOTOGRAPHS BY DAVID WATERSUN.

*A lanai off the central living area is tucked under a broad
overhang. For relaxation or entertaining, a bar at the kitchen
window is on the right; at center is a table for dining* (OPPOSITE);
*A footbridge over a lagoon leads to the main entrance of the
house* (ABOVE).

THIS *PLEIN-AIR* HOUSE is located in rural Maui on the
windward slopes of the 10,023-foot volcano Haleakala.
Lunar and soot-covered, Haleakala has experienced at
least ten eruptions in the past 1,000 years, providing views
to the summit of Haleakala from the house that are super-
natural and rugged: a scene that is scattered with "young"
cinder cones. The nearest town, Pa'ia, and the world-
renowned windsurfing Hoopipa Beach, revered by wind-
surfers from Europe, South America, and the West Coast,
are not far away. In mid-winter, during the birthing season,
whales can be seen with mist geysers spouting from their
nostrils from the front porch.

The North Shore house sits amid 31 acres of
extra-ordinary landscape. Designed in the Polynesian
tradition, the house has been assigned a discrete "pod"
for each individual activity in a family home, and "active"
spaces are placed at a respectful distance from "passive"
spaces. An asymmetry of shapes minimizes the perceived
volume of the three central pods, and a kitchen in the
fourth pod, with adjacent outdoor dining, helps blend
the structures further into their landscape. Open walk-
ways and covered bridges connect the pods and promote
natural cooling throughout the interior and around the
exterior of the house. The main entry is a bridge that
begins outdoors and continues through the front door
to the interior. Open interior spaces with few interior
walls offer a plentiful exchange of light between the
inside and the outside.

The pods are sited to take in the 180-degree views
of the ocean from the great room, master suite, and guest
areas. Natural, managed Hawaiian hardwood is found
throughout the living and leisure areas, where it is used
as columns and posts. Landscaping is sculpted along the

approach and around each pod dwelling: fragrant tropical flowers, colorful flowering shrubs, cocoa palms, and other native plants. A pool is placed at the center of a private, lush landscape on the mountainside of the house and protected from stiff trade winds. This is an island getaway on a getaway island.

The exterior of the great room (showing the lanai at front center) is the central "pod" in the group of structures (ABOVE); *the pool area is reached by taking a roofed walkway from the main house through an enclosure of heavily landscaped, fragrant vegetation* (RIGHT).

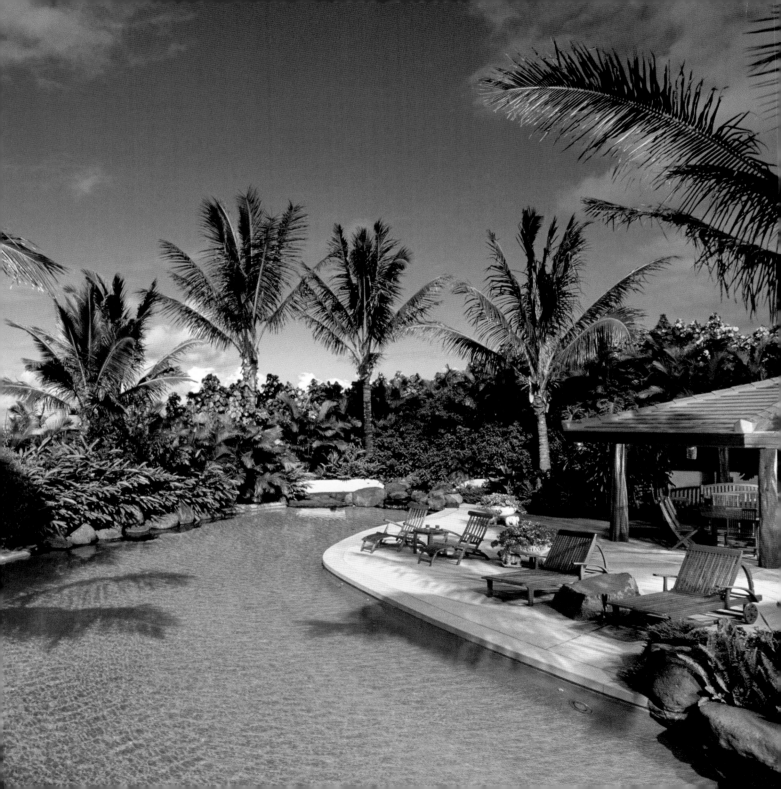

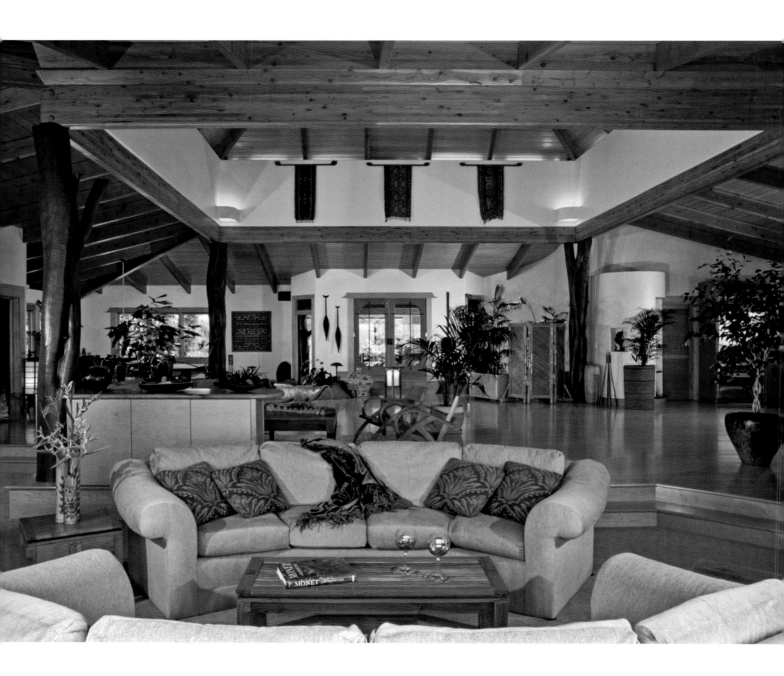

The interior of the great room is spacious, airy, and filled with light; a natural cooling and air circulation system is promoted by the pod design (OPPOSITE); the dining room is part of the great room. The atmosphere is enhanced by the sounds of a lovely water pond that flows into the room from the outside entrance (RIGHT); the master bedroom facing the ocean and views (BELOW).

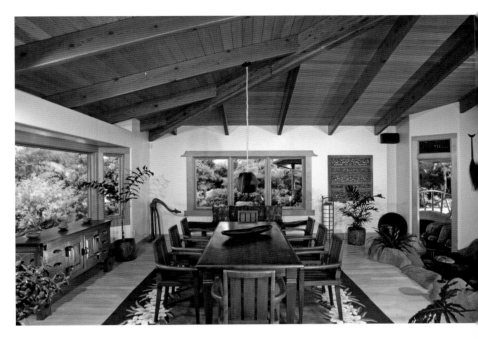

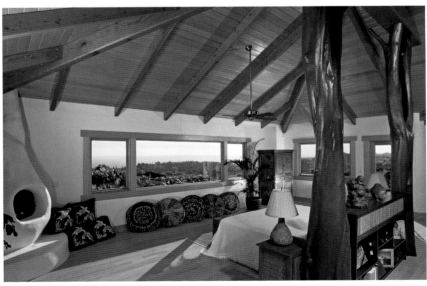

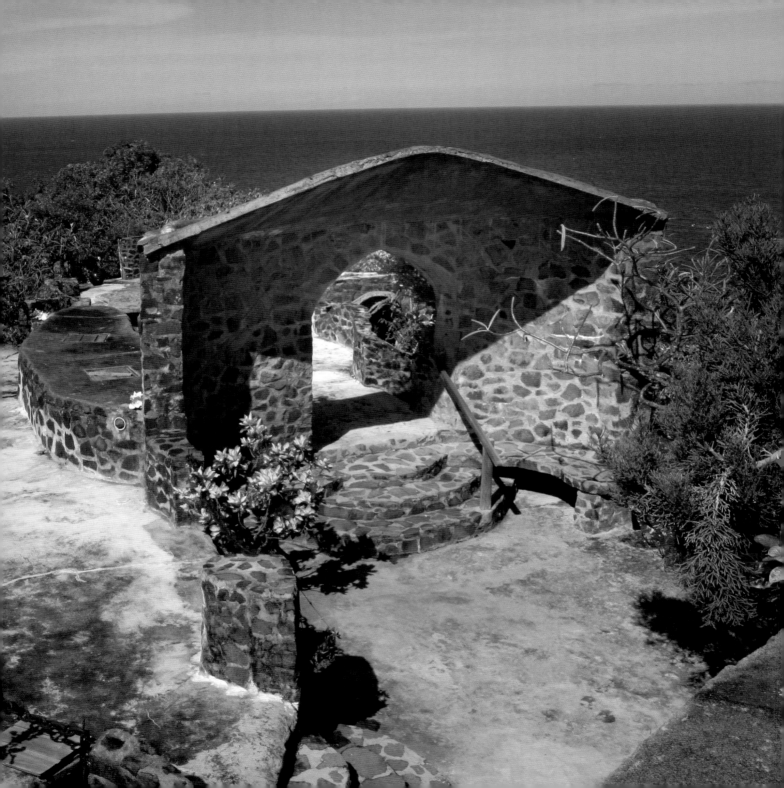

MOONHOLE

ORIGINALLY DESIGNED BY TOM AND GLADYS JOHNSTON, THE
FOUNDERS OF MOONHOLE, THIS ISLAND GETAWAY IS BUILT
INTO THE SIDE OF A CLIFF IN THE GRENADINES FOR PLEASURE
AND FANCY. PHOTOGRAPHS BY JOHN DIMAIO.

*Atop the island of Bequia, this stone terrace is a perfect site for
dinner parties, picnics, or a reading getaway* (**OPPOSITE**); *an
iron moon-shaped "door-bell" is placed near the entrance to signal
that visitors are on the path* (**ABOVE**).

THE GRENADINES ARE A TROPICAL archipelago in
the eastern Caribbean. Anchored in the south by the large
island of Grenada, the leeward Grenadines form a shallow
crescent to the northeast that includes Union Island, the
Tobago Cays, Canouan, Mustique, and other, smaller
islands, culminating with the largest island of the group,
Bequia, at the northern tip. Bequia is the home of a unique
group of dwellings that were first built in the 1960s, when
an advertising executive named Tom Johnston convinced
his wife, Gladys, that they could leave their professions and
live a wonderful life on the island.

A high, rugged stone formation that rises from the
water and arches over a natural cliffside path is called
"Moonhole." Tom fell in love with Moonhole and bought
20 acres surrounding the formation. He thought he would

The coast of Bequia and the sea lie below the house and the terraces, visible on the right.

clear a small area for picnicking—his plan was to carve and lay stone steps leading to a small patio. In no time, Gladys and Tom found themselves living amid Moonhole rocks. Partial bedrooms, floors, and even a kitchen area began to take shape. As the story goes, a rock fell from his beloved Moonhole arch onto his bed. Undaunted, he moved to another site and started a new house. Over time the stone arches and patios, terraces and walkways—rooms that were open to the air—began to expand and other dwellings evolved. Now there are almost 20 residences on the Moonhole land, and though Tom passed away four years ago, his free spirit reigns.

Paul Buettner owns a Moonhole dwelling on the top of Bequia. His house is at the highest point on the island, and its roof-top stone garden has a 360-degree view. Reading the stones of Moonhole is equivalent to reading the cliff dwellings of the ancient Anasazi in the southwestern United States. Few places are more simple, or as sophisticated.

The compound of dwellings is environmentally predisposed: rainwater is collected in cisterns and solar energy is used to generate electricity. Propane is used for cooking. Air conditioning is a part of the design, using covered stone pathways and open-air windows. The native stone floors and walls are solar collectors, maintaining steady temperatures during the day and releasing heat throughout the night. Nothing could be more beautiful.

The rising moon can often be seen through this hole in the rock formations, giving the location its name (**OPPOSITE**); *a covered stone path separates the dining room on the right and the master bedroom on the left* (**LEFT**); *a stone path and stone bench lead through the forest* (**ABOVE**); *the simplicity and beauty of an idyll is complete* (**BELOW**).

Interiors are always cool and breezy. Benches covered in brightly colored cushions and a large table create an ever-ready party space (**ABOVE**); the opposite side of the level that is open to the sea is a dining room, with stone benches, a wood table, chairs, end tables, and tropical foliage (**RIGHT**).

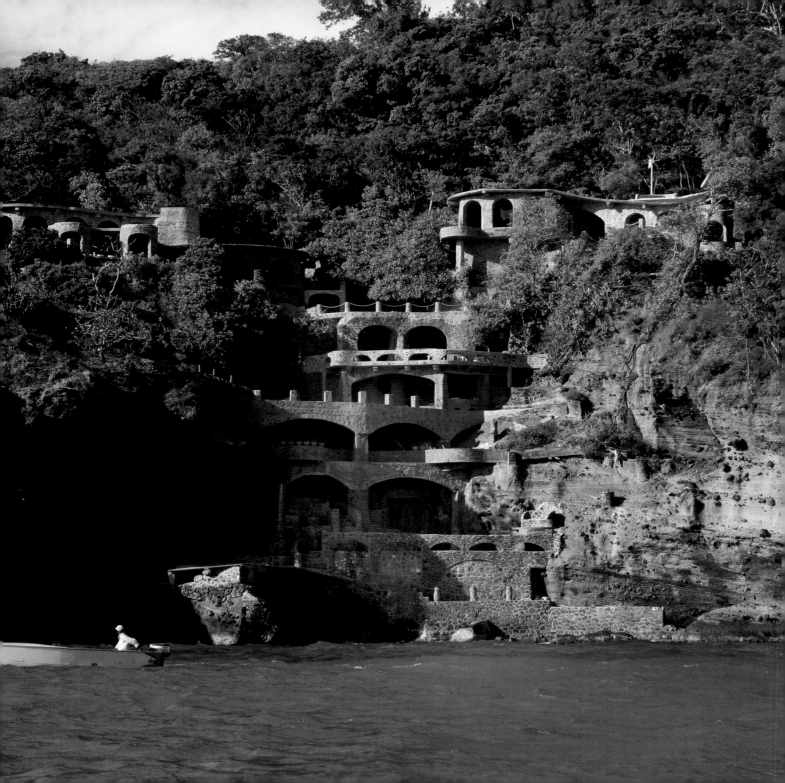

RAVINE LANDING

THE LOVELY TROPICAL ARCHIPELAGO IN THE EASTERN CARIBBEAN GRENADINES OFFERED ARCHITECT CHARLES BREWER, AMONG OTHERS, THE DREAM OF RESTORING THIS TOM JOHNSTON–DESIGNED RETREAT FOR HIMSELF AND HIS WIFE, CORNELIA BREWER. PHOTOGRAPHS BY JOHN DIMAIO.

CHARLES AND CORNELIA BREWER, a brave-hearted couple in active retirement, purchased one of Tom Johnston's Moonhole dwellings five years ago. The house had been abandoned for some time during the past 30 years and was derelict when the Brewers decided to buy it and begin a courageous tropical enterprise. Charles, an architect, knew the sort of work the place required: subtracting and adding spaces, trying always to honor the spirit of Tom Johnston's work without replication. Many years of sun and surf had pounded the site until concrete beams were crumbling and falling into the sea. Remnants of the original design, trees and natural rock still in place, had become a ruin.

Charles and Cornelia set to the restoration and renovation project. They started with the rebuilding of beams and roofs and began deciding where they would add new spaces. This was one of Johnston's more adventurous designs, rising from the water up into the sides of the rock cliff and into the hillside. Not to mention there are no straight lines in the "design" and the dwelling is open to the sea on every level. Charles managed to get a generator to power a few tools to begin the project, as there is no electrical current at Moonhole.

*Not far from the top of the island is the Brewer house, built up from the shore. From the water up is the pool area; two levels above that is the living area. Above and on the right is the master suite, and up on the left is the guest suite (**OPPOSITE**); A Caribbean sun filters through Japanese glass fishing floats to give a soft and harmonious color to the door surround (**ABOVE**).*

Lanterns light the way at dusk under the deliciously scented frangipani tree (**LEFT**); *this extraordinary seawater pool combines the sea, a hidden beach, and a private island dream* (**RIGHT**).

"step back." Johnston supervised every inch of Moonhole's development and construction. He once told Charles that he had made only one mistake and that had been rectified by a bolt of lighting.

The intense renovation of 90 percent of the Ravine Landing dwelling included rebuilding terraces, guest rooms, the swimming pool and platform, and the sea wall. The details created by Charles and Cornelia are well-designed accents such as soft arches and small hardwood drawers and closets. Stonework in the master bedroom is as beautiful as Frank Lloyd Wright's recipe for "desert concrete." Every nook and niche is put to use. Benches and couches are built in.

At sea level is an extraordinary seawater swimming pool separated from the ocean by a wall of stone arches. The pool's organic shape feels as though it is a large tidal pool on the beach. A lookout area can be reached only by swimming across the pool. Other charming follies express the lively imaginations fired by the freedom of a team that lives on the edge. Below are white sand beaches against the tropical blue ocean. Eight miles off the terrace, the islands of Mustique and Petite Mustique are visible.

Charles and Cornelia love their grotto. Always looking for the chance to make a minor adjustment here or there, they enjoy the evolution of architecture in flux.

The founder's basic convenants for Moonhole included the use of only indigenous island materials; all structures to be integrated into the site; a minimum disturbance of the land; no straight lines, nothing to destroy the natural ambiance; no engine noise, telephone poles, garish paint, or reflective surfaces. Originally no windows were allowed. Fresh water was to be collected from roofs and stored. When asked what to do when it rained, Johnston replied

A living room is complete when its furnishings include a chess set, a couch in a grotto, and a whalebone coffee table (**LEFT**); *the open-air vanity in the guest bath has views to Mustique on the left and Petite Mustique on the right* (**TOP**); *the master suite is designed for the comfort of a reinvigorating, cool night's sleep* (**ABOVE**).

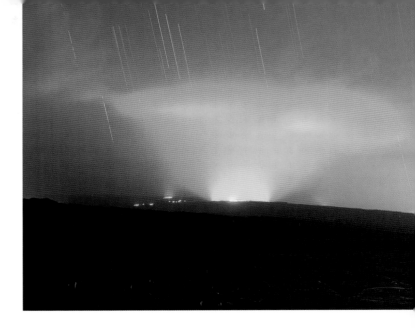

LAVA FLOW

ON THE BARREN COLD LAVA FIELD OF BEAUTIFUL HAWAII, A
NEW LANDSCAPE HAS BEEN CULTIVATED AROUND A DESIGN
MEANT TO FRAME THESE OTHERWORLDLY VISTAS. DESIGNED
BY CRAIG STEELY. PHOTOGRAPHS BY J.D. PETERSON.

DESIGNER ROBERT TRICKEY FIRST SAW the "intense
otherworldly beauty" of the lava flow landscape and
decided to build his contemporary modernist house on
the rocks. The site is located near Kilauea caldera on the
eastern side of Hawaii's Big Island. Down slope from the
ridge called the East Rift Zone, a large crack caused by
and connected to the volcano's movements runs from
the crater to the west, all the way to the deep sea in the far
northeast. Lava can travel sideways through the crack and
escape at any weak spot on its way toward the ocean. The
lava flow on which Robert's house is built occurred in
1955, an enormous event that escaped the rift zone in
five locations. A similar occurance could happen tomor-
row, or perhaps in 150 years.

There are no zoning regulations preventing construc-
tion from taking place on the lava flow. The site borders an

*Lava fields are home to new growth over time. Life is beginning
to emerge from both nature and man after the 1955 eruption of
the volcano at Kilauea (OPPOSITE); the distant glow of super-
heated lava glistens against streaks of falling rain as it flows into
the ocean (ABOVE).*

eight-mile section of the flow that is state-owned and will
never be developed, so his privacy is assured. He is in love
with the lavascape, especially with the white stuff that
grows on the lava and looks like snow, but is actually called
lichen (or *Limu-o-Pele*, which means Pele's algae or Pele's
snow, Pele being the goddess of the volcano).

Robert's concept was to have the house frame the
lava field. Craig designed it so that upon arrival, visitors
see the house visually float above the lava field. One climbs
a concrete stair onto a plateau of cut lava rock. From this
vantage point the house is visible sitting behind a pool,
framing the lava and sky with structure and line. From
there a bridge crosses the pool to the lanai.

The design of the house is essentially two boxes. The
lower, more transparent box is the space that houses the
lanai and living rooms, kitchen, dining, and guest room.
The upper box is the master suite, which is a long tube with
glass at each end. The east-end windows have views of the
sunrise and the lava flow; the west end views the plume of
steam where the hot flow enters the ocean, the sunset, and,

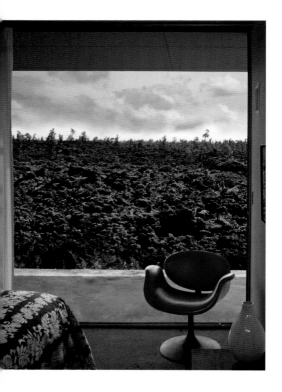

The view is otherworldly in the landscape outside Robert's bedroom (**LEFT**); *at the center of a field of lava, the sense of adventure and composure permeate the house* (**RIGHT**); *the cold, barren lava flow cradles the impulses of the architect's vision of modernity.* (**FOLLOWING PAGES 278–279**).

at night, the startling view of the hot red and white lava reflected from the bottom of the clouds above the caldera, back down to the earth.

Robert reserved much of the design work for himself and his own time frame. He designed the interior furniture and lighting plans. His work also includes the built-in case goods such as the mango and steel interior staircase. Robert selected all the finish details and the materials. The project is the result of the innovative collaboration between owner and architect.

Fifty years have passed since the lava flow emerged. Robert watches over Pele's snow as it turns into soil. He waits for tiny fern starts to take hold. Soon ohia trees, sacred to Pele, will get their footing, clinging to the lava rocks with their tiny hairlike roots. Robert notes the multitudes of insects, birds, lizards, mice, and every evolutionary creature that makes its home in the crevices of stone. Robert named his new home *Pohakunani*, "the Beautiful Rocks."

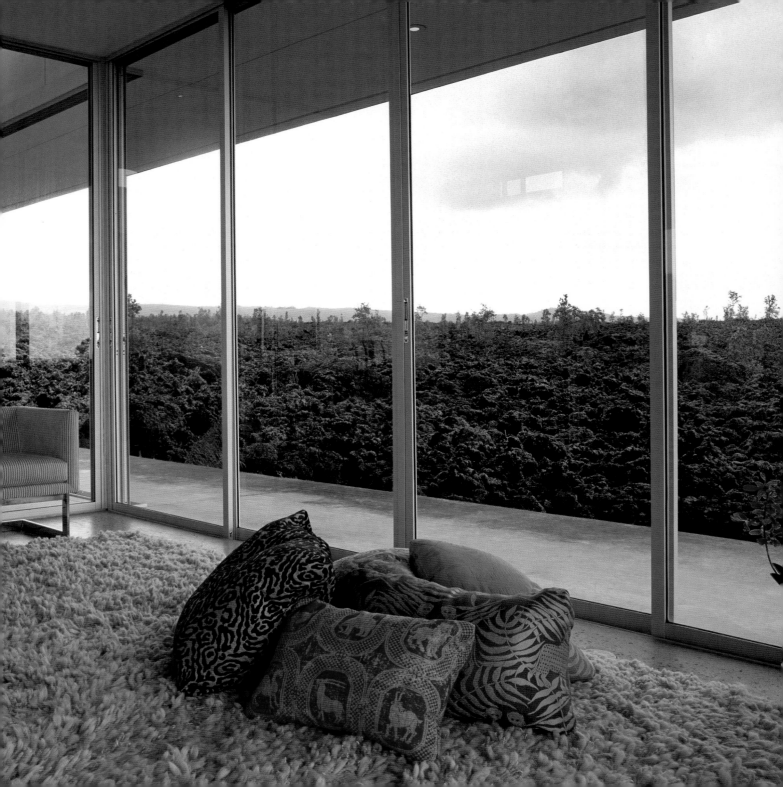

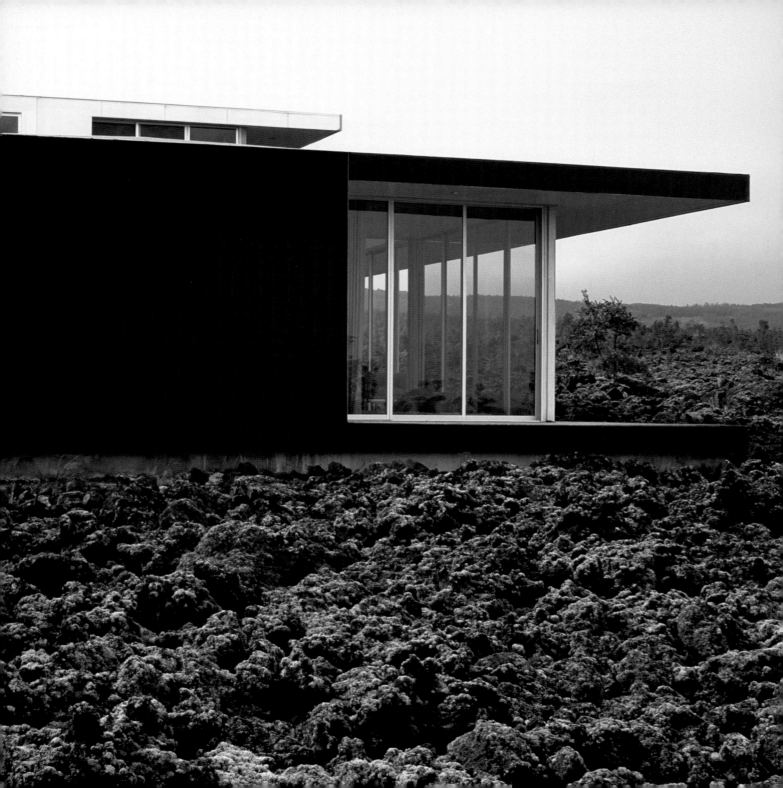

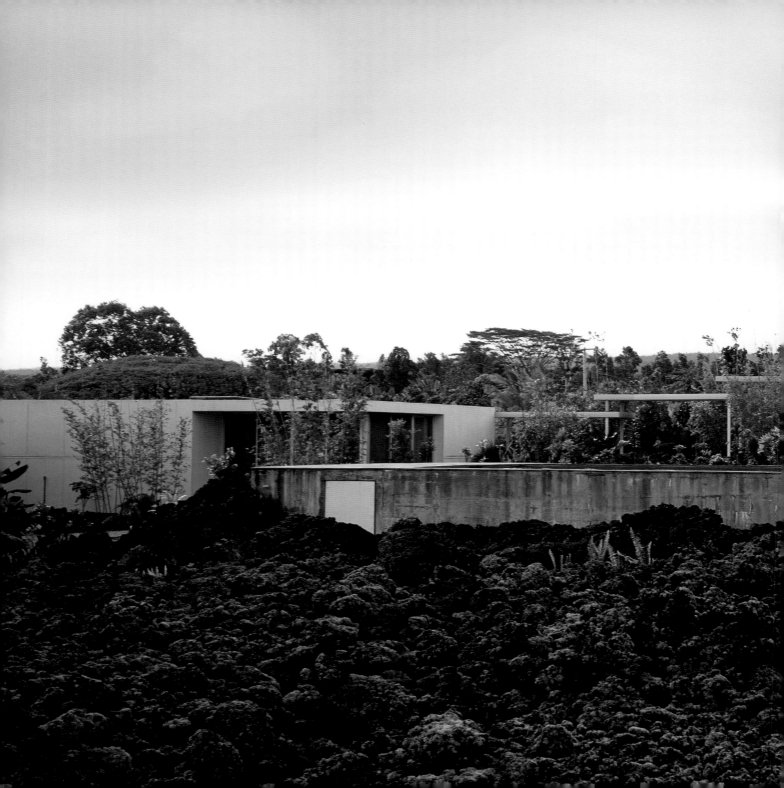

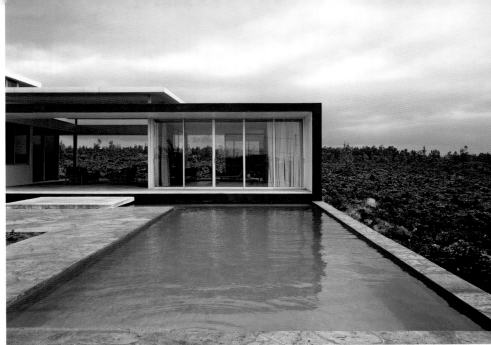

The house and a studio are separated by a large lanai. At night, from the lanai, the red glow of Kilauea crater is visible and is reflected by the underbody of low hanging clouds (**LEFT**); the lower, more transparent form contains the lanai, living room, kitchen, dining room, and a guest room. It is clad in black glass, which reflects the lava (**ABOVE**); just outside the living room is a compact lanai, perfect for a swimmer's launch into the pool (**RIGHT**).

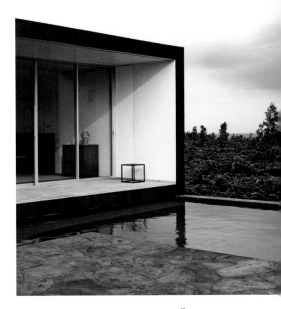

LAKESIDE
LIVING

INTRODUCTION

"Each day a new situation, chosen at pleasure; a neat, commodious house, built and furnished with all necessaries, in less than a quarter of an hour, with a pavement of flowers springing up on a carpet of the most beautiful green; on all sides simple and natural beauties, unadulterated and inimitable by any art." [1] —CHARLEVOIX, *DESCRIPTION OF A VOYAGE TO THE DETROIT OF LAKE ERIE*, 1721

ARCHITECTURE IS AS ORGANIC to the Great Lakes region as are morels, or fish. The region is vast, stippled by lakes uncountable and rivers that bind marshes and canals to each other. Lake water is fresh and clear enough to swim in with your eyes open. That may not seem remarkable, but try it in a swimming pool or an ocean. Architecture in the region is the process of building with one's eyes open. It rises from under fallen leaves, persists in the sandy dunes, and hangs over the edges of quarries and docks. Discussions about architecture in the Great Lakes region are a joy. Excerpts from a recent conversation with a new acquaintance follow:

DAVID: It would be difficult to talk about design in the Midwest without talking about Cranbrook, the broad spectrum of design instruction there, and the support for innovation and rigorous discovery. Both Eliel Saarinen and his son Eero were deeply involved in Cranbrook: Eliel became president of the academy. It was Eliel who was responsible for attracting Eero and Charles Eames as teachers. Intrinsic to the school is an ethic of "Making," which is evident in its approach to craftsmanship and furniture design. This, too, is in line with the Bauhaus ethic of Making, where artist, craftsman, and architect work together. Mies and Gropius came out of the Bauhaus, form-follows-function hard line. European modernists like them were fascinated by American grain elevators and warehouses.

LINDA: I am surprised that your first thought about Great Lakes architecture and design is of Cranbrook. I think of Frank Lloyd Wright as the pervasive influence of the region. By the time the Saarinen contributions of Beaux Arts *qua* Arts Nouveau aesthetic were emerging in the United States, Wright had already passed through the Prairie style—the Robie House, Wright's last Prairie house, was built in Chicago in 1908.

DAVID: Oh, you certainly couldn't breathe without the aura of Frank Lloyd Wright. He is the shining star and the enigma all rolled into one.

LINDA: . . . and one who finally gave us all a definition, an image-object, for the word "prairie." Here, let me read you something he wrote. "As a boy, I had learned to know the ground-plan of the region in every line and feature. For me now its elevation is the modeling of the hills, the weaving and fabric that clings to them, the look of it all in tender green or covered with snow or in the full glow of summer that bursts into the glorious blaze of autumn. I still feel myself as much a part of it as the trees and the birds and bees are, and the red barns." [2] Wright had his early design influences, the shingle styles of the day, and [Louis] Sullivan's "organic architecture," which originated in nineteenth-century European theories of evolution and genius. The design kernel in the Great Lakes region unfolded in a conflation of sources, includ-

ing an agricultural and industrial utility, as well as immigrants, who were infused with a heritage of European craftsmanship, and eager to achieve success. Originally, the Sheboygan Union Iron and Steel Foundry— purchased by John Michael Kohler, an Austrian immigrant—produced cast iron and steel tools for farming; Kohler later developed casings for furniture factories, then expanded to garden furniture, settees, and urns. The young Kohler had a great idea to improve his customers' quality of life when in circa 1883 he experimented with an application of a baked enamel coating on a horse trough/hog scalder and created the company's first bathtub. The early Kohler Company is a variation of what later emerged in the Bauhaus under Gropius as the *vorkurs*, a type of laboratory where success was measured by artists, craftsmen, and architects (often engineers) who worked together using form, color, and industrial products fused with practicality. What I am trying to work out is the adaptation from the farm vernacular to modern design and why the Great Lakes region so readily accepted modernism. Was it because their farming vernacular was the essence of a "form follows function" methodology?

DAVID: If that were strictly the case, Oklahoma, Kansas, and Nebraska would also be hotbeds of modernism. There is something else in the puzzle . . . but the expedience of design and the simple use of materials is definitely Prairie School, definitely agrarian based. The presence of an abundance of good quality wood and consequently, good craftsmen, does play a role. The Great Lakes basin built Chicago in white pine and oak, then built it again after the 1871 fire. Having that material and those craftsmen

around as a baseline resource played a role and raised design expectations. Yes, mass production, the auto industry, and even leisure have contributed to the mix. Who could enjoy the lake without a boat? Many of the lake boats are works of art in themselves.

LINDA: Indeed. I think everyone, from architect to carpenter, envies the boat-builder. What could be better than *virtuous* design: graceful, tight, and sturdy construction? Boats conquer; the simpler they are, the better.

You did touch on a point, though, one I've been thinking about as connected to the great Midwest architects. The architecture changed as social styles changed: the horse-trough became the enamel-coated bathtub, which then needed a place or a room of its own in the simple farmhouse, etc. That is not to say that there were not luxurious homes in the region. There was such a large variety of styles and influences in architecture that one critic in the 1930s described the region as having a "battle of the styles." [3] Those weren't indigenous; they did not abide by the inherent forces of topography, climate, and adaptation. In spite of the early clash of styles, Great Lakes architecture is now the geographical *locus* of modern architecture in the western hemisphere. What developed here could not have happened elsewhere—it is a product of its locality and the convergence of influences brought upon it *in that locale*. It would be difficult to attempt to transplant these designs with success. They are not only contingent upon the climatic, architectural, and aesthetic influences, but upon the material resources—stone and wood, and following that, steel and glass. We may find displaced versions of them elsewhere, but this is where they belong, with the morels and the fish.

ENDNOTES
1. Jerry Dennis. *The Living Great Lakes: Searching for the Heart of the Inland Seas* (New York: Thomas Dunne Books, 2003), p. 87.
2. *Frank Lloyd Wright: An Autobiography*, first ed. (New York: Longmans, Green and Co., 1932).
3. Rexford Newcomb, *Outlines of the History of Architecture* IV (New York, 1939), p. 126.

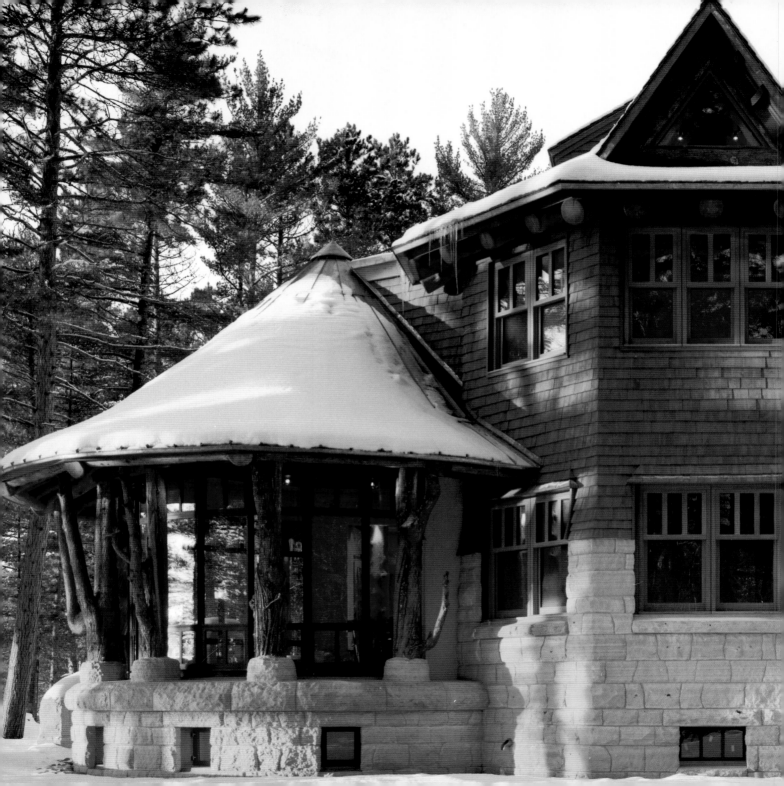

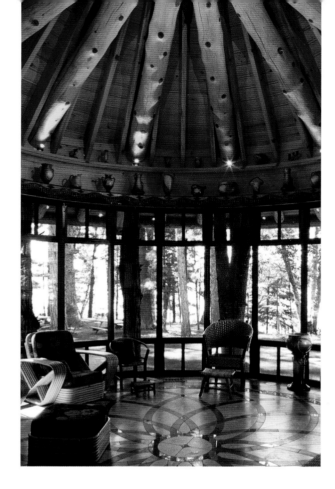

The snow-covered lodge rotunda features stone and tree columns. It was designed in the style of the lodges of the National Parks Service (OPPOSITE); the architectural emotion of the rotunda is generated by the circular beam construction of the high ceiling and the 180-degree views of the lake through the trees (LEFT).

THIS HOME IN NORTHERN WISCONSIN, amid days of cooling air and the scent of a freshwater lake nearby, is a collaboration between the owner and the architect that has been in progress for over a decade. What began as a pair of run-down cottages is being transformed into a collection of lively structures, now numbering four or five, both new and restored, and with more on the way. This is a remote part of Wisconsin, forgotten for decades after the treasure of its timber had been decimated. A few stalwart outdoorsmen would occasionally trek into the area, until finally it has reemerged as a pristine landscape, showing nothing of its spoiled past.

The first project was a renovation of an old boat-house. It was anchored to the land and extended a little over the water. The setting was too beautiful, however, to let an opportunity pass for a restoration befitting a cottage on a placid lake shore. The boathouse below, now clad in river rock, supports an upper dwelling of rustic character. The living quarters are surrounded by a strolling deck with rails of small branches in the Adirondack stick style.

BAER LODGE

THE TOUCH OF A HAND IS FOUND IN EVERY PART OF THIS LAKESIDE RETREAT CONCEIVED IN THE STYLE OF THE NATIONAL PARKS SERVICE LODGES. FROM THE INTRICATE CHANDELIERS AND PATTERNED MARBLE FLOORING IN THE LODGE, TO THE HANDRAILS IN THE RESTORED WORKSHOP, CRAFTSMANSHIP IS THE FOCUS. DESIGN AND PHOTOGRAPHS BY DOUGLAS KOZEL.

The interior is designed around a massive river rock fireplace and chimney, which carefully delineate the dining from the living area. The windows in the front of the cottage provide views of the water in a 180-degree setting. The stone chimney towers up the upper-level sleeping loft and through the roof. The sloping roof, with its large eyebrow windows, seems to wink at the passing boats as they return after a busy day on the water. The boathouse has an extraordinary relationship with the lake; visual, aural, and olfactory senses combine the coniferous aroma of the forest floor, the crystal scents of the freshwater lake, and the oils of the wood shingles—all of which conspire to create a Wisconsin-aroma recipe for northern woods health.

The owners' love of boats is obvious when the buildings in which to repair and house them are objects of desire themselves. A growing collection of meticulously crafted, small, vintage wooden boats called for such a place. The structure is of wood framing and sheathing materials selectively harvested from trees on the owner's property. The building is 35 x 37 feet and is hunkered down due to a graceful upsweep of the roof, which shelters arched windows with views out into the trees. The undulating roof framing reflects the spirit of the construction of the wooden boats.

Among the crafted collection of buildings rises the lakeside residence for an extended family. The construction is a combination of load-bearing masonry, wood framing, and timber framing. All wood framing, including the timber columns, was harvested on the property. Most of the materials traveled no more than a few miles to reach the site. There is a two-story main hall with smaller rooms positioned at the corners, where each extends out toward the lake and the forest. The lodge itself was inspired by the great lodges of the National Parks, thus the commanding central hall at its heart. Local craftsmen created much of the project, and certain pieces of work were designed around their particular skills. The beauty of craft specificity can be seen in the ironwork, the timber columns, the Adirondack sticking, and the material finishes.

The central hall was designed for use as both a gathering place and a system of natural ventilation; the windows were positioned not only for the view, but for ventilation using convection and the clerestory windows placed above.

A collection of vintage "old hickory" furnishings from now-defunct resorts and an extensive collection of early-twentieth-century ceramic vases decorate and add a homey familiarity to this marvelous family lodge. The couple, who adore their collections and enjoy providing unique homes for them, is about to embark upon the creation of a collection of follies in the woods: an elevated tree walk with tree houses and nature lookouts. This is a family compound where everyone will be amused for a lifetime.

A stone chimney towers through the gathering place of the great hall, passing the second-floor sleeping lofts.

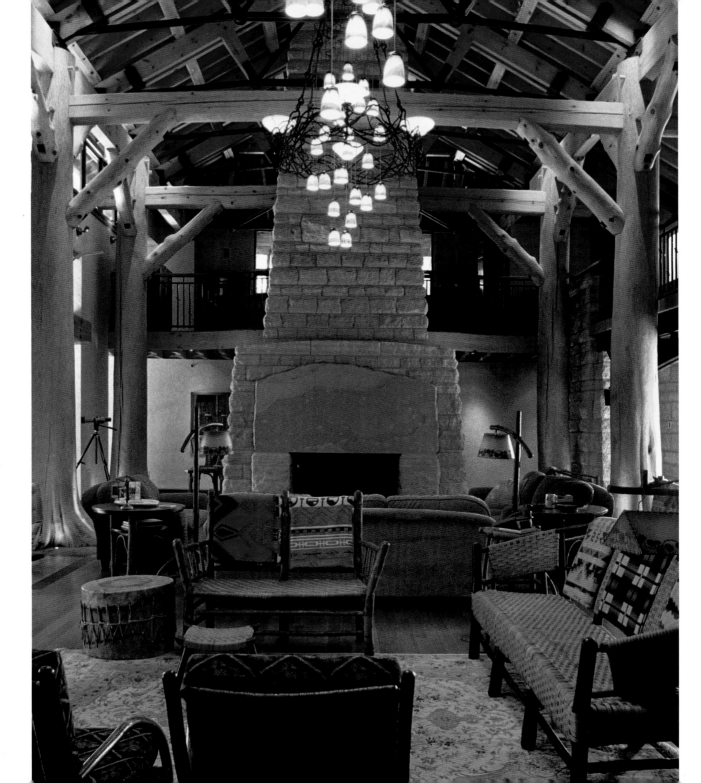

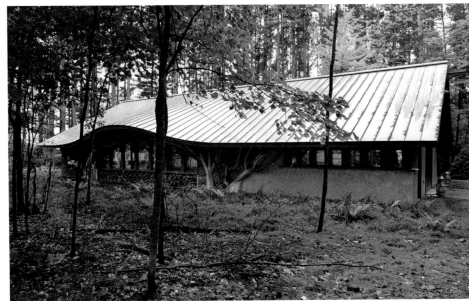

Intricate cedar-sticking detailing sets off the window framing as a complement to the crafted boats inside (LEFT); a structure for the storage of vintage wooden boats was designed with an undulating roof to open up the walls to the surrounding landscape (ABOVE).

 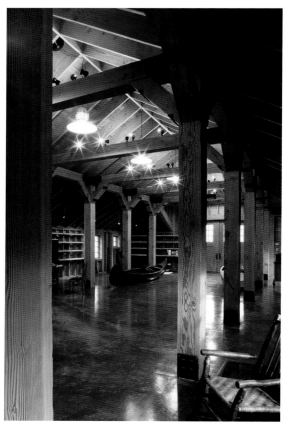

*This building for a collector houses an evolving accumulation of artifacts, toys, and machines (**ABOVE LEFT**); open loft space on the upper floor is used for organization and display. Framing and furnishings are used to contribute to a sense of memory and discovery (**ABOVE RIGHT**); a restoration workshop has a collection of tools on the far wall. Ironwork and timber columns throughout the compound are the work of Wisconsin craftsmen (**OPPOSITE**).*

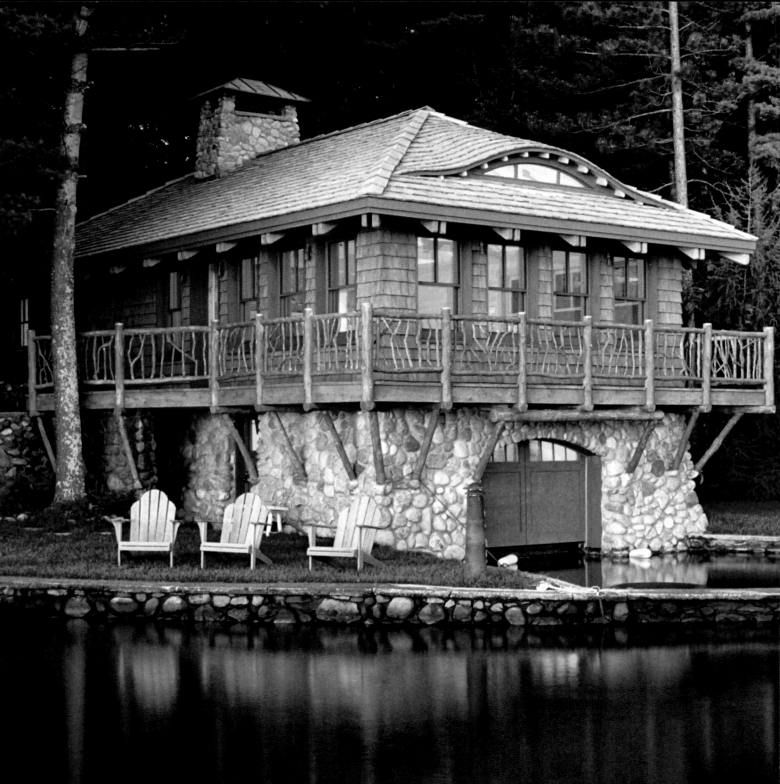

The stone and shingle boathouse with living quarters above is a sensory delight with the pleasures of lapping waters and gentle cross breezes from the lake (OPPOSITE); a large pavilion living space is surrounded by a wraparound deck where the setting sun can be viewed (LEFT); the back of the river rock fireplace separates dining from living areas. A sleeping loft is above (BELOW).

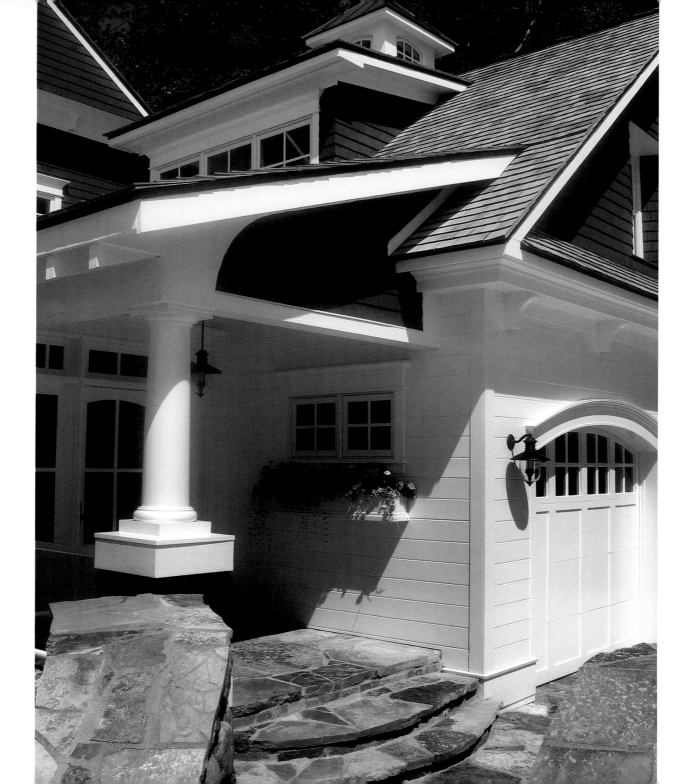

HARBOR SPRINGS

THE EARLY CLASSIC RAMBLING COTTAGES AND GUEST
HOUSES OF NORTHERN LAKE MICHIGAN HAVE BEEN A MODEL
FOR VACATION ARCHITECTURE FOR MORE THAN A CENTURY.
THIS NEW HOME BY ARCHITECT ROBERT B. SEARS IS A
TESTAMENT TO THE STYLE AND ROMANCE OF THE PAST.
PHOTOGRAPHS BY ROBERT SEARS AND DAVID SPECKMAN.

*A covered entrance to the main house is welcoming in the
cottage style (OPPOSITE); the expansive lakeside veranda is
designed for relaxation, cold drinks, and watching the ever-
changing patterns of the lake (ABOVE).*

THE MAIN HOUSE RISES ABOVE 950 FEET of sandy
shoreline. The house is designed after the classic ram-
bling cottages that were built in Northern Michigan at
the turn of the twentieth century, as expressed by its
gambrel roof, dormers, and many timeless architectural
details. Four outdoor fireplaces create cozy vignettes on
the 1,800 square feet of relaxing porches and verandas.

Nestled into the trees high on a bluff overlooking
beautiful Lake Michigan is the Mossburg guest house.
Below are the ever-changing patterns of light and shade on
the lake surface and the sugar-sand beaches. Views from
the porch offer daily, up-close sightings of eagles as they
circle and soar at eye level. Occasionally one will dive to
catch a large salmon from the lake. The porch runs the
entire length of the house, with an outdoor fireplace and
an enclosed sleeping porch for those who just can't spend
a moment away from the wonder of wildlife.

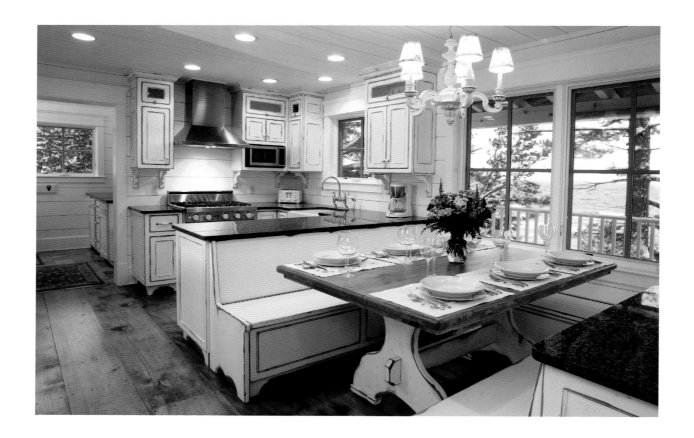

The guest house is accessible only by a footpath. Hand-built stairs add to the seclusion and privacy. The owner, who serves on the board of the local land conservancy and is active in promoting smart growth efforts in Michigan, donated a large conservation easement adjacent to the guest house. The parcel will never be developed and will remain forever in this natural state. The house was designed to not disturb the bluff, and while three trees were removed, nearly all the native vegetation remains intact.

The exterior features a copper roof with a copper hatch opening to the sun deck. At 1,200 square feet, the interior includes a main-floor kitchen, dining, and living room, and a bedroom and bath. A handmade wooden staircase spirals from the family room to the upper master bedroom and bath, with views of the beach through the treetops. Designed to be a warm and cozy retreat in the winter, the house is quite casual and breezy in the summer. It is tucked into the trees to respect its surroundings in all seasons and holidays.

The guest cottage kitchen, pantry, and breakfast nook were designed for old-style comfort (**OPPOSITE**); a cozy space in front of the fireplace. Circular stairs lead to second-floor guest rooms (**LEFT**); the living space, wet bar, breakfast nook, and upper landing all have views of the lake (**BELOW**); the main house on the Lake Michigan shoreline (**FOLLOWING PAGES**).

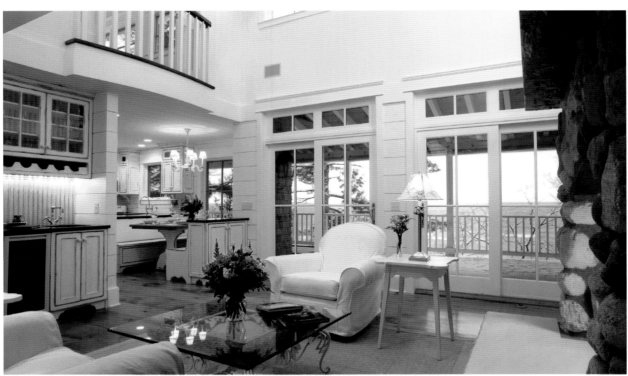

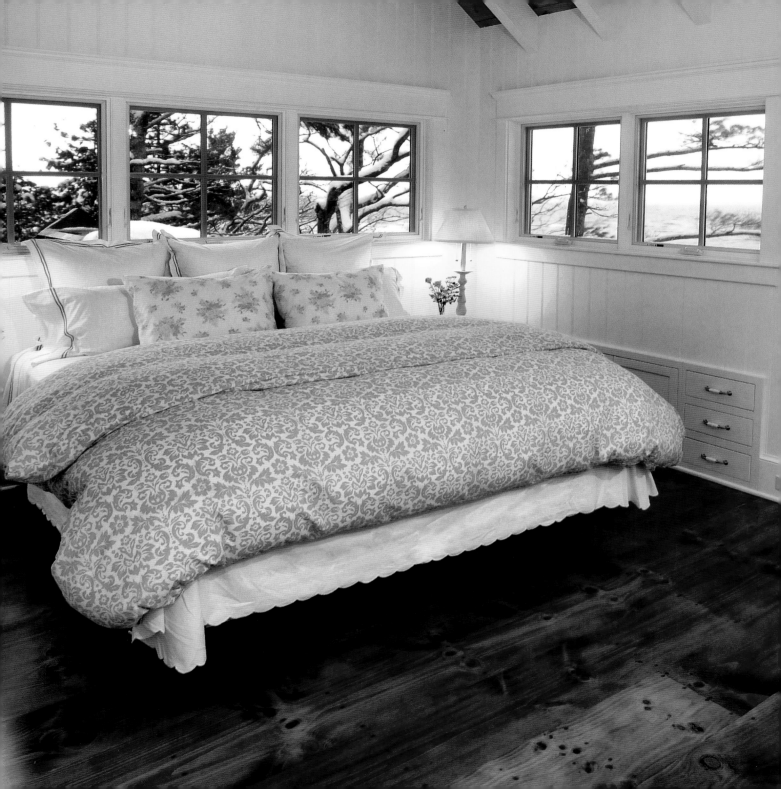

*An open-beamed ceiling and ribbon of windows make an airy, bright guest bedroom (**OPPOSITE**); the children's bunk room has an outdoor balcony (**ABOVE LEFT**); an irresistible sleeping porch is equipped with wind-guard curtains for guest comfort (**ABOVE RIGHT**).*

DOOR COUNTY

THE SIMPLICITY OF THIS DOOR COUNTRY REFUGE BELIES
THE DISTINCTION OF THE ARCHITECTURE AND ITS SPIRIT OF
PLACE. HERE WE FIND AN EXTRAORDINARY EXAMPLE OF
 THE EVOLUTION OF A NEW INDIGENOUS ARCHITECTURE FOR
THE REGION. DESIGN BY EIFLER & ASSOCIATES ARCHITECTS.
PHOTOGRAPHS BY WILLIAM KILDOW PHOTOGRAPHY.

THE FAMILY HAS OWNED THE LAKEFRONT parcel in
Door County for more than 50 years. The parents and
their five children spent summer vacations in this glorious
place, living in a small two-bedroom wooden cottage
until 2002, when the little cottage was destroyed by a fire.
One of the sons and his wife took on the responsibility of

*Family and friends gather in the single large space of the living
room, dining room, and kitchen (OPPOSITE); a small, rocky spit
curves into the lake near the fire pit (ABOVE).*

305

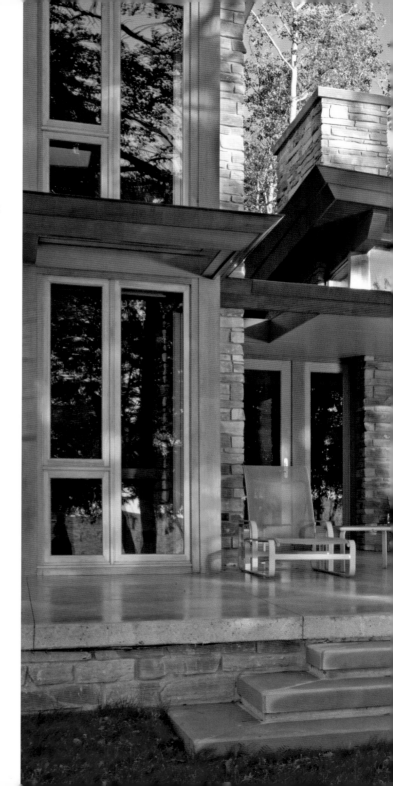

replacing the old cottage with a new one and brought in
Eifler & Associates. The firm had recently completed the
owners' new home in a western Chicago suburb.

The plan for the new cottage was to have two wings
connected by a central corridor and foyer. The cottage is
arranged so that the owners and their guests can congre-
gate in a large single space, comprised of the kitchen, dining
and living rooms. The bedrooms are located in a separate
wing and secluded from the rest of the house, allowing for
tranquility and privacy. Each bedroom is provided with
exterior doors to the terrace, for access to enjoyable views
of the water and setting sun, and stargazing at night.

A variety of historical references and local materials
are used in a very contemporary manner. Cedar, Douglas
fir, and walnut were used for interior finishes and furnish-
ings. Distinctive white dolomitic limestone from the
nearby peninsula is represented in the white polished
concrete floors. The showers were finished in matte glass
tiles, reminiscent of the weathered glass found on the
beach. Finally, the beautiful striated stone used through-
out the house in fireplaces, interior, and exterior walls
comes from a nearby quarry.

*All rooms are provided with exterior doors for direct access to
the outdoor terraces and lake.*

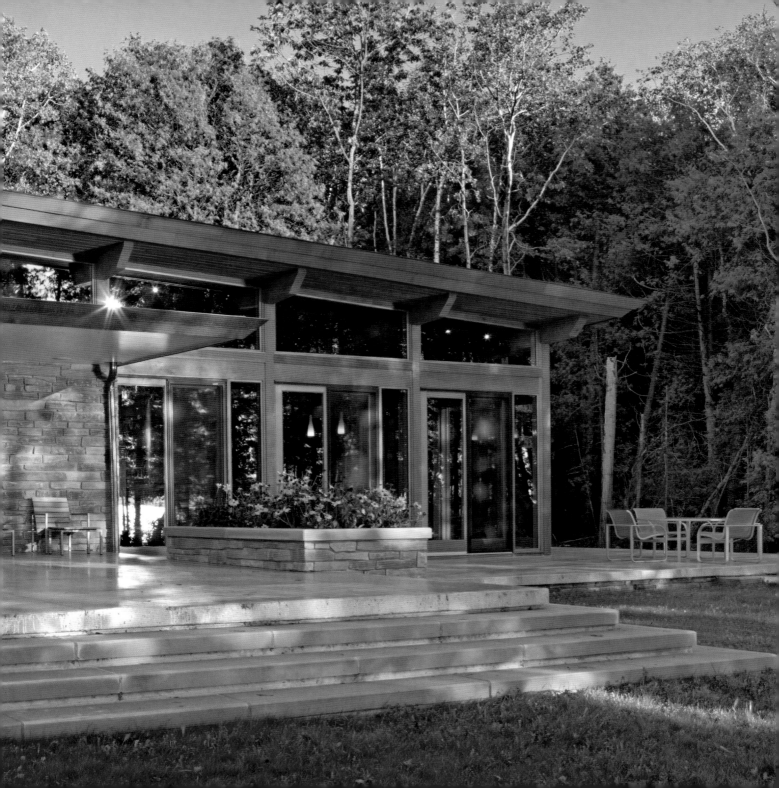

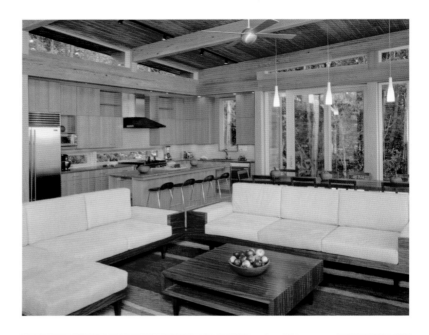

This shared living space is paneled in ash-veneered plywood, offering an attractive contrast to the dark bamboo floors (**TOP**); the interior color palette of natural materials is intended to reinterpret the traditional rustic aesthetic of a weekend home (**BOTTOM**); a second-floor bedroom suite with fireplace and floor-to-ceiling glass doors and windows offers views of forest, lake, and terrace activity (**OPPOSITE, TOP**); a guest bedroom with fireplace faces the setting sun (**OPPOSITE, BOTTOM**).

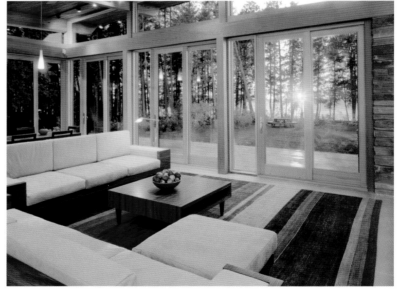

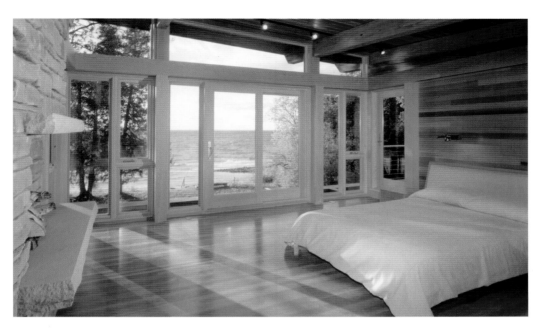

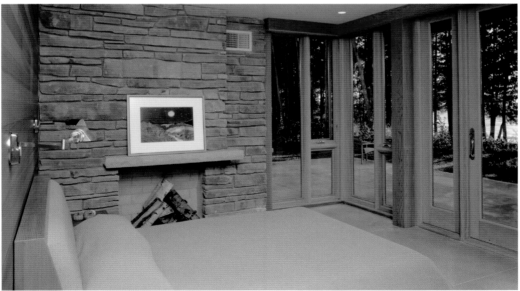

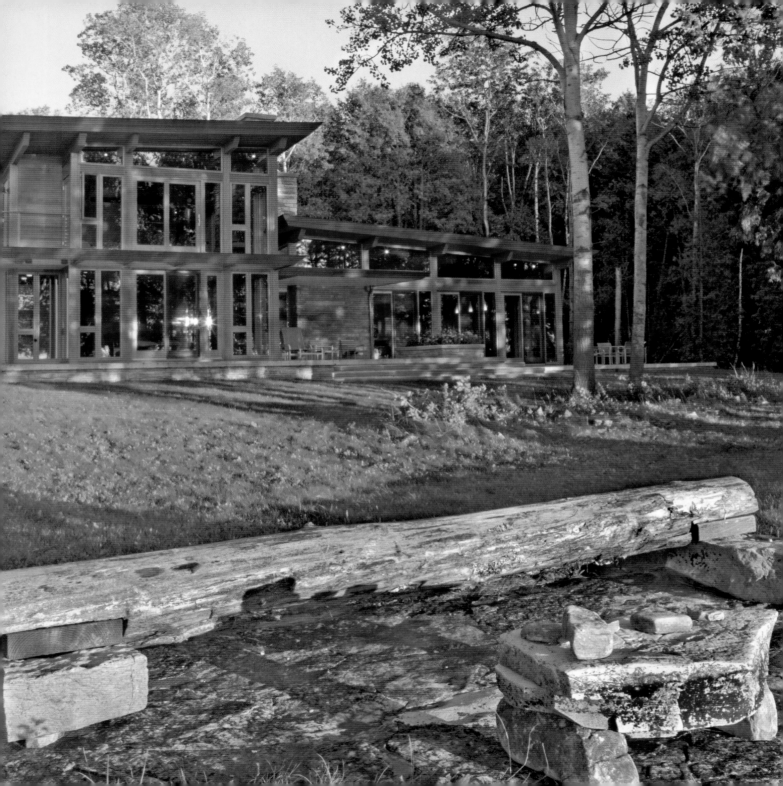

Three private suites and a library are housed under the soaring roof plane. Roofs pitch downward over less important spaces (**OPPOSITE**); *a vision of a solitary moment at the end of the day* (**ABOVE**).

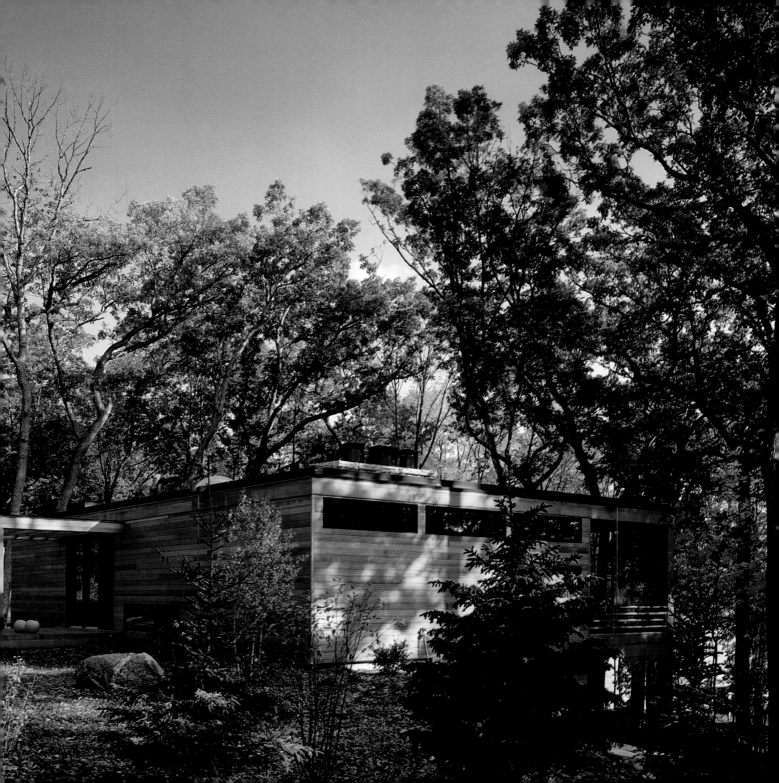

GREENLAKE COTTAGE

THIS NEO-MODERN RETREAT REVEALS MANY OF THE SIGNATURE STYLING TRAITS OF JAMES NAGLE'S SOPHISTICATED AND INNOVATIVE DESIGNS FOR LEISURE. DESIGNED BY ARCHITECT JAMES L. NAGLE, FAIA. PHOTOGRAPHS BY BRUCE VAN INWEGEN.

WHEN MAKING A STATEMENT about modesty, context, and environmental requirements, it is important that the technical problems associated with the earlier particulars of modernism be resolved. The idea here was to construct a modest cottage and boathouse that were consistent with the maxim "small is beautiful." To pursue the two combined goals, the architects planned that the wood-frame pavilion be clad in a natural-finish clear cedar siding. The clerestory windows and 12-foot rolling doors are framed in polished, sustainable mahogany. Wisconsin fieldstone from nearby quarries is integrated into the exterior walkways and retaining walls, and moves into the interior space as a framed and focused floor-to-ceiling

The heavily wooded site faces the lake on the south. The upper floor is designed as a private, self-contained weekend retreat for two people (OPPOSITE); custom shelving displays art and artifacts (ABOVE).

fireplace and hearth, which divides the living space from a sleeping area. The nine-foot ceilings are varnished cedar; floors are cedar fir; doors are of lovely river birch.

The cottage was built on a south-facing, wooded, sloping site on the lake. The upper level enjoys views of the lake, and the lower level—for family, guests, and visitors—is a full story that opens directly onto the lake. A south-facing porch spans the entire south façade and is sheltered by a roof of cedar louvers, which allow protection from the hot summer sun and provide natural light in the winter days.

The cottage and its boathouse building follow the contours of an oak-covered hillside overlooking the lake waters. The boathouse aligns with the house, preserving the trees between the two structures. The two-story steel-and-wood-framed structure houses the upper-level entry to the living and dining rooms and the master bedroom. The lower-level walk contains the children's bedroom and a family activity area. This is a quiet, understated wood cottage that is clearly a modern building. The best part of the house combines indoor and outdoor terraces in a perfect balance of public and private spaces for informal living.

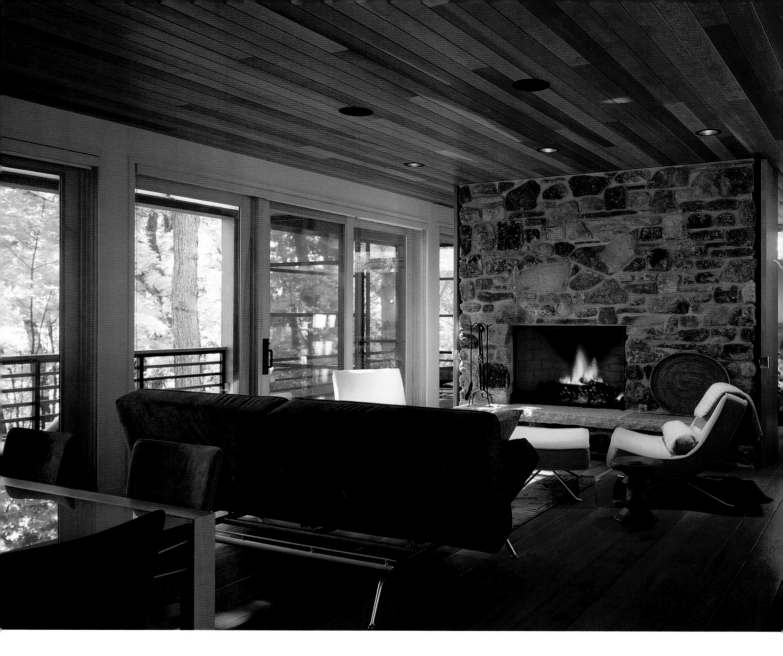

The upper-level plan is a contemporary cottage design using a wood-framed granite fireplace in the living area. The fireplace divides the living area and master bedroom.

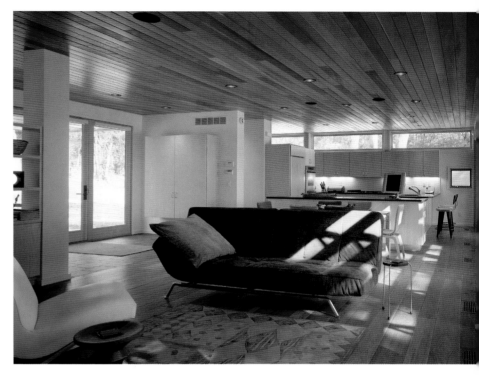

*Kids' dormitory bunks are on the lower full-story level, which has full sunlight and opens onto the lake (**ABOVE LEFT**); the kitchen and bar area on the east features high ribbon windows to allow morning light into the upper floor (**ABOVE RIGHT**).*

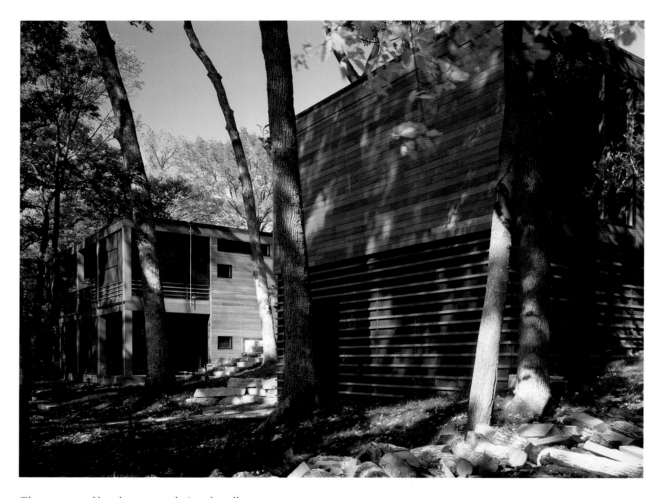

The cottage and boathouse were designed to allow green space in between and to minimize the impact of visual volume (**ABOVE**); *the spacious south-facing porches shade the façade with a roof of cedar sun louvers* (**OPPOSITE**).

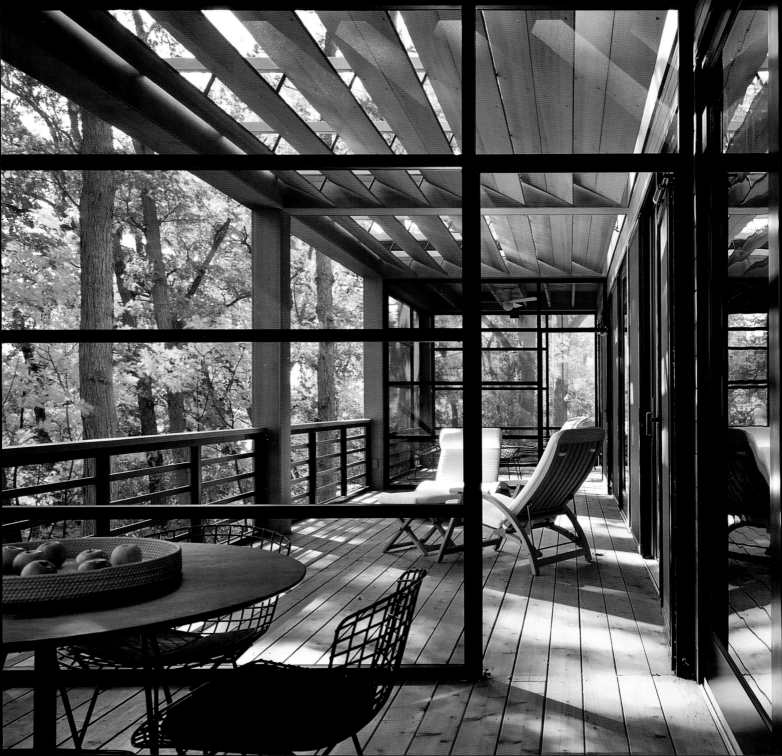

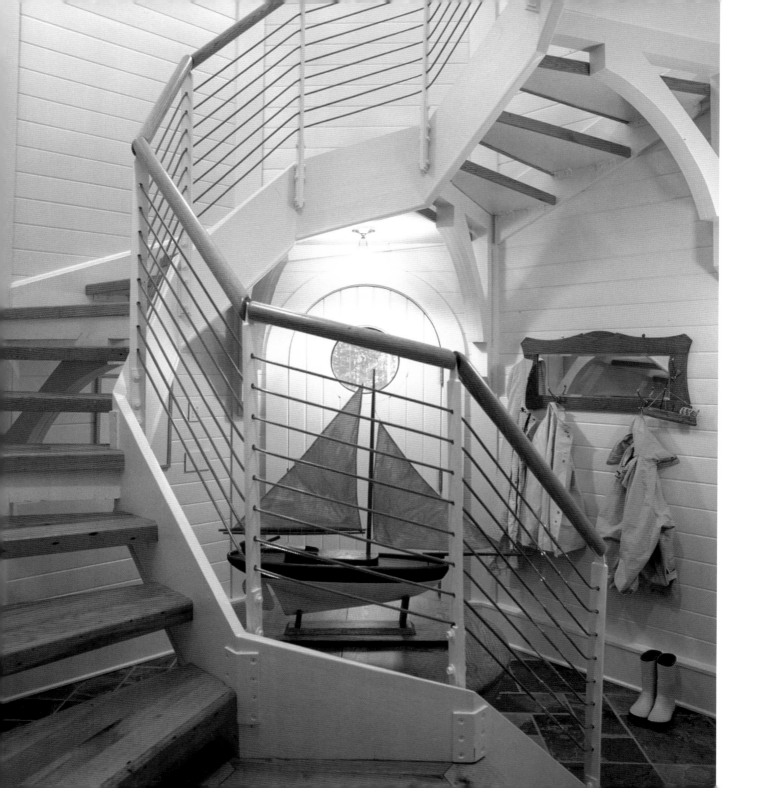

BAYFIELD CARRIAGE HOUSE

THE SINGULAR LOCATION OF LAKE SUPERIOR'S APOSTLE ISLANDS IS A CHOICE SITE FOR THE STUNNING WORKMANSHIP AND CREATIVITY FOUND IN THE DESIGN PLAYFULNESS OF WHAT MAY SURELY BE DESCRIBED AS A CAPTIVATING LAKE GETAWAY. DESIGNED BY ARCHITECT DAN NEPP. PHOTOGRAPHS BY ALEX STEINBERG.

THE ONE DOMINANT FEATURE OF great lakes living is the variety of lighthouses. The client of this architect was looking for a whimsical retreat that would capture the playful elements of a lighthouse that reflected the unique character of Bayfield in the Apostle Islands. The carriage house was to be used as temporary housing until the main house was built; then it would be a guest house.

The concept was to provide a form and spaces suggestive of a carriage house and a lighthouse. The goal was to inhabit an unconventional living space for the sense of

A casual entrance and foyer carry the lighthouse styling into the interior with a classic curved door to the tower staircase (**OPPOSITE**); *the architectural detailing of this whimsical nautical cottage retreat* (**ABOVE**).

getting away, but also to make it a very livable and appropriate place to be. Large-scale gables and recessed, arched windows allow the house to balance with the animated form of the tower itself, while creating dramatically framed views of the north woods and the lake.

The house was designed around the kitchen, where most of the living and eating take place in the vaulted space above the "carriage functions" below. The larger space is made more intimate by incorporating a banquette in the deep window recess and the curving canopy over the kitchen area. Intimacy and warmth are also created by the use of recycled Douglas fir paneling that wraps the entire room. The tower is not just an icon but is an integral and multifunctional part of the house. It contains the entry, the stair to the second floor, and the observation room, where built-in seating; cabinets and shelves for books, TV, and

music; and dramatic views of the surrounding islands and lakes can be found.

The carriage house is across a circular driveway from where the main house will be located. Both are angled to take advantage of an existing opening in the trees and vista of Lake Superior. The tower and drive-through opening declare this house not a typical house and will keep it from being confused with the future main house. Until then, all the fun is in the carriage house.

The carriage lighthouse sits on a curved drive, angled toward an existing opening in the trees for a vista of the lake (ABOVE); the sturdiness of a lighthouse greets visitors at the arched door and the porthole window (OPPOSITE).

Dark mahogany paneling and moldings enrich the interiors. The curved wall of the entrance from the foyer to the living room is echoed by the strong curvature of the bar and windows.

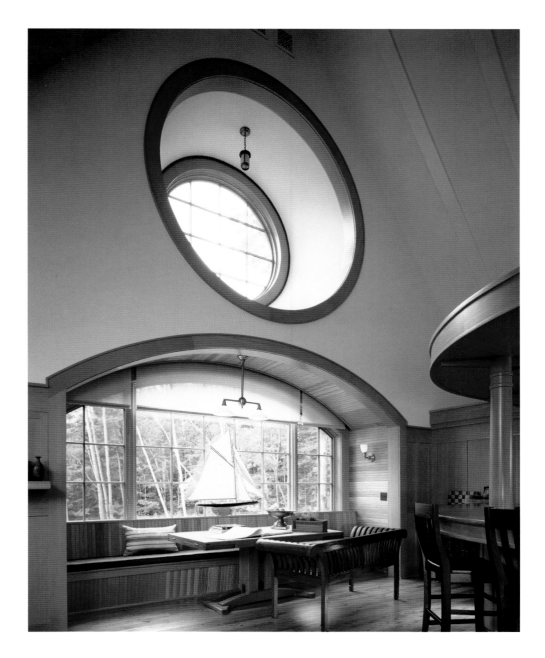

The built-in window bench and curved overhead bead-board paneling recall captains' quarters at the aft of a tall ship.

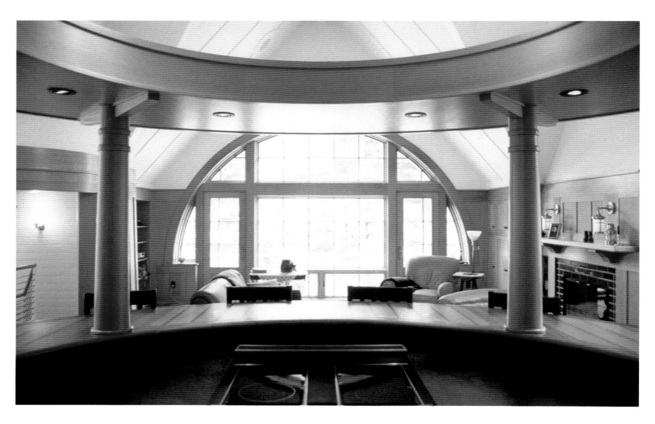

The curvatures of polished wood supported by posts and columns confidently enfold the room. Large paned windows allow natural light to flood into the space (**ABOVE**); the top of the tower is a sunroom and an observation room with built-in furniture. A glass portal in the floor peers down the center of the staircase (**RIGHT**).

A detail of wood paneling and trim molding used on the bar
(**ABOVE LEFT**); *the simple geometries of the tower stair as it*
reaches the floor of the observatory (**ABOVE RIGHT**).

The approach to the main entry from the parking area. Large bent logs form an arch over the door (OPPOSITE); the exterior view of the great room through cathedral glass and river rock framing the high window (RIGHT).

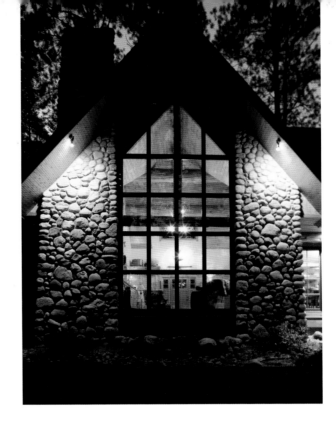

WHITEFISH CHAIN OF LAKES

A HISTORIC SITE IS HOME TO A NEW RETREAT AND A RENEWED FAMILY TRADITION. BUILT WITH THE INHERENT NOSTALGIA OF THE RUSTIC STYLE, IT IS THE PLACE ONE LONGS TO REACH AT THE END OF A LONG WEEK. DESIGNED BY ARCHITECT KATHERINE HILLBRAND. PHOTOGRAPHS BY TROY THIES.

THIS LAKESIDE RETREAT IS THE FORMER SITE of a historic cabin that had been cherished by the entire lakeside community, but had fallen on hard times. The idea for the new cabin was that it, too, would be a gathering place for family and friends to relax and enjoy the outdoors. It was built with the texture and qualities that hearken to the great camps of the Adirondacks, and it was created to become a legacy for future generations.

The new camp was built with milled lumber, although it has the feeling of a sheltering log retreat from bygone years. The materials reflect and illuminate nature. The oversized stone piers of the cathedral window on the lakeside frame the lake between the majestic old pines. The light filters through the trees and gives the large and comfortable gathering room an aura of late afternoon serenity and peace. The gathering room is cradled among higher-than-usual cabinets, which house books, games, and music. The scale of the built-in cabinets creates the illusion of constricting the proportions of the room, making it ever more cozy. The fireplace anchors the corner of the room as a companion to the view and not in competition with it.

The dining room and kitchen are integral and tucked under the second-level bedrooms. The simple detailing in these rooms makes it comfortable for guests to show up for breakfast in their pajamas. The essential screened porch

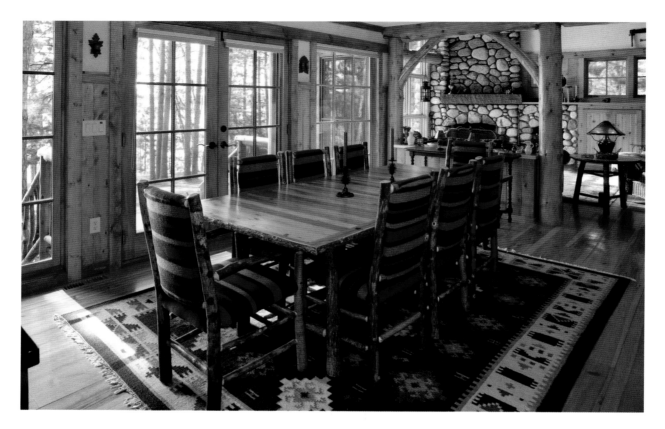

The dining area features arched logs repeating from the main entrance. The dining table and chairs are made in the style of old hickory resort furniture (**ABOVE**); a stickwork wood railing curves up the stairway and around the upper landing that overlooks the great room (**OPPOSITE**).

opens from the dining room and steps out to take its place among the fragrant old pines.

All bedrooms are on the second level found at the top of a gnarly, log-accented stair and a landing that looks over the gathering room. Each bedroom is tucked under the eaves. Dormers allow for cozy window seats in the children's rooms. The couple's bedroom has a small balcony that overlooks the lake.

The roofs are steeply pitched and cascade to the lower levels, thus reinforcing the reserved and submissive disposition of the new member of the community.

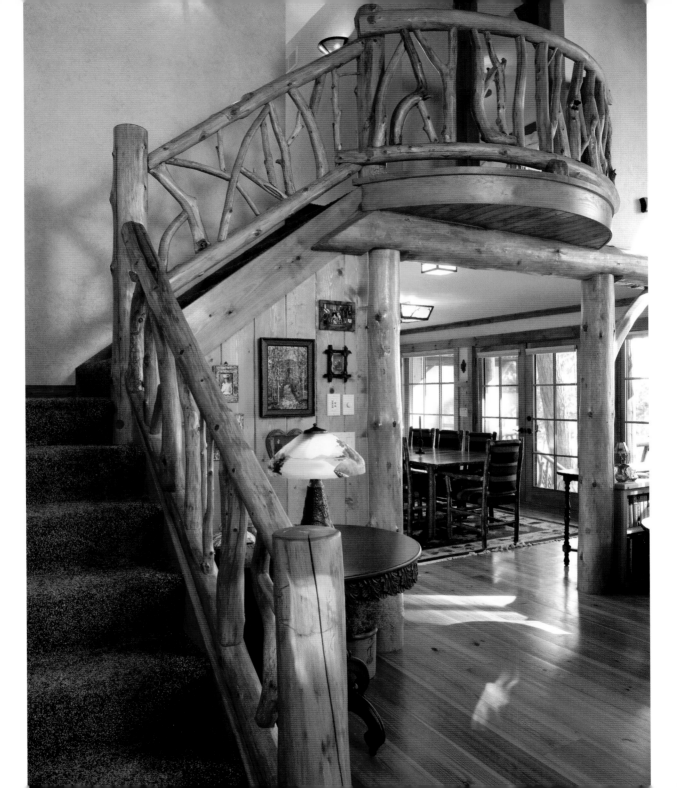

A small master bedroom above a screened porch has French doors that open to a small balcony with a rustic, stickwork railing. Setting suns are the main attraction for this room.

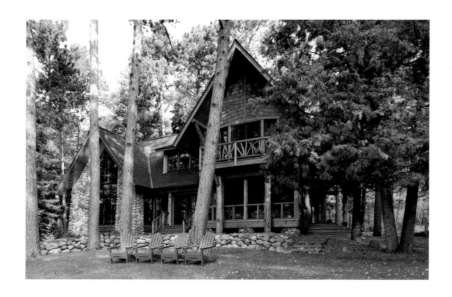

The new cabin was built to replace a cherished historic cabin that had fallen on hard times (**ABOVE**); the new cabin was built with the hope that it, too, would become a gathering place for family, friends, and members of the community (**RIGHT**).

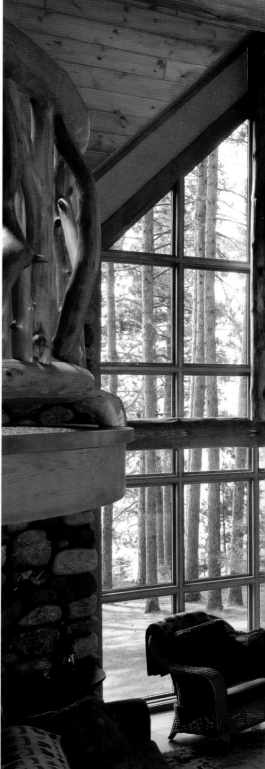

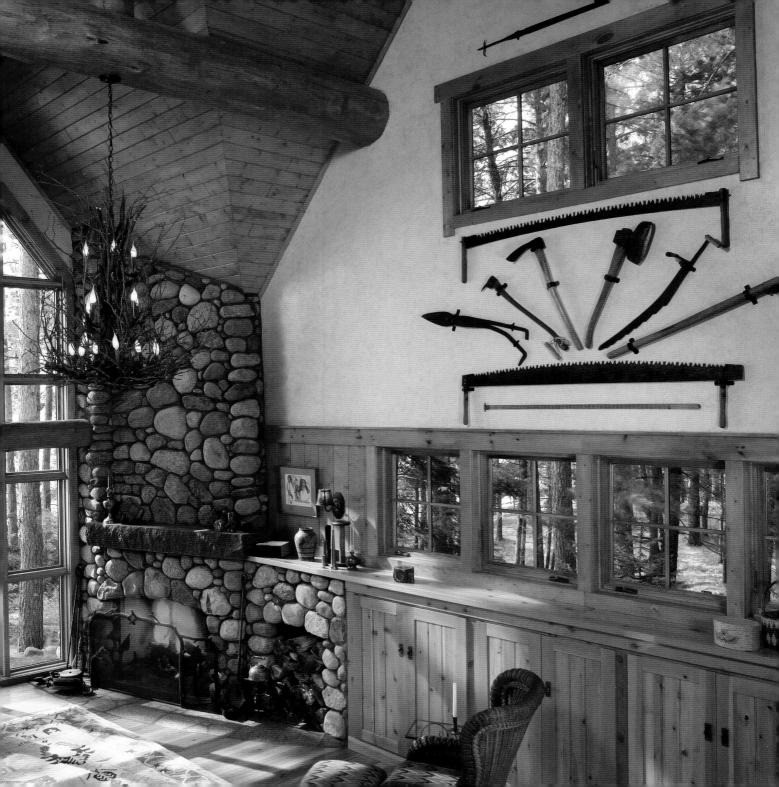

CREDITS

WOODLAND RETREATS

COLORADO LOG CABIN
Architect: Charles Cunniffe
 Architects, Aspen, Colorado
 www.cunniffe.com
Photographer: Tim Murphy, Tim
 Murphy Photography, Inc.

CORTES ISLAND CABIN
Architect: Greg Robinson, AIA,
 The Cascade Joinery,
 Bellingham, Washington
 www.cascadejoinery.com
Photographer: J. K. Lawrence
 www.jklawrencephoto.com

CAMANO ISLAND CABIN
Architect: Tim Carlander, Vandeventer
 & Carlander Architects,
 Seattle, Washington
 www.vc-arch.com
Photographer: Steve Keating,
 Steve Keating Photography
 www.steve-keating.com

CANYON CABIN
Architect: Paul F. Hirzel, Pullman,
 Washington
Photographer: Art Grice

NORTH CASCADES CABIN
Architect: Nils Finne, Finne
 Architects, Seattle, Washington
 www.finne.com
Builder: Rick Mills
Photographer: Art Grice

BIRDING CABIN
Architect: Suyama Peterson Deguchi,
 Seattle, Washington
 www.suyamapetersondeguchi.com
Photographer: David Story

SONOMA COUNTRY CABIN
Architect: T. Olle Lundberg, AIA,
 Lundberg Design,
 San Francisco, California
 www.lundbergdesign.com
Photographer: Jon D. Peterson
 www.jdpetersonphotography.com

CARLISLE CABIN
Architect: Marley + Wells Architects,
 Petaluma, California
Photographer: Tim Maloney, Technical
 Imagery Studios
 www.technicalimagery.com

RIDDELL CABIN
Architect: Will Bruder, Will Bruder
 Architects, Ltd.,
 Phoenix, Arizona
Design Team: Richard Jensen,
 Michael Crooks
 www.willbruder.com
Photographer: Bill Timmerman
 www.billtimmerman.com

LONG CABIN
Architect: Jim Cutler, AIA, Cutler
 Anderson Architects, Bainbridge
 Island, Washington
 www.cutler-anderson.com
Photographer: Art Grice

THE PERFECT PLACE
Photographer: François Robert
 www.francoisrobertphotography.com

COASTAL RETREATS

BOLES BEACH RETREAT
Architect: Stanley Boles, FAIA,
 Portland, Oregon
 www.boora.com
Photographer: Laurie Black
 www.laurieblack.com

LONG BEACH HOUSE
Architect: Replinger Hossner,
 Seattle, Washington
 www.rhoarchitects.com
Design Team: Jim Replinger, Tim
 Hossner, Christopher Osolin
Interior Design: Rocky Rochon
 Design
Photographer: Michael Moore
 www.arcshots.com

HOOD CANAL CABIN
Architect: Castanes Architects,
 Seattle, Washington
 www.castanes.com
Photographer: Michael Moore
 www.arcshots.com

DECATUR ISLAND HAVEN
Architect: George Suyama Architects,
 Seattle, Washington
 www.suyamapetersondeguchi.com
Photographer: Claudio Santini
 www.claudiosantini.com

TEMPIETTO
Architect: Thomas L. Bosworth,
 FAIA, Seattle, Washington
 www.bosworthhoedemaker.com
Photographer: Michael Skott
 www.skottphoto.com

CABIN AT ELBOW COULEE
Architect: Balance Associates,
 Architects, Seattle, Washington;
 Tom Lenchek, principal designer
 www.balanceassociates.com
Photographer: Steve Keating,
 Steve Keating Photography
 www.steve-keating.com

BLUE LAKE RETREAT
Architect: Allied Works Architecture,
 Portland, Oregon; Brad Cloepfil,
 partner-in-charge
 www.alliedworks.com
Photographer: John Dimaio
 www.johndimaiophotography.com

COTTAGES ON THE COAST

VINTAGE VINEYARD COTTAGE
Architect: Stephen Blatt Architects,
 Portland, Maine; Stephen Blatt,
 Principal; Douglas W. Breer,
 Project Architect
 www.sbarchitects.com
Photographer: Brian Vanden Brink
 www.brianvandenbrink.com

RABBIT RUN
Architect: Botticelli & Pohl Architects,
 Boston, Massachusetts
 www.botticelliandpohl.com
Photographer: Jeffrey Allen
 www.jeffallenphotography.com

OCEAN POINT COTTAGE
Architect: Rob Whitten, Whitten
 Architects, Portland, Maine
 www.whittenarchitects.com
Photographer: Brian Vanden Brink
 www.brianvandenbrink.com

DEXIOMA
Photographer: Cary Hazlegrove
 www.hazlegrove.com

FAIR HARBOR IN CARMEL
Builder: M. J. Murphy, Framingham,
 Massachusetts
Photographer: Steve Keating,
 Steve Keating Photography
 www.steve-keating.com

**CONNIE UMBERGER'S
COTTAGE**
Photographer: Cary Hazlegrove
 www.hazlegrove.com

TREASURE COTTAGE
Designer: Michael Pelkey Interior
 Design, Key West, Florida
Photographer: John Dimaio,
 Northfield, New Jersey
 www.johndimaiophotography.com

**MICHELLE DIANE'S STONE
COTTAGE**
Architect: Mark Mills
Photographers: Steve Keating,
 Steve Keating Photography
 www.steve-keating.com

ISLAND LIVING

CLINGSTONE
Architect: Henry A. Wood, FAIA,
 Kallmann McKinnell & Wood
 Architects, Inc.,
 Boston, Massachusetts
 www.kmwarch.com
Builder: J. D. Johnstone
Photographer: John Dimaio
 www.johndimaiophotography.com

FISHERS ISLAND
Architects: Mark Simon, FAIA,
 and Leonard J. Wyeth, AIA,
 Centerbrook Architects and
 Planners, Centerbrook, CT
 www.centerbrook.com
Photographer: Timothy Hursley /
 Arkansas Office
 www.timothyhursley.com

ORCAS ISLAND
Architect: David Coleman,
 David Coleman Architecture,
 Seattle, Washington
 www.davidcoleman.com
Photographer: Claudio Santini
 www.claudiosantini.com

NANTUCKET
Architect: Lyman Perry, Berwyn,
 Pennsylvania
 www.lparchitects.com
Photographer: Kristin Weber,
 Bruce Buck Photography
 www.brucebuck.com

NORTH SHORE
Architect: Jim Niess, Maui
 Architectural Group,
 Wailuku, Hawaii
Design Team: Margaret J. B. Sutrov;
 Dan Graydon
 www.mauiarch.com
Photographer: David Watersun
 www.watersunphotography.com

MOONHOLE
Architect: Tom and Gladys Johnston
Photographer: John Dimaio
 www.johndimaiophotography.com

RAVINE LANDING
Restoration: Charles Brewer,
 Architect
Photographer: John Dimaio
 www.johndimaiophotography.com

LAVA FLOW
Architect: Craig Steely, Architect,
 San Francisco, California
Photographer: J. D. Peterson, J. D.
 Peterson Photography
 www.jdpetersonphotography.com

LAKESIDE LIVING

BAER LODGE
Architect: Douglas Kozel, Madison,
 Wisconsin
Photographer: Douglas Kozel

HARBOR SPRINGS
Architect: Robert B. Sears,
 Grand Rapids, Michigan
 www.searsarchitects.com
Photographer: Robert Sears,
 main house; David Speckman,
 guest house

DOOR COUNTY
Architect: John Eifler, Eifler &
 Associates Architects,
 Chicago, Illinois
 www.eiflerassociates.com
Photographer: William Kildow
 Photography
 www.kildowphoto.com

GREENLAKE COTTAGE
Architect: James L. Nagle,
 Chicago, Illinois
Photographer: Bruce Van Inwegen
 www.bviphoto.com

BAYFIELD CARRIAGE HOUSE
Architect: Dan Nepp, Minneapolis,
 Minnesota
 www.tea2architects.com
Project Manager: John Enloe
Photographer: Alex Steinberg
 www.alexsteinberg.cc

WHITEFISH CHAIN OF LAKES
Architect: Katherine Hillbrand,
 Minneapolis, Minnesota
 www.salaarc.com
Photographer: Troy Thies
 www.troythiesphoto.com